EYE
TO
I

DISCARD

EYE
TO
I

SELF-PORTRAITS
FROM THE
NATIONAL PORTRAIT GALLERY

NATIONAL PORTRAIT GALLERY,
SMITHSONIAN INSTITUTION, WASHINGTON, D.C.

HIRMER

This publication and the related exhibition have been
made possible through the generous support of:

Mr. and Mrs. Michael H. Podell

Mark Aron
Mr. and Mrs. Glen S. Fukushima
Mr. and Mrs. Marcel Houtzager
Ellen Miles and Neil Greene
Mr. and Mrs. Walter Moore
Mr. and Mrs. John Daniel Reaves
Paul Sack

Additional support has been provided
by the American Portrait Gala endowment.

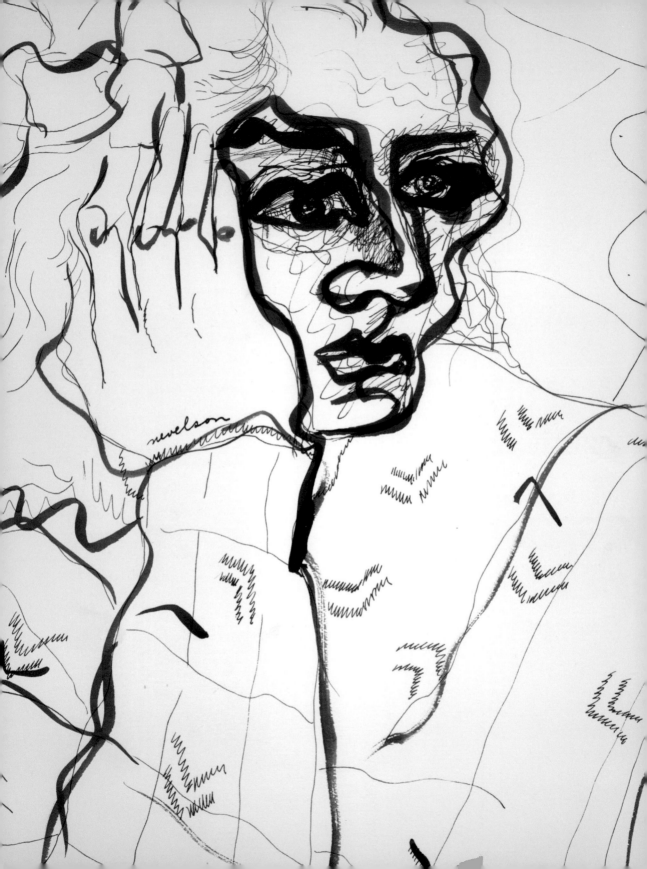

CONTENTS

DIRECTOR'S FOREWORD

"The artist embodies in himself the attitude
of the perceiver while he works."
– John Dewey, *Art as Experience*, 1934.

It is a strange thing to look at someone looking at themselves. For example, when you see another person brushing their teeth, shaving, or putting on their makeup in front of a mirror, it feels at once intimate and voyeuristic. What goes through their mind as they scrutinize eye to "I"? Are they pleased with what they see? If they catch you looking, twinned faces staring back at each other in the glass, do they react with pleasure, awkwardness, or irritation? Suddenly, two separate entities are no longer alone but are sharing an experience. Then there is a *moment* when someone returns a look, a gesture, starts a conversation, makes a *connection*—or disengages, and turns away.

How even stranger then, when the self-looking is not happenstance but deliberately made for an audience—even an audience of one. Pygmalion-like choices are made, giving the artist the ultimate power to make and remake their identity. As Andy Warhol remarked: "When I did my self-portrait, I left all the pimples out because you always should."

Because we are all on a journey of self-discovery, there is something compelling about looking at someone imaging themselves. The common phrases "I was just thinking" or "If it were me" are used to test out who we are linguistically—how fascinating, then, to be able to do so pictorially. When an artist looks in a mirror, s/he is caught by a trapped face that will arrange itself, regardless the circumstances, but the adjustments they make are their own. In the end, it's all a performance.

The "performative self" has further developed with the selfie. As the artist Molly Soda notes, it is "the idea that we're all walking around with these complicated and discrete emotions that are basically triggered by our devices."

As the National Portrait Gallery reflects upon its first fifty years since opening to the public, it seems wholly appropriate to turn our attention to artists looking at themselves. This publication illustrates 143 of the over 540 self-portraits in the collection, providing rich materials for future discussions about performing identity and visual biography.

Thanks go to Chief Curator, Brandon Brame Fortune, for penning the wonderful lead essay, curating the accompanying exhibitions in Washington, D.C., and on tour, and providing the intellectual framework for this project. This scholarship would not have been possible without the visionary support of Cathy and Michael Podell. Deepest appreciation also goes to all those artists, collectors, and donors who have helped the National Portrait Gallery assemble such a wonderful collection of artistic introspection that meets us *Eye to I*.

We would also like to thank all of the contributors to the catalogue for their careful research and wish to extend a special thanks to Pie Friendly for her research assistance.

Kim Sajet, Director
National Portrait Gallery, Washington, D.C.

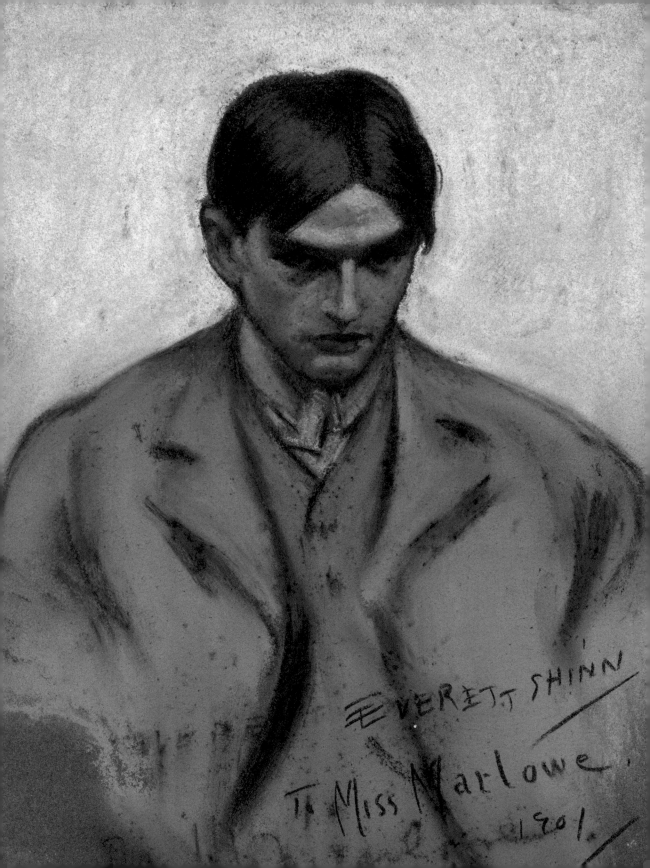

EVERETT SHINN

To Miss Marlowe.
1901.

EYE TO I
THE SHIFTING NATURE OF SELF-PORTRAITS

BRANDON BRAME FORTUNE

Self-portraits are unsettling. At least, they are to me, a student of portraiture for over forty years. When encountering the self-portraits in the collection of the National Portrait Gallery, I often question what I am seeing. A public persona? A glimpse of a private personal self? Artists usually intend for others to view their self-portraits and may choose to reveal aspects of themselves in the process. And yet, self-portraits—as works of art—are inherently products of the imagination. Likeness may be asserted, that's the work that portraits do, but will we learn much about personal identity?

The comparative literature scholar Didier Maleuvre notes: "The artist depicts himself not by looking inward but by looking at what other people see. Self-depiction here is filled with the acknowledgment of other people's gazes. It is a confession about the ghostliness of the so-called inner self."[1]

This slippage between the public self and the private one is the source of my own unsettled attitude when looking at self-portraits of artists. We can certainly feel a strong sense of presence, and we might think that we are learning something personal about the artist through her expression or pose, or objects included in the portrait. We may also see something of the shifting consideration of the artist's role in society. For example, do we see artists as set apart from the world, or do we see them as offering insight into issues of our time, sparking conversations? The artist's gaze, showing us a likeness seen in a mirror, is very compelling. So much so that writers have even used a character's encounter with an artist's self-portrait to introduce a moment of self-discovery.[2]

There is no fixed reason to make a self-portrait. In the twentieth century and in our current moment, artists who create images of themselves do so with an enormous variety of intentions. Elaine de

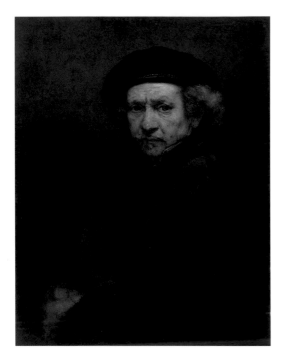

Kooning explained: "The only sitter I could find with time for endless posing was myself."[3] She is among countless artists who have asserted that they make self-portraits because their own visage, reflected in a mirror, is the cheapest model available. Artists can also be serial self-portraitists, such as Rembrandt van Rijn, who famously pictured himself repeatedly over the course of his lifetime (fig. 1). Rembrandt's portraits, particularly those he made in old age, are exercises in duration, of the time he spent creating a self that would be subject to the gaze of others.[4]

The critic John Yau recently wrote about the contemporary painter Susanna Coffey, who has been creating self-portraits for over thirty years (fig. 2). Coffey's subject, Yau notes, is the nature of self-portraiture, "refusing to use the markers commonly associated with portraits of women."[5] The creation of any self-portrait—one by de Kooning, Rembrandt, or Coffey—is multifaceted.

Artists think deeply about representation, particularly when they make self-portraits. By depicting themselves, they explore their own identities, linking their eyes to a self, an "I." Thanks to the advent of photography in the mid-nineteenth century, artists of the twentieth century began to shift away from looking in the mirror toward looking through the camera; from painterly or sculpted surfaces or drawings to mechanical reproductions that assert their existence through prints, photographs, and video. While these created selves may or may not show us an artist's true character, we can, through slow looking, see something of their activism, self-reflection, or engagement with the history of art.

The self-portraits from the collection of the National Portrait Gallery that are presented in this volume allow us to explore the expansive variety of self-portraiture in the modern age. Many of the works are from a major 2002 acquisition of self-portrait prints and

drawings that launched a major exhibition and provided an opportunity for the museum to further research a selection of those works and investigate the history of the genre.[6]

Self-portraits by Lee Simonson and Marguerite Zorach reveal their knowledge of the history of art and the impact that European modernism had on their work (p. 41, p. 82). Artists Alfred Frueh and Miguel Covarrubias, who sent self-portrait caricatures to greet their friends at Christmastime, openly embraced humor (p. 62, p. 161). Both James A. Porter and Roger Shimomura used visual tropes and templates to assert their presence as successful artists in the face of being ignored or marginalized because of their heritage or the color of their skin (p. 176, p. 313). Elaine de Kooning collapsed time and space in a drawing that combines a remembered appearance with what the mirror showed her a few days after her fiftieth birthday, a time of reckoning in her life (p. 202). Meanwhile, María Magdalena Campos-Pons created an image that explores the experience of exile and her identity as part of the African diaspora (fig. 3; p. 295). These are just a few examples of the motives underlying self-portraits.

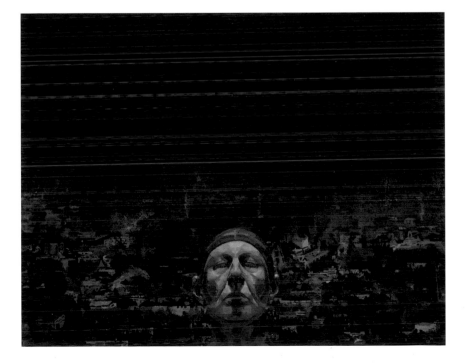

FIG. 02 *Day for Night* by Susanna Coffey, 2005; Oil on linen 71.1 × 91.4 cm (28 × 36 in.); Collection of the artist, courtesy Steve Harvey Fine Arts Project

Any presentation of self-portraiture at this time must acknowledge an intersection of the works created by practicing artists with today's "selfie" culture. The smartphone's camera has become the mirror—but it is also a tool to share images and information with others, so that it serves both private and public functions. Every day, countless selfies are posted on the internet. While some see a search for authenticity or truth in those digital images, they are entirely mediated and announce (through careful selection for social media posts) our status, our connections, and our hopes. The very concept of identity is fluid and open to constant re-invention.

"Selfies," as art critic Jerry Saltz observes, "have changed aspects of social interaction, body language, self-awareness, privacy, and humor, altering temporality, irony, and public behavior. It's become a new visual genre—a type of self-portraiture formally distinct from all others in history. Selfies have their own structural autonomy. This is a very big deal for art."[7] Richard Saunders, who has studied American portraiture for over four decades, has recently written an essay outlining the history of the selfie and its context.[8] The famous selfie illustrated here displays many of the poses we associate with these images—groups gathered around a smartphone held by one person, attempting to fit multiple, smiling subjects into one rectangle—creating an image that will immediately be shared with others (fig. 4).

Increasingly, concerns for privacy and protection of information posted on social media have inflected how we look at self-portraits created by practicing artists.[9] Scholars posit that the remarkable rise of the "selfie" in the twenty-first century is not only tied to the simple availability of a phone with a camera but to a contemporary desire for individuals to belong to a social group, to be part of a networked connection.[10]

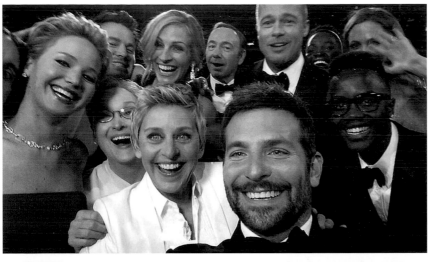

FIG. 04 Bradley Cooper taking a group selfie at the 2014 Academy Award ceremonies

FIG. 05 *Who's Sorry Now* by Amalia Soto (Molly Soda), 2017; Video, with sound; 2 minutes, 54 seconds; Courtesy of 315 Gallery, Brooklyn, New York

In the last decade, artists have co-opted social media for their own purposes. Given such interest in creating self-images, one ought to look to self-portraits by twentieth- and twenty-first-century artists to find a context within the visual arts for this plethora of born digital images. As a curator, I often think about how images on social media do or don't draw from other forms of visual culture. Many other scholars are writing about this phenomenon or about how artists are disrupting the tropes of social media with their own work.

Artists are increasingly making use of smartphones to create work. Molly Soda's Instagram posts and videos, for example, examine a teenage girl aesthetic as the artist creates that persona (fig. 5),

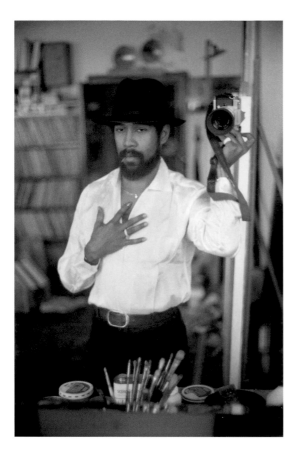

FIG. 06 *Self-Portrait with Black Hat* by Barkley L. Hendricks, 1980/2013; Digital chromogenic print, (27 ¾ × 18 ¾ in.); Estate of Barkley L. Hendricks. Courtesy of the artist's estate and Jack Shainman Gallery, New York

while Christina Balch's *Awake* project (2012–16), presents selfies of the artist that she took of herself every morning upon awakening, creating a flawed, falsely authentic image of herself. K8 Hardy's series of self-portraits, *Outfitumentary* (2001–11/2015), comprises raw and vulnerable photographs of the artist dressed in hundreds of creative outfits, which she often sourced from thrift shops. Curator Lauren Cornell, who frequently reviews the work of artists who push against the norms of today's social media, points out that this platform for art is constantly changing: "What feels dissonant today, erasure, say, or disorder or reinvention . . . may, in only a short time, become status quo. But social media, in its omnipresence and ubiquitous use, has become a main site for the contestation of identity and the self—a new arena that repeats and extends previous eras' questions of visibility and self-definition, and begs for artistic challenge."[11]

Other writers have examined self-portraits and difference, investigating how one's likeness is constructed to reveal or obscure ability, gender, or race. For instance, Kristin Lindgren has recently written on Laura Swanson and Diane Arbus to reflect on "how disability inflects and redefines the conventions of portraiture," with a focus on Swanson's *Anti-Self-Portraits* series (2005–8).[12] And multiple authors contributed to *Portraits of Who We Are*, a catalogue published in 2018 to accompany an exhibition of African American portraits and self-portraits at the University of Maryland's David C. Driskell Center (fig. 6).[13] Self-portraits often make up a significant number of the winning entries in the Portrait Gallery's triennial Outwin Boochever Portrait Competition (2006, 2009, 2013, 2016).[14] Because self-portraits can serve so many purposes, from simply

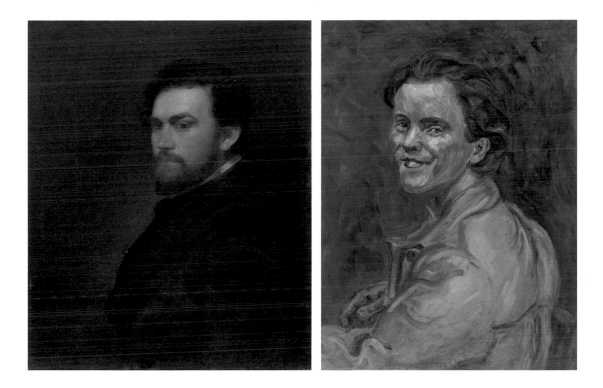

showing us what the artist looks like to providing sophisticated commentary on contemporary issues or inviting us to learn something about the artist's style or medium, the Outwin Boochever Portrait Competition allows for a continuing investigation of the genre.

The works featured in this book represent about a quarter of the self-portraits in the National Portrait Gallery's collection. The very first self-portrait acquired for the collection is an image of George Fuller, a New England artist who is best known for the visionary paintings created toward the end of his life (fig. 7). The work, which was previously in the collection of the National Gallery of Art, was transferred, in 1965, to the newly founded museum, as part of a larger transfer of American portraits.

While many of the self-portraits that entered the Portrait Gallery's collection over the next decade tended to be rather straightforward-looking images of black-suited white men addressing us with a level gaze, often with pencils, brushes, and palettes in hand, there were notable exceptions in the institution's early years. In 1966, two years before the museum opened to the public, Ira Gershwin made a

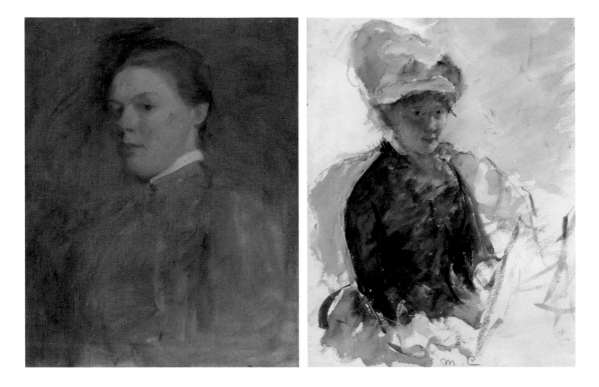

gift of a self-portrait of George Gershwin—a bright, witty painting that references his talent for composing (p. 111). In 1969, the museum acquired an animated, gold-hued painting by Morgan Russell, which in its wit and pose, alludes to the work of the seventeenth-century Dutch artist Frans Hals (fig. 8). Russell moved to Paris in 1908 and, with Stanton MacDonald-Wright, founded the Synchromist movement of abstraction around 1912. By 1971, the Portrait Gallery acquired its first self-portrait of a woman, Philadelphia artist Cecilia Beaux (fig. 9), and a bold self-portrait painting of Alexander Calder, from 1925, made before he began to focus on sculpture (p. 79). Throughout the 1970s, the museum slowly—yet steadily—acquired important self-portraits, many of which are included in this book. One major acquisition was a watercolor self-portrait by Mary Cassatt, which entered into the collection in 1976 (fig. 10), and another was a likeness of one of America's best-known colonial artists, John Singleton Copley (fig. 11).

The first photographic self-portraits entered the collection in 1977, just a year after the museum's Commission voted to allow the

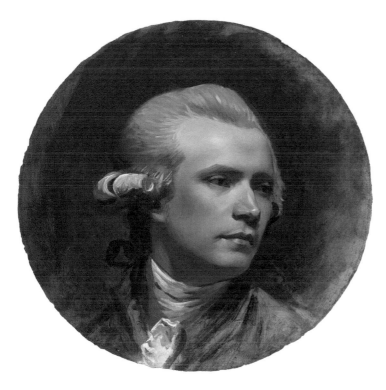

acquisition of photographs, giving the Portrait Gallery the ability to represent many subjects who would never have been pictured through an expensive painting or sculpture. One of those early photographs was an image of Walker Evans (c. 1934) (p. 109).

Several self-portraits were acquired each year during the 1980s and 1990s, as the collection grew, but it wasn't until 1992 that the museum acquired a self-portrait of an African American artist—a painting of James A. Porter given to the museum by his wife, Dorothy Wesley Porter (p. 176). The museum continues to address the absence of portraits of people of color in its collections and is working to correct the imbalance.

Perhaps the most audacious and surprising likeness in this collection is a self-portrait by Alice Neel, which was purchased in 1985 (p. 257). Completed in 1980, when the artist was eighty years old, the strength of the painting and the artist's willingness to show us her aging, nude body makes this a truly iconic painting.

The museum's most significant acquisition of self-portraits came in 2002, when Wendy Wick Reaves, who was then curator of prints

FIG. 11 *Self-Portrait* by John Singleton Copley, 1780–84; Oil on canvas, 56.5 cm (22 ¼ in.) diam. National Portrait Gallery, Smithsonian Institution; gift of the Morris and Gwendolyn Cafritz Foundation with matching funds from the Smithsonian Institution; frame conserved with funds from the Smithsonian Women's Committee (NPG.77.22)

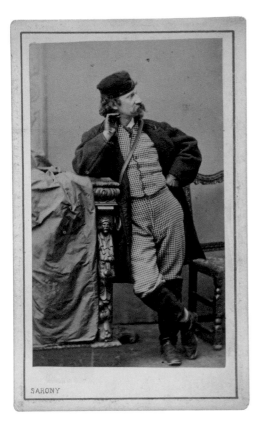

FIG. 12 *Self-Portrait* by Napoleon Sarony, c. 1860–65; Albumen silver print, 8.8 × 5.1 cm (3 7/16 × 2 in.); National Portrait Gallery, Smithsonian Institution; gift of Larry J. West (NPG.2007.105)

and drawings, secured a joint gift and purchase of the Ruth Bowman and Harry Kahn Twentieth-Century American Self-Portrait Collection. The collection had been created over many years by the couple and comprised nearly two hundred prints and drawings by well-known artists, notably Jim Dine, Chuck Close, Andy Warhol, Elaine de Kooning, and Joseph Stella, but also by lesser-known artists, such as John Wilson, Pele deLappe, and Antonio Frasconi. Reaves and curator Anne Collins Goodyear organized a major exhibition of selections from that gift in 2009 and published a scholarly catalogue on the subject.[15] Another notable acquisition came to the museum in 2007, when Larry J. West made a gift of a number of self-portraits of nineteenth-century American photographers (fig. 12).

With such a broad base of self-portraits in the collection, curators have focused in recent years on finding unusual and important self-portraits by contemporary artists, many of whom address their own activism around issues of inclusion. A prime example of this is *Memorial to a Marriage*, Patricia Cronin and Deborah Kass's double self-portrait that shows them entwined on their bed, cast in bronze to evoke the tradition of the burial monument (p. 302). As a powerful commentary on gender, sexuality, and marriage, it tells both a transcendent story and one that is historically and culturally significant; the work was made a decade before Cronin and Kass were granted the right to marry in their home state of New York.

Self-portraits, including those presented in this sampling of the large collection of the National Portrait Gallery, provide a background for today's fascination with self-portraiture and social media. They are a source of inspiration, and perhaps, self-reflection. These works of art also provide an entry point to the history of American portraiture over the last century. Ultimately, I hope that they may inspire more self-representations that encourage empathy and understanding.

1 See p. 31 in Didier Maleuvre, "Rembrandt, or the Portrait as Encounter," in *Imaging Identity: Media, Memory and Portraiture in the Digital Age*, ed. Melinda Hinkson (Canberra: Australian National University Press, 2016), 15–36.

2 See, for example, a passage in Adam Haslett, *Imagine Me Gone* (New York: Back Bay Books, Little Brown and Company, 2016), 289–90

3 Quoted in Wendy Wick Reaves, "Reflections/Refractions: Self-Portraiture in the Twentieth Century," in *Reflections/Refractions: Self-Portraiture in the Twentieth Century* (Washington, DC: Smithsonian Institution Scholarly Press, in cooperation with Rowman & Littlefield, 2009), 1

4 Maleuvre, "Rembrandt, or the Portrait as Encounter," 31.

5 John Yau, "Susanna Coffey Studies the Nature of Portraiture," *Hyperallergic*, June 24, 2018: www.hyperallergic.com/448204/susanna-coffey-crimes-of-the-gods-steven-harvey-fine-art (accessed July 2, 2018).

6 The exhibition *Reflections/Refractions: Self-Portraiture in the Twentieth Century* was presented at the National Portrait Gallery from April 10 to August 16, 2009. A catalogue accompanied the exhibition.

7 Jerry Saltz, "Art at Arm's Length: A History of the Selfie," *Vulture*, January 26, 2014: http://www.vulture.com/2014/01/history-of-the-selfie.html (accessed August 5, 2016).

8 Richard Saunders, "Making Sense of Our Selfie Nation," in *Beyond the Face: New Perspectives on Portraiture*, ed. Wendy Wick Reaves (Washington, DC: National Portrait Gallery; London: D Giles, Ltd., 2018), 270–85.

9 For instance, see Joseph Nechvatal, "The Alluring Dance of Selfies and Self-Portraits," *Hyperallergic*, May 23, 2018: www.hyperallergic.com/444066/dancing-with-myself-punta-della-dogana-venice-review (accessed July 2, 2016).

10 Karen Ann Donnachie, "Selfies, #me: Glimpses of Authenticity in the Narcissus' Pool of the Networked Amateur Self-Portrait," in *Rites of Spring* (Perth, Australia: Black Swan Press, 2015). Uploaded to www.researchgate.net January 20, 2015.

11 See p. 41 in Lauren Cornell, "Self-Portraiture in the First-Person Age," *Aperture* 221 (Winter 2015): 34–41.

12 Kristin Lindgren, "Looking at Difference: Laura Swanson's Anti-Self-Portraits, Diane Arbus's Portraits, and the Viewer's Gaze," *Journal of Literary & Cultural Disability Studies* 9, no. 3 (2015), 277–94.

13 David R. Brigham, Cheryl Finley, Curlee R. Holton, Keren Moscovitch, and Deborah Willis, *Portraits of Who We Are* (College Park, MD: David C. Driskell Center at the University of Maryland, 2018). For more on the Outwin, see the museum's website and accompanying catalogues.

14 See https://portraitcompetition.si.edu/content/exhibition-2006 and similar pages for subsequent competition exhibitions.

15 See Wendy Wick Reaves, *Reflections/Refractions: Self-Portraiture in the Twentieth Century* (Washington, DC: Smithsonian Institution Scholarly Press, in cooperation with Rowman & Littlefield, 2009); and Anne Collins Goodyear, "Repetition as Reputation: Repositioning the Self-Portrait in the 1960s and Beyond," 13–26 in ibid.

CATALOGUE

AUTHORS

RUBYN ASLESON

TAÍNA CARAGOL

BRANDON BRAME FORTUNE

ANNE COLLINS GOODYEAR

FRANK H. GOODYEAR III

DOROTHY MOSS

ASMA NAEEM

PATRICIA QUEALY

WENDY WICK REAVES

EMILY CAPLAN REED

ANN M. SHUMARD

LESLIE UREÑA

ANN PRENTICE WAGNER

JACOB RIIS (1849–1914)

Jacob Riis, a Danish immigrant, struggled to make ends meet until the *New York Tribune* hired him as a police reporter in 1877. As a photojournalist, he was drawn to stories about African Americans and immigrants from Asia and Europe who lived in New York City's poverty-stricken tenements. After years of writing articles and giving public lectures, he voiced his outrage over slum life in his illustrated book *How the Other Half Lives* (1890).

Laying the foundations for modern photojournalism, Riis used technical innovations, such as magnesium flash powder, to photograph the dark interiors of tenements. In the early 1890s, he formed a close friendship with Theodore Roosevelt, who worked with him to improve tenement conditions. This photograph was taken around the time that Riis published his autobiography, *The Making of an American* (1901), to great acclaim. Riis is holding a book, and while we cannot read its cover, it is likely one that he authored. BF

Self-Portrait, c. 1901
Gelatin silver print
10.1 × 15 cm (4 × 5 ⅞ in.)
(NPG.90.120)

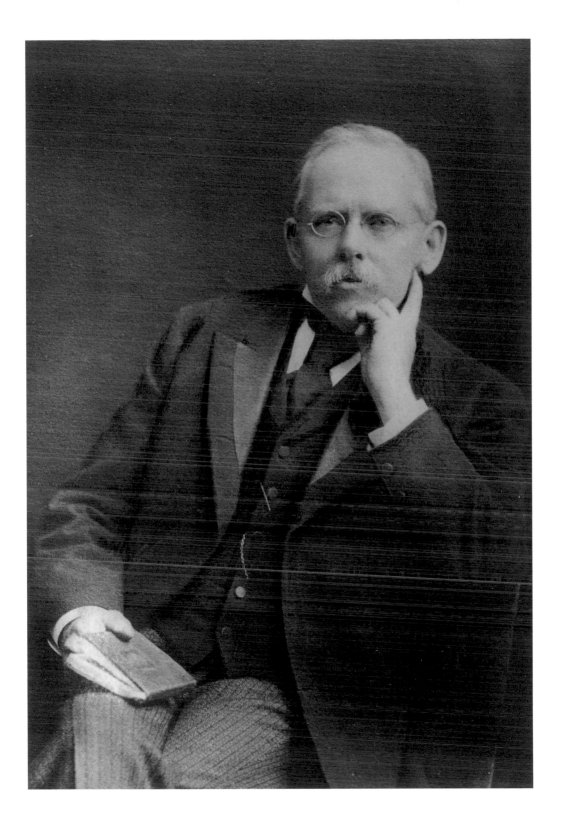

EVERETT SHINN (1876–1953)

By 1901, when he drew this self-portrait, Everett Shinn was an acclaimed illustrator and pastel artist whose bright impressionist palette was very popular. In this drawing, he displays his theatrical personality with muted tones, vivid colors, and a downturned face. Recognizing that a degree of dramatic posturing was expected of an artist, he assumed the role of a brooding romantic and paid tribute to the celebrated actress Julia Marlowe in an inscription.

In 1908, the artist—who is best remembered as one of the Ashcan painters of urban scenes—sent a sketch of himself posing for publicity photos to fellow Ashcan artist John Sloan. "Great fun. being an artist. with temperament," Shinn quipped.
WWR

Self-Portrait, 1901
Pastel on blue paper
35.6 × 25.5 cm (14 × 10 1/16 in.)
(NPG.78.219)

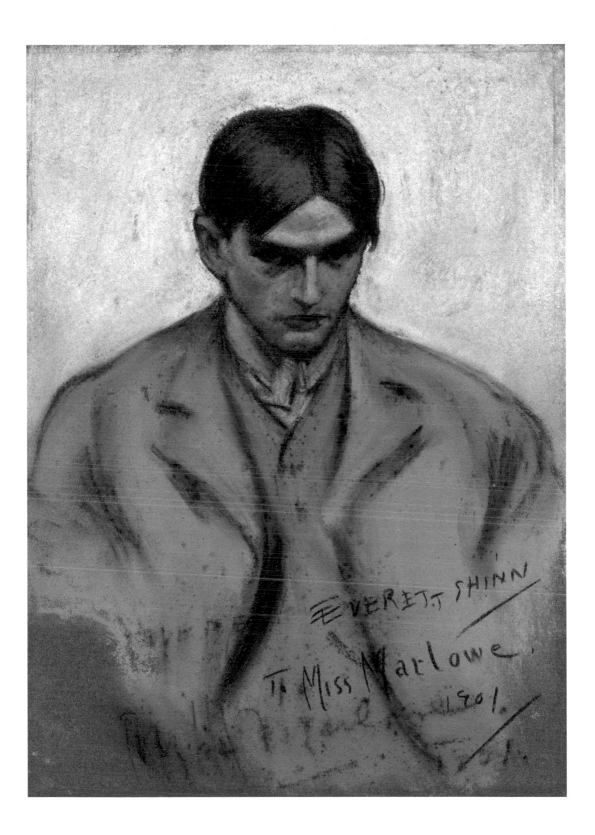

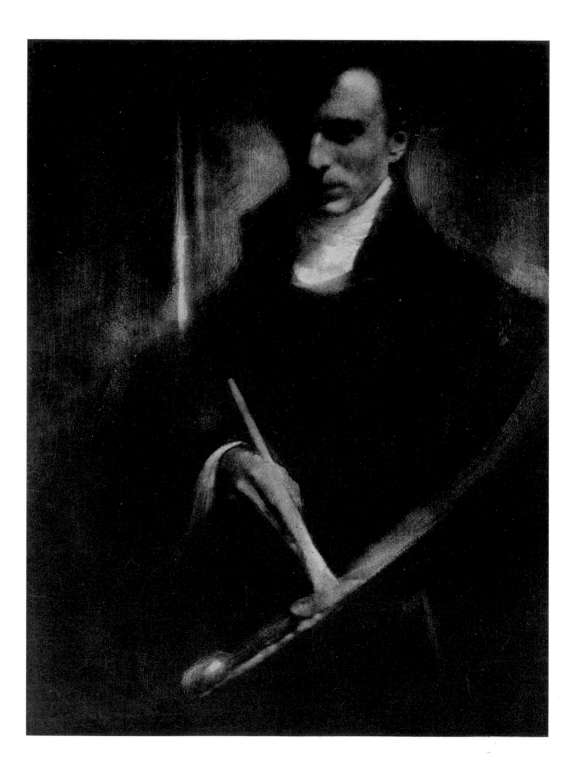

EDWARD STEICHEN (1879–1973)

Working simultaneously as a painter and a photographer in the early years of his career, Edward Steichen believed in the complementary nature of these two expressive mediums. When he created this self-portrait, he conveyed the duality of his artistic identity and his ambitions by posing as a painter, with brush and palette in hand, yet capturing his likeness by means of the camera. Noting that he was "intrigued by the possibility of producing by photography a picture as good as one that might be done in any other way," Steichen blurred the boundaries between painting and photography by employing a printing method that allowed him to manipulate the self-portrait through extensive handwork. The final image, which was subsequently reproduced as a photogravure, was praised by a critic who noted that it presented Steichen as "an artist, genius, and leader." AMS

Self-Portrait with Brush and Palette,
1901 (printed 1903)
Photogravure
30.5 × 21.4 cm (12 × 8 7/16 in.)
The Ruth Bowman and Harry Kahn Twentieth-Century American Self-Portrait Collection
(NPG.2002.342)

EDWARD HOPPER (1882–1967)

Edward Hopper was twenty-one when he sketched this quietly confident self-portrait. A student at the prestigious New York School of Art, Hopper earned awards for drawing and oil painting. One fellow student recalled that he produced "brilliant" drawings with impressive speed. This quick sketch reveals the influence of Hopper's teacher, Robert Henri, in its informal pose and strong, loose strokes of charcoal. Hopper is dressed in a jacket and roll-neck sweater. Such sweaters were popular for masculine outdoor athletics, especially football and cycling.

In part through his choice of clothing, Hopper depicts himself as youthful, unpretentious, and modern. Although two decades would pass before he gained recognition for his oddly mysterious realist painting, this drawing demonstrates a modern sensitivity to medium and self-representation. In 1935, Hopper remarked, "In every artist's development, the germ of the later work is always found in the earlier.... What he was once, he always is, with slight modifications." WWR

Self-Portrait, 1903
Charcoal on paper
47.6 × 30.7 cm (18 ¾ × 12 1/16 in.)
(NPG.72.42)

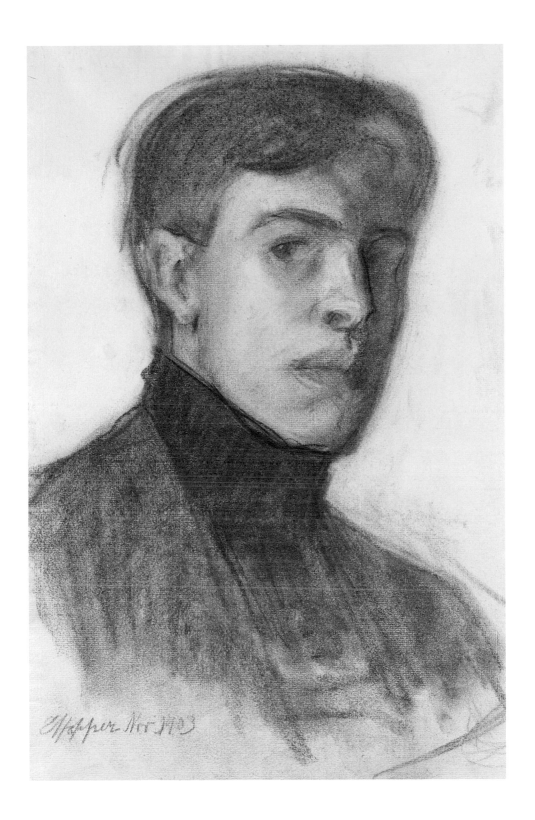

JESSIE TARBOX BEALS (1870–1942)

Jessie Tarbox Beals, the first woman to work as a news photographer, believed those in her profession needed to have "health and strength, a good news instinct that will tell what picture the editor will want, a fair photographic outfit," and above all, "the ability to hustle." This self-portrait gives us a good sense of Beals's drive. She is pictured alongside her 8 × 10 large-format camera and her assistant "Pumpkin," who is shown carrying a case of glass plate negatives. When the photograph was made, Beals was working as a press photographer at the 1904 Louisiana Purchase Exposition in St. Louis. Her husband, acting as her assistant, produced prints of her work in his darkroom. She was the first woman to be given credentials to photograph the fair for major publications. BF

Self-Portrait, 1904
Gelatin silver print
19.2 × 14.5 cm (7 9/16 × 5 11/16 in.)
Gift of Joanna Sturm (NPG.81.137)

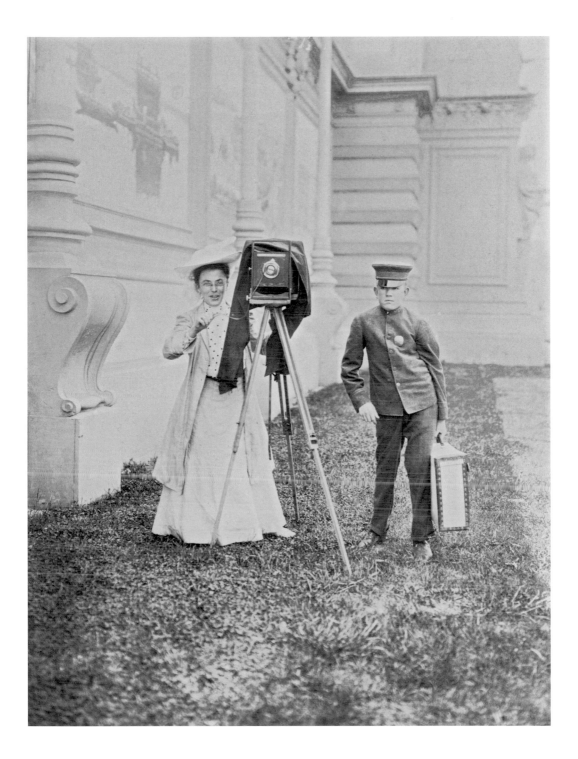

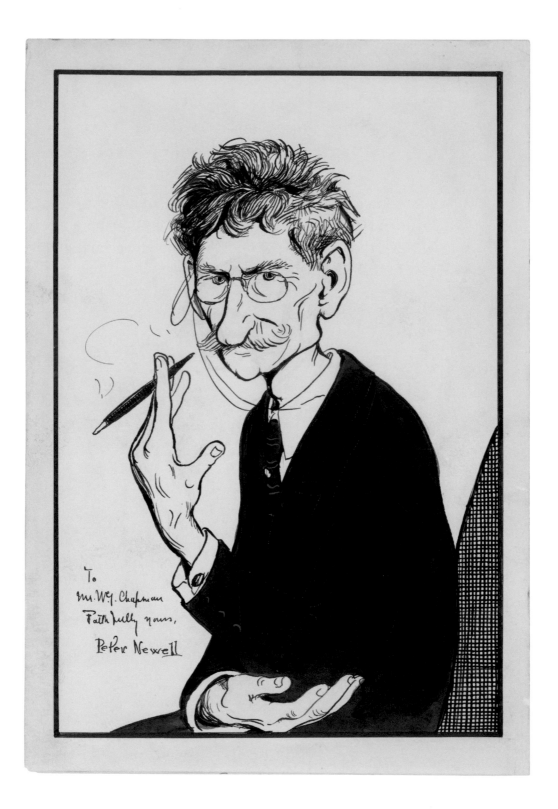

To
Mr. W.J. Chapman
Faithfully yours,
Peter Newell

PETER NEWELL (1862–1924)

The self-taught artist Peter Newell studied at the Art Students League in New York City for only three months before leaving. Nevertheless, he went on to become an acclaimed illustrator for leading magazines in the 1880s and 1890s and is remembered for his humorous illustrations, including those he created for an edition of *Alice in Wonderland* (1901). Newell also wrote and illustrated a series of whimsical books for children, some of which are still in print. In addition to the charming *Mother Goose's Menagerie* (1901), these include *The Slant Book* (1910), which literally slants to tell the story of a runaway baby carriage, and *The Hole Book* (1908), with pages pierced by a hole.

In this gentle caricature, Newell captures his thin frame. The portrait aligns with how a friend of his once described him as having "looked like a hickory tree." It is inscribed to another writer, William G. Chapman, who wrote for many of the same magazines Newell illustrated. BF

Self-Portrait, c. 1905
Ink on paper
25.7 × 17.8 cm (10 ⅛ × 7 in.)
(NPG.94.66)

GERTRUDE KÄSEBIER (1852–1934)

Wearing an antique dress, photographer Gertrude Käsebier pictures herself in this self-portrait as a traditional matron. In the world of fine art photography, however, Käsebier was hardly a conservative figure. One of the founding members of the Photo Secession and the first photographer to be profiled in Alfred Stieglitz's magazine *Camera Work*, she earned a reputation at the turn of the twentieth century for reimagining the creative possibilities of portrait photography.

After raising three children, Käsebier began training to be a painter at Brooklyn's Pratt Institute in 1889, but she decided to pursue photography instead. Less than a decade later, she opened her own professional studio in Manhattan, where she soon attracted many of the leading artistic and literary celebrities of the day. Refusing to employ the painted backdrops and contrived poses used by many portrait photographers, Käsebier adapted lessons drawn from her study of modern art to craft portraits that were rich in character and psychological insight. FG

Self-Portrait, 1905
Platinum print
17.5 × 12.2 cm (6 ⅞ × 4 ¹³⁄₁₆ in.)
Gift of Larry J. West (NPG.2007.81)

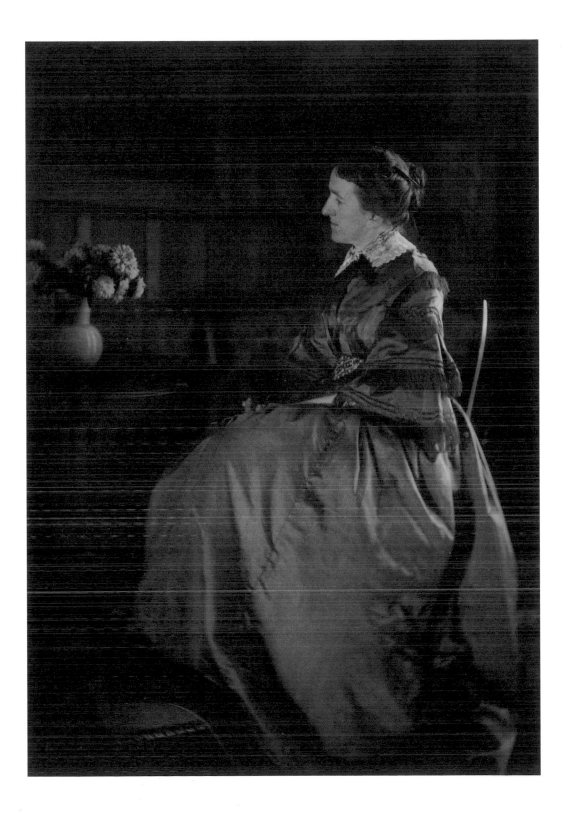

MINERVA CHAPMAN (1858–1947)

In 1906, the year she created this drawing, Minerva Chapman, who was raised in Chicago and later moved to Paris to pursue her career as an artist, became one of the first women elected to France's Salon of the Société Nationale des Beaux Arts (National Society of Fine Arts). The sensitive self-portrait suggests an air of animated reserve as Chapman firmly asserts her identity as a professional artist. She seems to testify to her work ethic with her furrowed brow and the slight shadows beneath her eyes, and her seriousness is evident in her mastery of modeling and her drawing technique. The portrayal also recalls a phrase that appears in one of her notebooks from around this time: "Work. Ambition. Perseverance. Determination." ACG

Self-Portrait, 1906
Charcoal on paper
31.6 × 24 cm (12 7/16 × 9 7/16 in.)
The Ruth Bowman and Harry Kahn Twentieth-Century
American Self-Portrait Collection (S/NPG.2002.226)

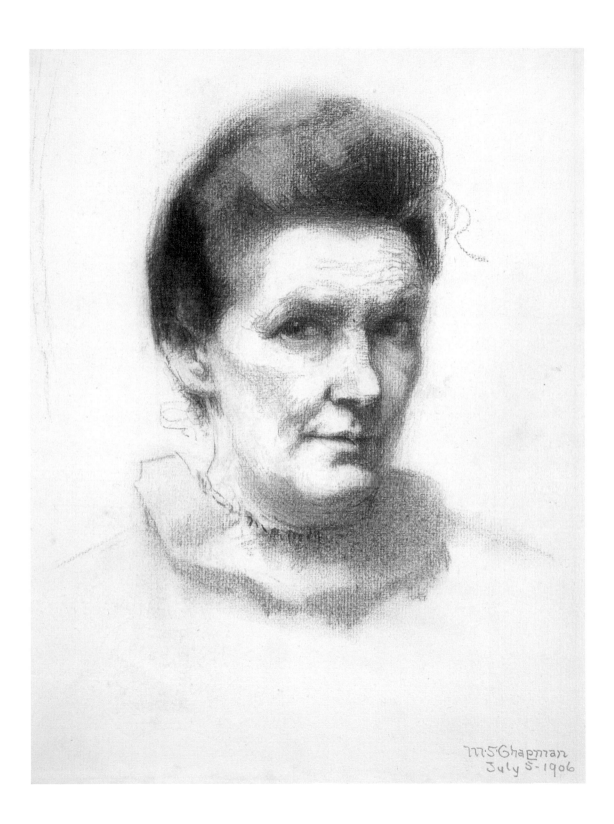

M·S·Chapman
July 5-1906

LEE SIMONSON (1888–1967)

Lee Simonson, a major force in American scenic design, discovered in his youth what "painters' and designers' vision could do to revivify the theater." After graduating from Harvard in 1909, he sought to become a muralist and went to Paris. There, over the course of three years, he honed his skills while attending some of the most experimental European theatrical productions. He also formed friendships with other American expatriates, notably the writer Gertrude Stein and the painter Stanton MacDonald-Wright. Upon returning to New York City in 1912, Simonson felt determined to launch his career as a set designer.

When he created this self-portrait, he may still have been living in Paris. The painting shows his mastery of pattern and composition, and the areas of pure, vibrant color reveal his interest in Paul Cézanne, Paul Gauguin, and the French contemporary painters known as the Fauves. BF

Self-Portrait, c. 1912
Oil on canvas
102.2 × 81.9 cm (40 ¼ × 32 ¼ in.)
Gift of Karl and Jody Simonson. Frame conserved with funds from the Smithsonian Women's Committee (NPG.77.239)

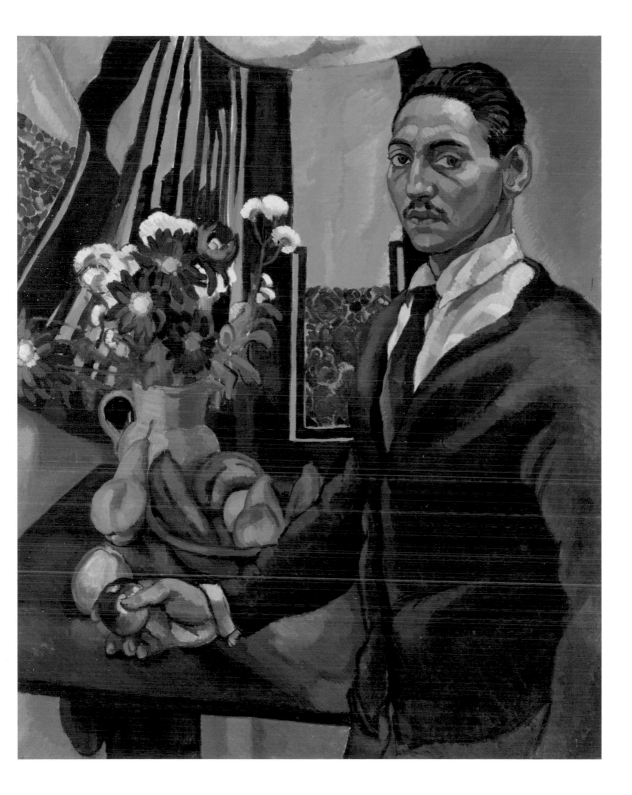

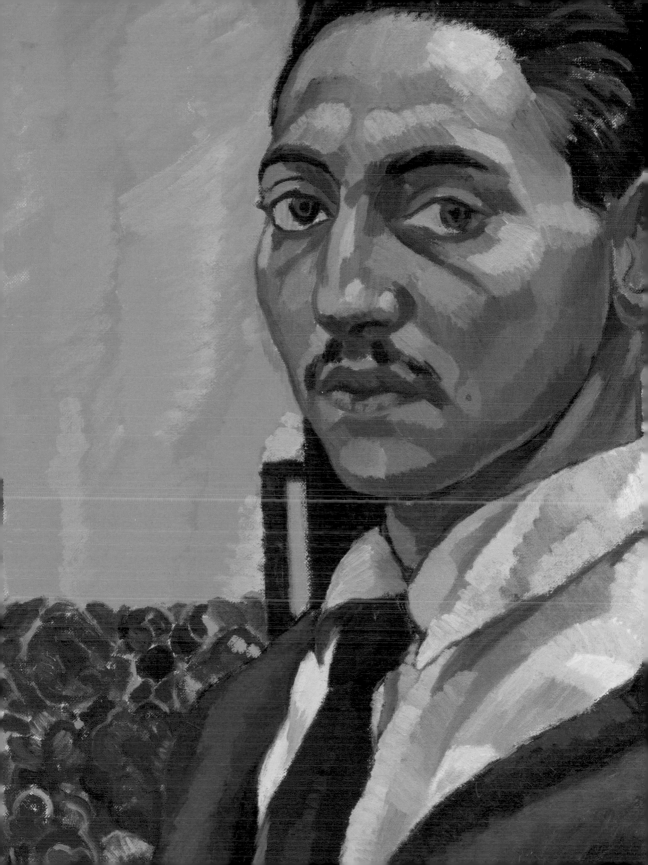

LUCY MAY STANTON (1875–1931)

Lucy May Stanton is best known for her impressionistic portrait miniatures. She spent most of her life in Georgia, but she studied art in Paris and was well known in the art centers of New York City, Philadelphia, and Boston. In this portrait, Stanton presents herself in a forthright, no-nonsense pose, displaying her virtuosity in handling watercolor. She followed the traditional technique of roughening the surface of the ivory so that pigment would adhere to it but then tilted her work board to move the flow of the washes. In "puddling," an innovative wet-on-wet technique, she allowed broad pools of color to shift over the surface and then dry, leaving a rich texture. BF

The Silver Goblet, 1912
Watercolor on ivory
13.7 × 9.5 cm (5 ⅜ × 3 ¾ in.)
Gift of Mrs. Edward C. Loughlin (NPG.72.24)

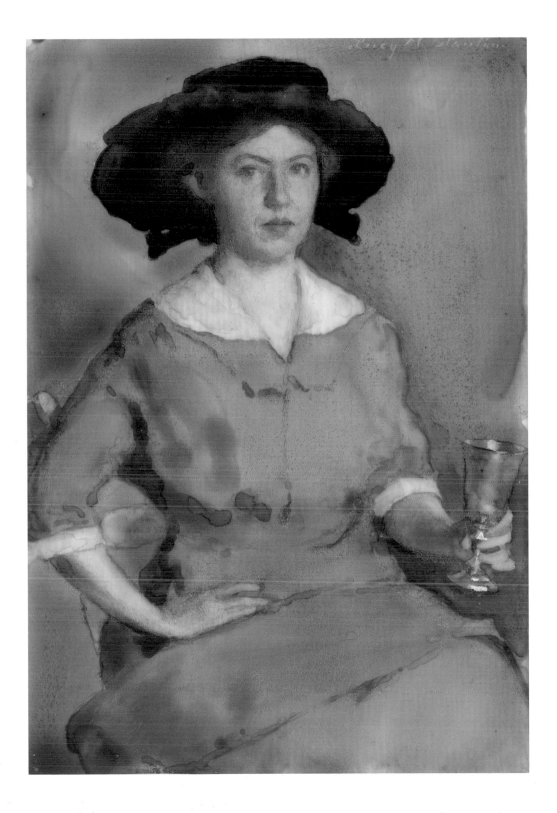

FRANCIS PICABIA (1879–1953)

A friend of Alfred Stieglitz and part of the circle of modernists surrounding Stieglitz's 291 gallery in New York City, Francis Picabia was in effect the star of the July/August 1915 issue of the short-lived *291* journal. This issue, unlike any other, comprised five conceptual portrait prints, created with clear dark lines, hand coloring, and puzzling inscriptions. Called "mechanomorphs," the subjects appear to be mechanical objects but were meant to represent specific individuals. Picabia depicted himself as an upright car horn, in the company of four friends: Stieglitz, a photographer; the French writer Paul Haviland, the Mexican caricaturist Marius de Zayas, and a "Young American Girl," thought to stand in for Agnes Meyer, a patron and friend of the group. According to scholar Hannah Wong, the fold-out publication, when engaged by a viewer and folded or refolded, puts these subjects into dialogue with each other. Ultimately, Picabia presents himself as a leader of modern art and the portraits as a playful way to engage art's audiences. BF

Self-Portrait, 1915
Relief print
44 × 28.9 cm (17 5/16 × 11 3/8 in.)
Gift of Katharine Graham (NPG.93.477.B)

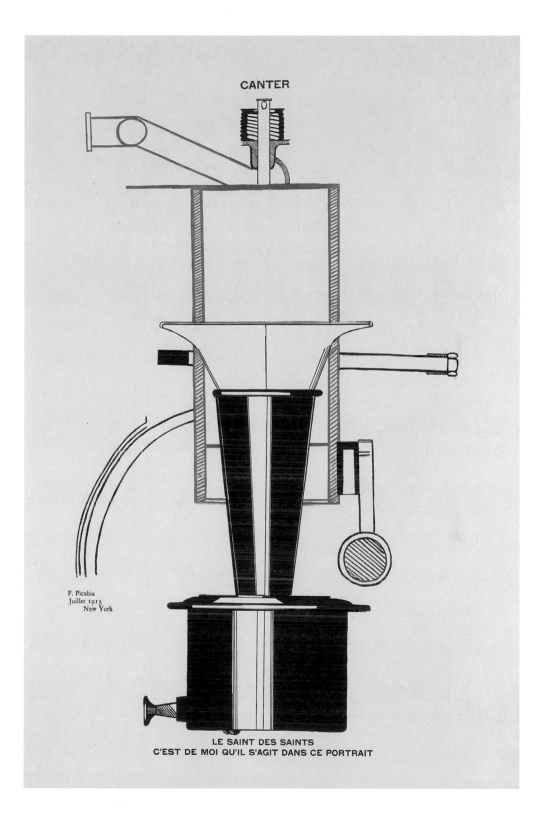

JOSEF ALBERS (1888–1976)

Created early in his career, this bold self-portrait lithograph by Josef Albers reflects his interest in the new artistic trends of his day, particularly Expressionism and Cubism. This work not only suggests the young artist's mastery of recent modern art but also highlights his focus on the future and his capacity to innovate. Indeed, for Albers, self-portraiture provided critical terrain for artistic experimentation, and this print serves more as an exercise in the development of form than it does as a psychological study. The intensity of the subject's expression, however, is nonetheless striking, and one can read in this fragmented self-representation something of the strains of World War I. Living in Germany when he made this work, Albers surely observed the bandaged faces and mutilated bodies of returning veterans. ACG

Self-Portrait (Left Profile), 1916
Lithograph
30.3 × 23 cm (11 ¹⁵⁄₁₆ × 9 ¹⁄₁₆ in.)
The Ruth Bowman and Harry Kahn Twentieth-Century
American Self-Portrait Collection (NPG.2002.188)

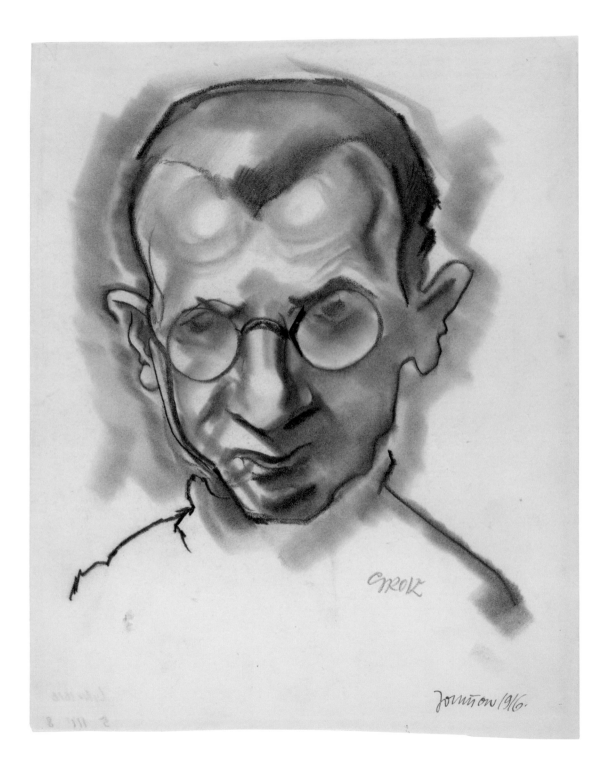

GEORGE GROSZ (1893–1959)

This 1916 self-portrait by George Grosz was drawn at a moment of intense psychic turmoil that would affect his art for years to come. The Berlin-born artist had enlisted in the German army in 1914, and this anguished portrayal reveals the psychological scars of his wartime experience. Grosz channeled his anger into apocalyptic imagery and trenchant political satire, depicting the venality and brutality he saw around him. The maimed soldiers, grotesque generals, and bloated officials of his paintings and drawings made him famous.

A leading figure of the Berlin Dada movement, Grosz moved to the United States in 1933 and became a citizen. Through teaching, a Guggenheim fellowship, securing commissions, and winning merit prizes for his art, he achieved recognition for his unflinching diatribes against war and corruption. The introspective expression and delicacy of this early charcoal, in contrast, reveal a painful vulnerability that one friend felt explained his ferocity rather than contradicted it. WWR

Self-Portrait, 1916
Charcoal and graphite on paper
26.9 × 21.1 cm (10 ⁹⁄₁₆ × 8 ⁵⁄₁₆ in.)
The Ruth Bowman and Harry Kahn Twentieth-Century
American Self-Portrait Collection (NPG.2002.260)

BEATRICE WOOD (1893–1998)

Beatrice Wood's own life was a work of art. Born into privilege and schooled in art and theater, she entered the world of New York Dada in 1917. She lost her virginity quite on purpose to a Frenchman, Henri-Pierre Roché, and cultivated a strong friendship with Roché and the artist Marcel Duchamp. Her circle expanded to include other leading modernist artists—both Europeans who had escaped the war in Europe, and Americans—as well as the collectors Walter and Louise Arensberg.

This small, softly brushed drawing captures much of Wood's talent and charisma in its sophistication and seemingly ephemeral presentation. The artist, completely nude, stands by the bed while her lover still sleeps. The drawing, dated May 23, 1917, was made during a time when Wood and her friends were generating publications, hosting parties, and presenting art exhibitions, all of which were meant to shock and amuse. BF

Self-Portrait, 1917
Watercolor and graphite on paper
29.1 × 20.9 cm (11 ⁷⁄₁₆ × 8 ¼ in.)
Gift of the Abraham and Virginia Weiss Charitable Trust,
Amy and Marc Meadows, in honor of
Wendy Wick Reaves (S/NPG.2010.100)

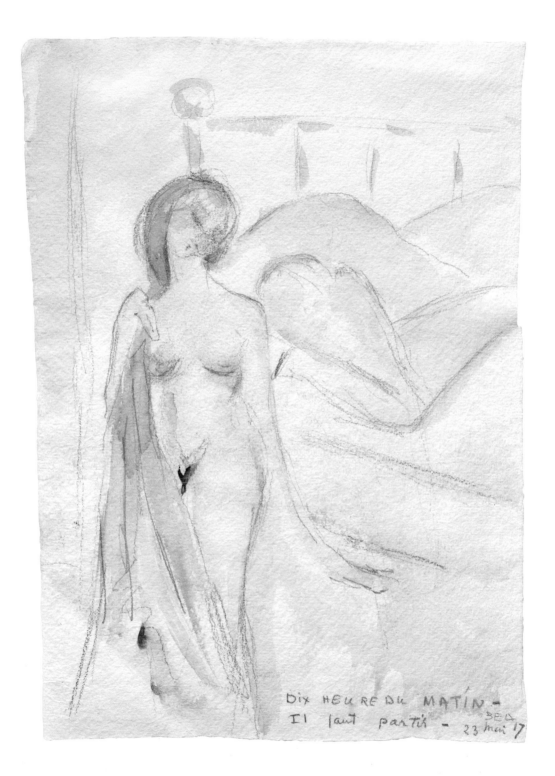

DIX HEURE DU MATIN -
Il faut partir - 23 mai 17

CHARLES HOPKINSON (1869–1962)

Charles Hopkinson, who was born into a well-to-do family in
Boston and attended Harvard University, later studied at the
Art Students League in New York City and at the Académie
Julian in Paris. By the early 1900s, he had established himself
as a portrait painter, with a home and studio on the coast
north of Boston, and had begun showing his work in galleries.
In addition to portraits, Hopkinson painted landscapes and
marine views that more clearly express his connections to
American Impressionism and the Boston School artists.
Hopkinson was interested in color theory, and critics often
praised his work for its brilliance of color and subtle value
contrasts. This intimate sketch, like many others he created
over the course of his lifetime, reveals not only a sharp ap-
praisal of himself but also a careful orchestration of dark
hues, pink flesh tones, and bright highlights. BF

Self-Portrait, c. 1918
Oil on wood
34.6 × 24.1 cm (13 ⅝ × 9 ½ in.)
Gift of the artist's daughters (NPG.77.26)

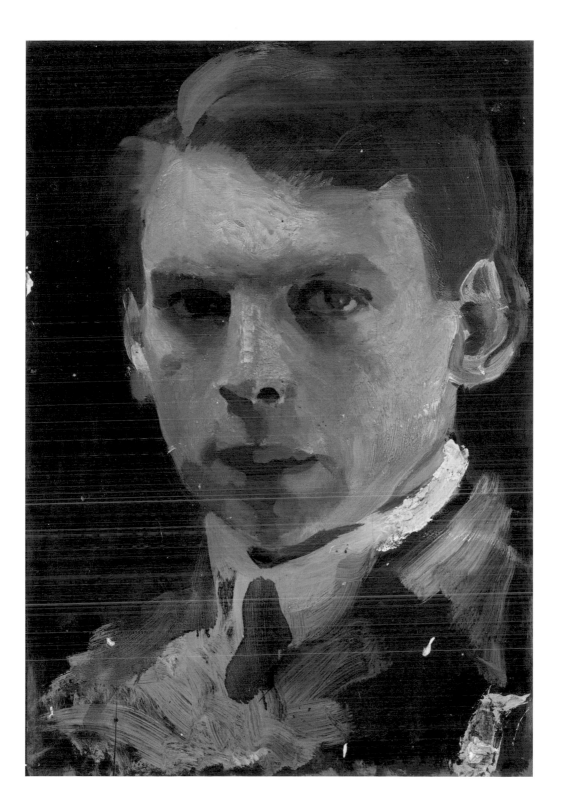

RAPHAEL SOYER (1899–1987)

Only through his art, as in this early self-portrait, could the young Raphael Soyer feel comfortable facing the world. When he and his twin brother, Moses, immigrated to the United States from Russia with their family in 1912, the teenagers were already enthusiastic artists, but Raphael was cripplingly shy and sought to hide his Russian accent from his New York neighbors. He admitted that as a young man, "I had lots of problems, and for a long time I wouldn't talk— I wouldn't go out."

In this lithograph, the young Soyer has warily camou-flaged himself, taking on the habits of his New York contem-poraries. "In those days everybody smoked," he recalled. "It was the fashion for an artist to draw or paint with a cigarette in his mouth." With works like this one, Soyer began his decades-long process of constructing a self-image. AW

Self-Portrait, c. 1920
Lithograph
37.7 × 27.2 cm (14 ¹³⁄₁₆ × 10 ¹¹⁄₁₆ in.)
The Ruth Bowman and Harry Kahn Twentieth-Century
American Self-Portrait Collection (NPG.2002.336)

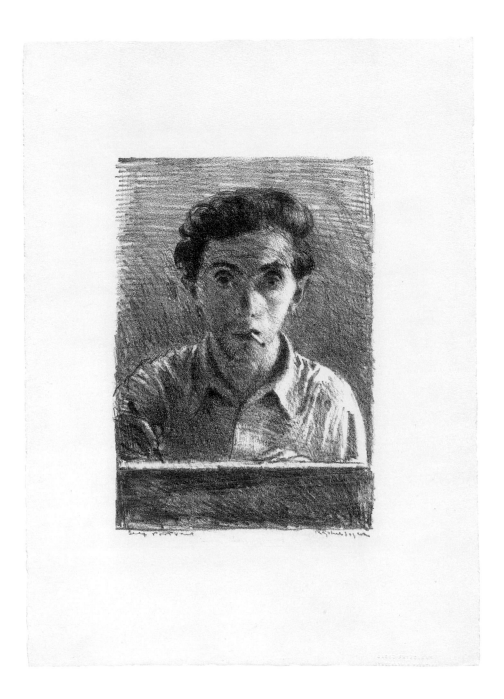

Self Portrait Raphael Soyer

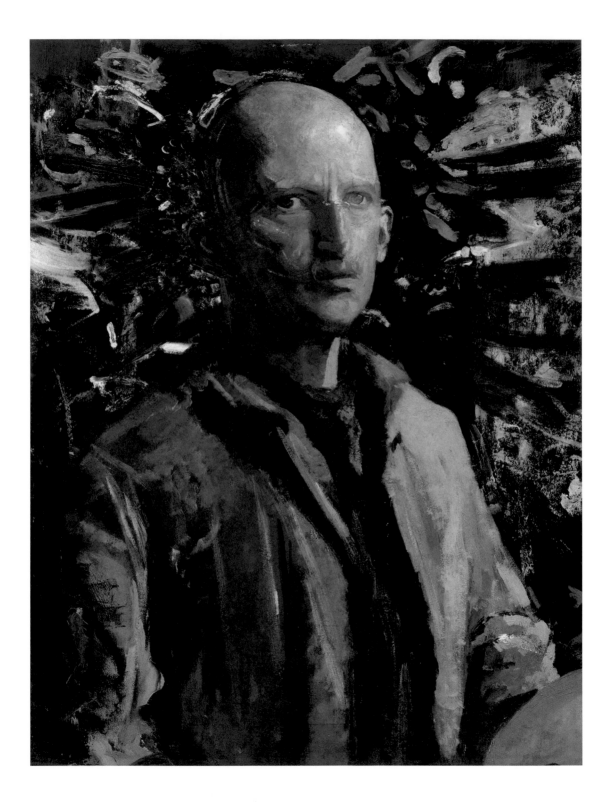

ABBOTT HANDERSON THAYER
(1849–1921)

Completed a year before Abbott Handerson Thayer's death, this darkly dramatic self-portrait is one of several the artist created at the end of his life. According to scholar Kevin Murphy, Thayer's need to protect—from guarding his own children to caring for the environment in his home state of New Hampshire—was his guiding force.

Thayer is best known for his landscapes and paintings of ideal women and winged angels, but he spent many years studying natural science and theories of evolution. He developed ideas about camouflage and visual protection in the natural world and co-authored a book with his son Gerald entitled *Concealing-Coloration in the Animal Kingdom* (1909). These ideas informed his approach to painting as well, for as in this portrait, he often used the painterly surface of his work, with its dark coloration and sense of insubstantiality, to hide elements of the figure. BF

Self-Portrait, 1920
Oil on plywood panel
73.7 × 55.9 cm (29 × 22 in.)
(NPG.81.22)

GEORGE BELLOWS (1882–1925)

George Bellows, whose realist paintings of urban life in New York City are iconic pictures of early twentieth-century art, began to pursue printmaking with great zeal in 1916. He installed a lithography press in his home, where he created images with freedom of expression and spontaneity, using a crayon to transfer the broad strokes and sketchy lines of his paintings to the stone. Around 1921, he made portraits of his family, including two versions of this group, featuring his wife Emma and his daughters Jean (left) and Anne (right), with the artist hovering behind the couch. There is a psychological distance here, as each figure looks in a different direction. Yet the group is linked pictorially through the pyramidal composition, creating a sense of subtle, fragile unity. Bellows' paintings of his family and a contemplative portrait of Emma were created shortly before. BF

My Family, Second Stone, 1921
Lithograph
29.5 × 22.7 cm (11 ⅝ × 8 ¹⁵⁄₁₆ in.)
The Ruth Bowman and Harry Kahn Twentieth-Century
American Self-Portrait Collection (NPG.2002.203)

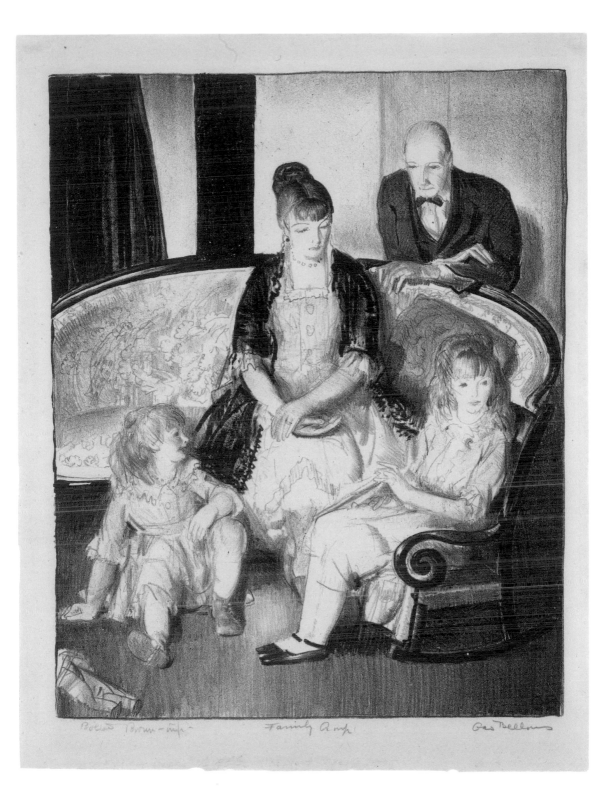

Rosin brown-ink Family Amp Geo Bellows

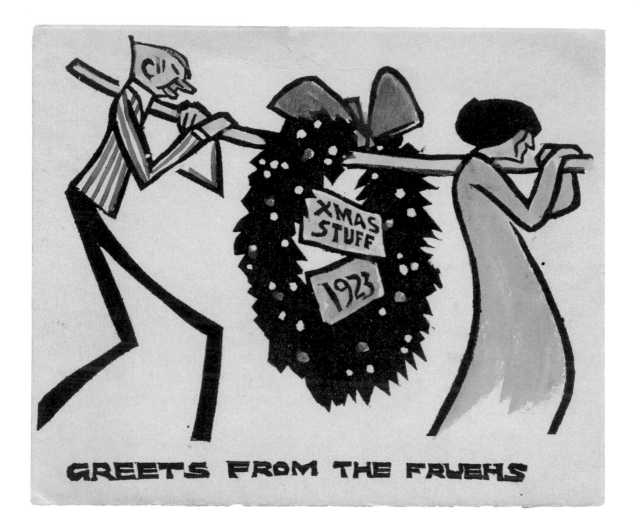

AL FRUEH (1880–1968)

Al Frueh's Greenwich Village home was a center for artists, writers, and theatrical figures, many of whom he had caricatured through incisive drawings that appeared in the *New York World* in the 1920s.

Each year, Frueh designed a Christmas card for his friends, starring himself and his wife, Giuliette Fanciulli Frueh, as figures of fun. One time, they presented themselves as the puppets Punch and Judy, and another time they appeared as a pair of chimpanzees. For this card, they are shown carrying an enormous wreath. Frueh captured the essence of their likenesses in a few bold strokes and washes of color. BF

Greets from the Fruehs, 1923
Relief print and watercolor on paper
12.3 × 14.6 cm (4 ½ × 5 ¾ in.)
Gift of the children of Al Frueh (NPG.93.34)

THOMAS HART BENTON (1889–1975)

At the turn of the twentieth century, Thomas Hart Benton was among many young painters who embraced abstraction. He soon rejected that brand of modernism, however, and emerged in the 1920s as a leader of the regionalist school of realism, whose primary concern was the portrayal of local life and history in America.

Benton made this portrait of himself and his wife (wearing the latest in bathing-suit fashion) at Martha's Vineyard in Massachusetts, sometime around 1924. Best known for his panoramic murals, he brought to his works a boldness of composition that led one critic to describe him as "the most ... vigorous and virile of our painters." Benton was also interested in Hollywood's star culture, and his bare-chested likeness in this work may reference Douglas Fairbanks Sr.'s appearance in *The Thief of Bagdad* (1924). BF

Self-Portrait with Rita, c. 1924
Oil on canvas
124.5 × 100 cm (49 × 39 ⅜ in.)
Gift of Mr. and Mrs. Jack H. Mooney (NPG.75.30)

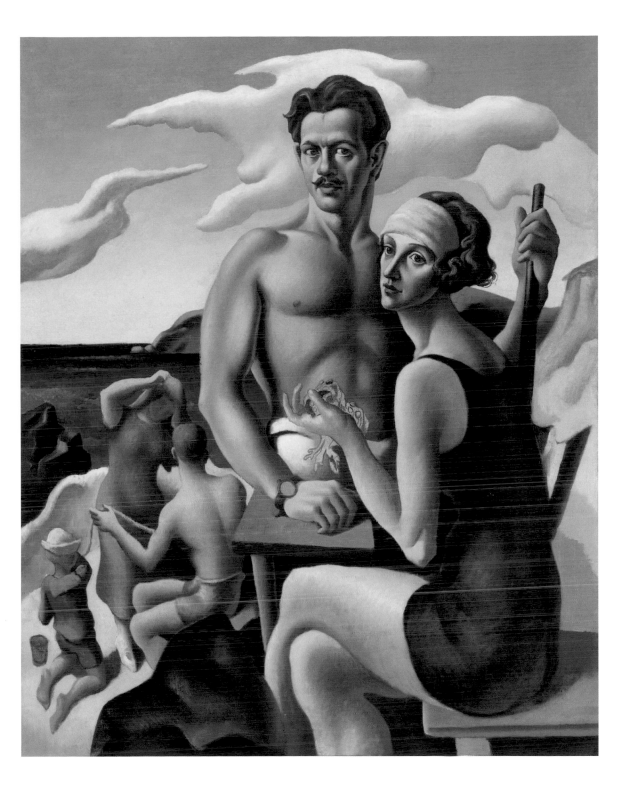

MAN RAY (1890–1976)

Man Ray, an American artist who embraced modernism, Dada, and Surrealism, created this self-portrait in 1924. Moving between the United States and Paris, he worked in a variety of mediums and generated purposefully shifting identities. This image carries a strange sense of alienation and foreboding. Man Ray directs his intense gaze away from the camera and the viewer, and he appears with his tie askew, in the midst of arrested movement.

One could chart a connection between Man Ray's efforts to both conceal and reveal himself and his stated desire to be always a "foreigner" and to have "complete freedom from social conformity." During this period, he was making photographic portraits of expatriates in Paris, including Ernest Hemingway, James Joyce, Gertrude Stein, and Sylvia Beach, in whose bookstore they all gathered. As Beach wrote in her memoirs, "To be 'done' by Man Ray and Berenice Abbott means that you were rated as somebody." Abbott, whose self-portrait is included in this volume (p. 99), served as Man Ray's darkroom assistant when he made this image. BF

Self-Portrait, 1924
Gelatin silver print
20.8 × 16.2 cm (8 ³⁄₁₆ × 6 ³⁄₈ in.)
(NPG.82.142)

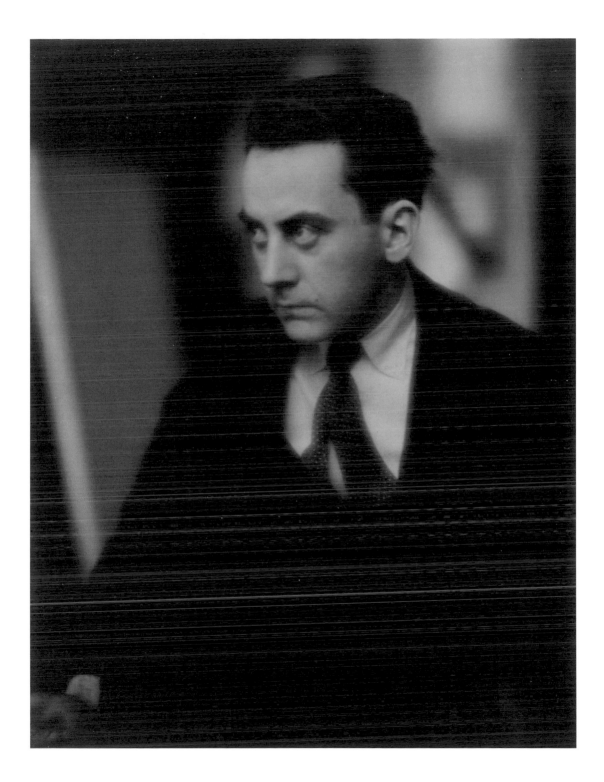

CHARLES SHEELER (1883–1965)

In 1924, Charles Sheeler—who rarely ventured into self-por-
traiture—composed this pastel with a modernist's sensibility
and a photographer's eye. That same year, an exhibition at
the Whitney Studio Club called attention to his enigmatic
realism—what his friend the poet William Carlos Williams
later referred to as the "bewildering directness of his vision,
without blur."

The portrait initially appears more conventional than the
painted still lifes, cityscapes, industrial landscapes, and
domestic interiors that Sheeler preferred. But his works share
many characteristics, revealing what he called "the absolute
beauty [of] . . . objects suspended in a vacuum."

This pastel parallels Sheeler's approach to photography,
particularly in the strong, artificial lighting that throws the
head into sharp relief, casting abstract patterns of light and
shadow. Sheeler understood, Williams wrote, that through
the camera, the subject could "be intensified, carved out,
illuminated." A similar heightened reality enhances his
self-portrayal with its intensely focused, melancholy gaze.

WWR

Self-Portrait, 1924
Pastel on paper
58.4 × 48.2 cm (23 × 19 in.)
(NPG.73.15)

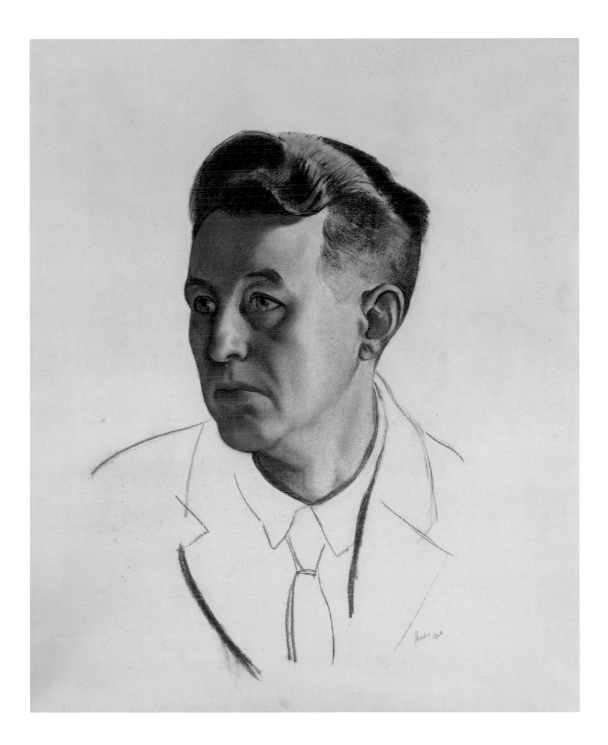

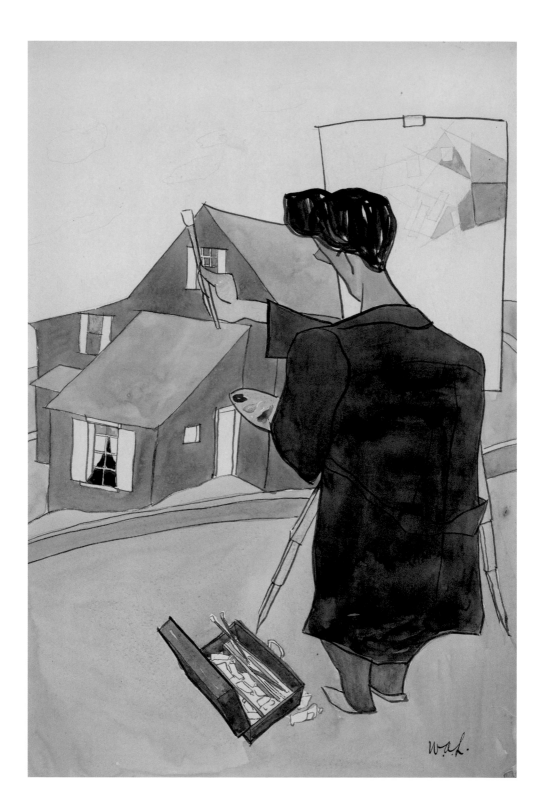

WILLIAM AUERBACH-LEVY
(1889–1964)

When is a self-portrait not exactly a likeness? William Auerbach-Levy gained fame from the 1920s through the 1940s as a caricaturist of literary and theatrical figures, artists, and movie stars. For years, his drawings could be found in the *New York World* and other major publications. Auerbach-Levy also caricatured himself, showing his thinning hair, round face, and weak chin. In this drawing, he reveals an alter ego—one who is broad shouldered, with a full head of thick hair—the artist as he "should" look. This figure recurs in Auerbach-Levy's work, in the same pose and displaying the same features.

Here, he is shown creating a modernist interpretation of a house. In other sketches, the same artist character is seen caricaturing a nude model, or making a painfully thin model look like a modernist sculpture by Gaston Lachaise, or transforming a large-boned fleshy model into a svelte ideal. BF

Self-Portrait, c. 1925
Watercolor and ink on paper
48.1 cm × 35.5 cm (18 $^{15}/_{16}$ × 14 in.)
(NPG.89.116)

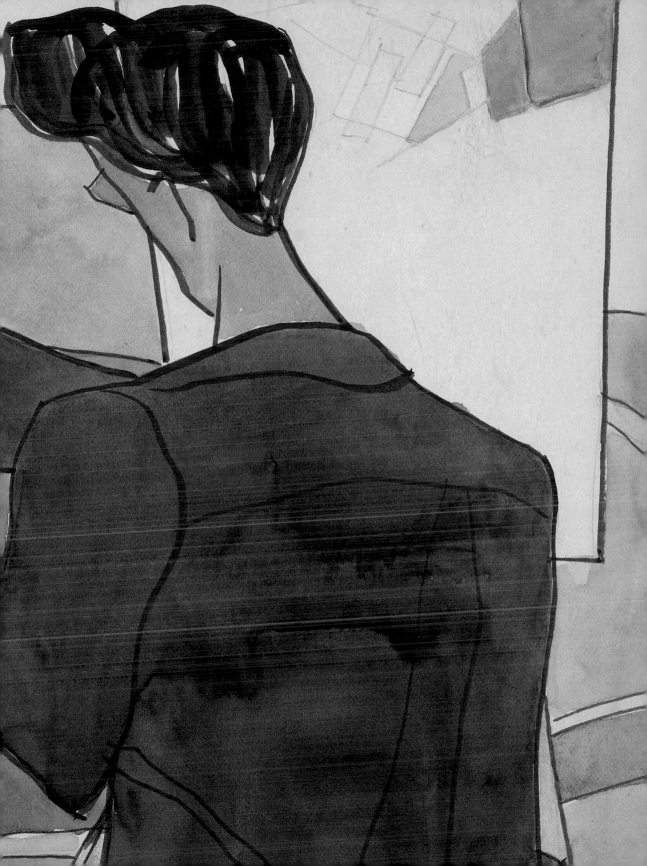

RALPH BARTON (1891–1931)

Caricaturist Ralph Barton garnered fame and fortune in the 1920s, spoofing the urban "smart set" with an infectious wit and an elegant, calligraphic line. In this haunting self-portrait, however, the artist reveals what he usually took pains to conceal: the turmoil of the psyche. Inscribed "with apologies to Greco and God," he suggests the tormented subjects of El Greco's portraits and his own mental anguish. As Barton wrote in 1926, "the human soul would be a hideous object if it were possible to lay it bare." Despite his own distress, he helped invent a new type of stylish, lighthearted celebrity caricature that refrained from exposing weaknesses. "It is not the caricaturist's job to be penetrating," he insisted. "It is his job to put down the figure a man cuts before his fellows in his attempt to conceal the writhings of his soul." WWR

Self-Portrait, c. 1925
Watercolor and graphite on paperboard
mounted on illustration board
37.3 × 28.3 cm (14 $^{11}/_{16}$ × 11 $^{1}/_{8}$ in.)
(NPG.83.170)

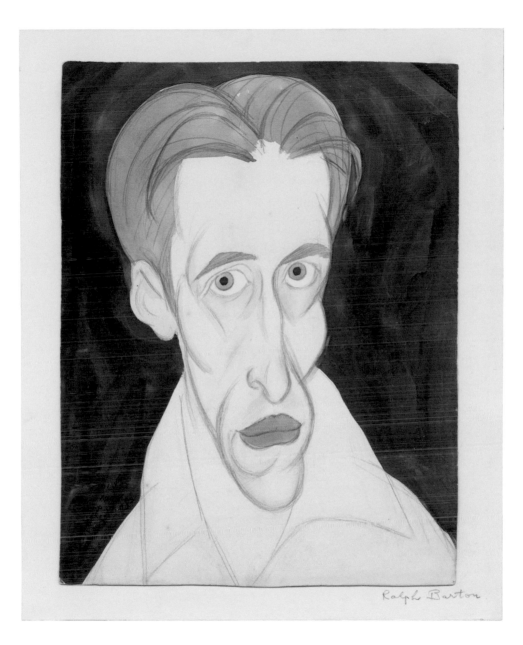

GRANT WOOD (1891–1942)

The regionalist painter Grant Wood had a wry, sometimes dark sense of humor. This smiling caricature, with its dimples and pince-nez, was probably made around 1925, when the artist was still in the midst of launching his career.

Wood's family members have recalled that at Christmas, he gave away between fifty and one hundred of these original tiny sculptures, made in gilded plaster. Through these small gifts, the artist literally presented himself and his compliments to his recipients. This metal version may have been created in the early 1970s. BF

Self-Portrait, c. 1925
Brass and bronze
8.2 × 5.7 × 2.5 cm (3 ¼ × 2 ¼ × 1 in.)
Gift of Esther Y. Armstrong (NPG.96.29)

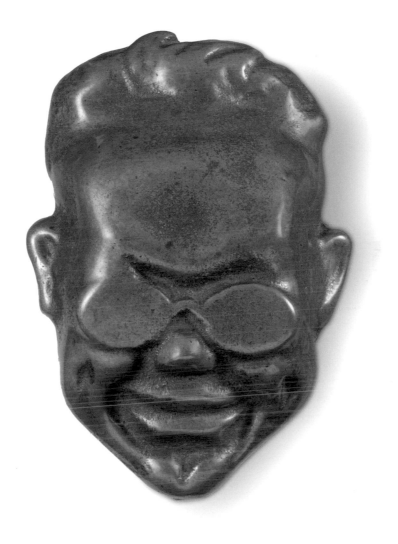

ALEXANDER CALDER (1898–1976)

The wire constructions, mobiles, and monumental stabiles of Alexander Calder represent the fruits of one of the most productive and varied careers in the history of American sculpture. Best remembered as "the artist who made sculpture move," Calder brought fantasy and lighthearted wit to his work. In his younger years, he worked as an engineer in various capacities and places, but by the mid-1920s, he had begun making wire sculptures and painting New York City street scenes and portraits. Calder's early works reflect the realist approach of his teachers at the Art Students League, notably John Sloan. In this self-portrait, Calder pictures himself with broad strokes of paint, a pared-down modernist style, and a minimal palette of grays, browns, and creams. Later, he noted the presence of the mustache, which he said he "raised . . . to look more like a seasoned engineer." BF

Self-Portrait, 1925
Oil on canvas
50.8 × 40.6 cm (20 × 16 in.)
Gift of the artist (NPG.71.35)

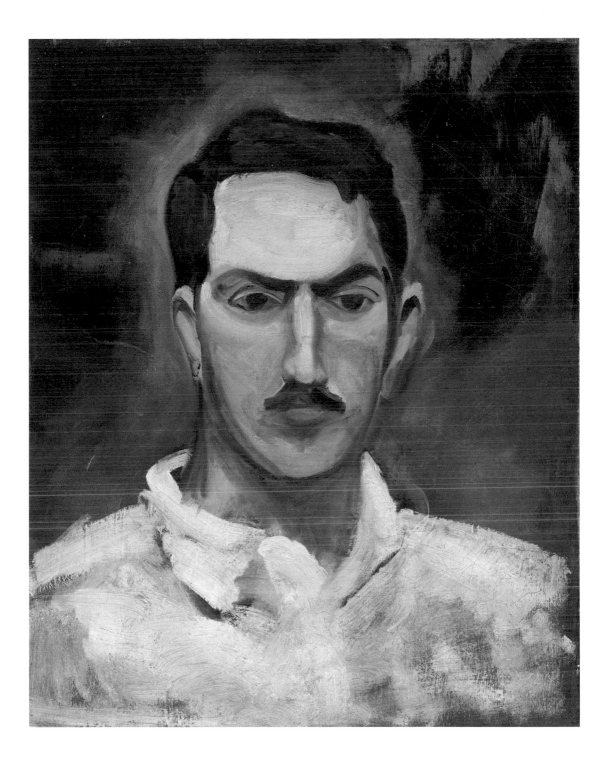

AARON DOUGLAS (1899–1979)

Aaron Douglas was one of the leading figures in the flowering of modernist African American culture in the early twentieth century. This 1925 self-portrait attests to the remarkable skill and draftsmanship, not to mention the self-possession, of the young artist months after he had left his position teaching high school art in Kansas City, Missouri, and moved to Harlem, New York. Using red Conte crayon and exercising restraint to create highlights on the cheeks, chin, and forehead, Douglas depicts himself as a sensitive, sentient black man.

During the Harlem Renaissance, when this work was made, many young African Americans were exploring their identities, their roots, and their place in the world. Douglas depicts himself just as his self-consciousness and his political yearnings were being stirred. At the time, he had begun creating illustrations for the Urban League's journal, *Opportunity*, as well as for the landmark manifesto of the Harlem Renaissance, Alain Locke's *The New Negro* (1925). AN

Self-Portrait, 1925
Red Conte crayon on paper
31.8 × 23.2 cm (12 ½ × 9 ⅛ in.)
Gift of the Abraham and Virginia Weiss Charitable
Trust, Amy and Marc Meadows, in honor
of Wendy Wick Reaves (NPG.2017.73)

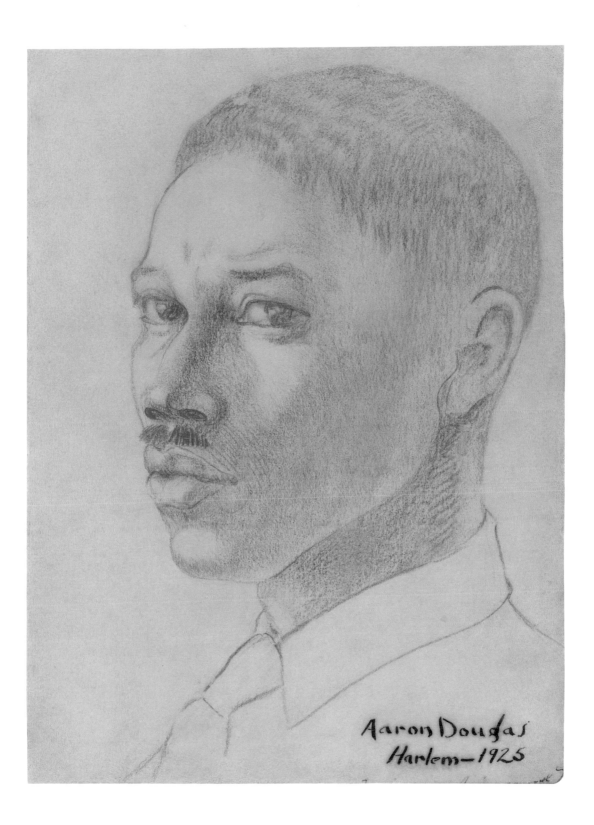

Aaron Douglas
Harlem—1925

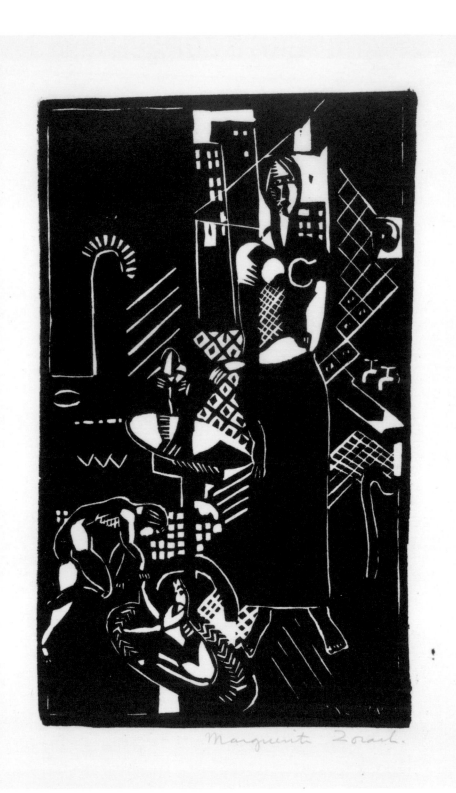

Marguerite Zorach.

MARGUERITE ZORACH (1887–1968)

Marguerite Zorach is best known for her paintings and textiles, but she also made prints that focus on domestic subjects, such as her family and friends. As one of the artists who brought Cubism and Fauvism to the United States after several years of European study, Zorach reveals her interest in the structure of her environment in this stark black-and-white print. Sternly modernist in its staccato rhythms and dense patterning, the composition foregrounds a strong vertical image of the artist herself, with her daughter Dahlov and the family dog cavorting beneath a small table. Zorach was the president of the New York Society of Women Artists around the time that she made this linocut, and she rebuked the art world for not championing women's work. In 1925, she wrote, "I am certain that had I not had an artist husband, and had I tried to exhibit on my own, I would have had all the difficulties." BF

Marguerite at 10th Street Studio with Dahlov, 1927
Linocut
40.2 × 27.5 cm (15 13/16 × 10 13/16 in.)
The Ruth Bowman and Harry Kahn Twentieth-Century
American Self-Portrait Collection (NPG.2002.369)

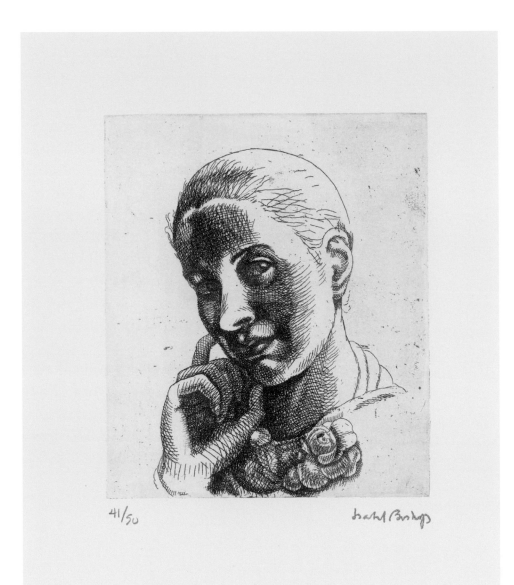

41/50 Isabel Bishop

ISABEL BISHOP (1902–1988)

Isabel Bishop generally chose her subject matter from the street life of New York City that flowed beneath her studio window. She recalled enjoying "the incredible richness of this coming and going of these multitudes of people." But as a young woman in the late 1920s, she found herself a convenient subject, noting that self-portraiture may serve just "to provide oneself a model, especially handy for a young artist as a means for studying picture problems."

In this etching, Bishop's concerns are formal: structure, form, gesture, and the play of light on a tilted, slightly turned face. The detached unreadable expression and elegant geometry of the head disguise her personality. Even the hand, resting too lightly to support the head, seems merely a pose she wished to explore. Concealing internal emotions, Bishop used her mirrored reflection to solve pictorial challenges. The resulting print reveals what one critic called "her combination of precision and delicacy." WWR

Self-Portrait, 1929
Etching
39.2 × 30.5 cm (15 ⁷⁄₁₆ × 12 in.)
The Ruth Bowman and Harry Kahn Twentieth-Century
American Self-Portrait Collection (NPG.2002.211)

EDWARD STEICHEN (1879–1973)

Prior to becoming chief photographer for Condé Nast Publications in 1923, Edward Steichen had never worked with anything but natural light. When an electrician armed with floodlights, reflectors, and other exotic equipment joined the photographer for one of his first assignments, Steichen improvised to avoid admitting that he had no experience with artificial lighting. His instincts proved excellent, and the electrician came away from the session convinced that the photographer was truly an innovative professional. Steichen soon grew to regard electric lighting as an essential tool in bringing variety to his compositions. In the later years of his work for *Vanity Fair*, Steichen recalled that he had "lights going all over the place," as evidenced in this self-portrait.

AMS

Self-Portrait, 1929
Gelatin silver print
24.2 × 19.2 cm (9 ½ × 7 ⁹⁄₁₆ in.)
Acquired in memory of Agnes and
Eugene Meyer through the generosity of
Katharine Graham and the New York Community
Trust, The Island Fund (NPG.2001.30)

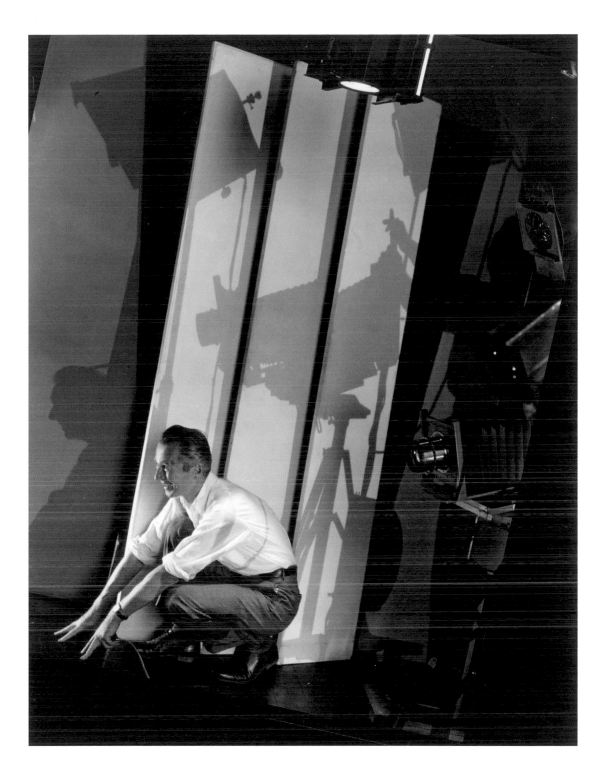

RALPH STEINER (1899–1986)

Although the photographer and filmmaker Ralph Steiner studied pictorialist photography at the Clarence White School, he shifted toward modernism after encountering Paul Strand and his photography around 1927. Strand's work caused Steiner to realize that he "was not yet a photographer."

To perfect his technique, Steiner bought an 8 × 10 large-format camera and spent three months working intensively at Yaddo, an artist's retreat near Saratoga Springs, New York. That summer he made many photographs of billboards, and shortly thereafter, he created this self-portrait. The composition features an enormous billboard, with one image partially pulled away to reveal another, and Steiner posing at the bottom of the frame, cradling his camera like a heavy infant as he stares out at the viewer. Steiner's acerbic wit, so evident in his writing, and often in his photographs, is clear in the conception of this image, with its visual complexity. BF

Self-Portrait, 1929
Gelatin silver print
24.3 × 19.2 cm (9 9/16 × 7 9/16 in.)
(NPG.93.17)

A. STIRLING CALDER (1870–1945)

The father of artist Alexander Calder, A. Stirling Calder began his own career working in the Beaux Arts realist tradition, which he absorbed during his student years in Paris. Influenced by the spirit of modernism, however, he moved toward greater simplification and abstraction. This severely spare self-portrait, like much of his later work, reflects this stripped-down aesthetic. A few years later, Calder created a sculpture entitled *Introspection*, where a figure holds its own severed head as though interrogating it, allowing us to project a similar self-examination in this truncated terracotta. BF

Self-Portrait, c. 1930
Terracotta
31.7 × 22.9 × 15.3 cm (12 ½ × 9 × 6 in.), without base
Conserved with funds from the Smithsonian
Women's Committee (NPG.88.157)

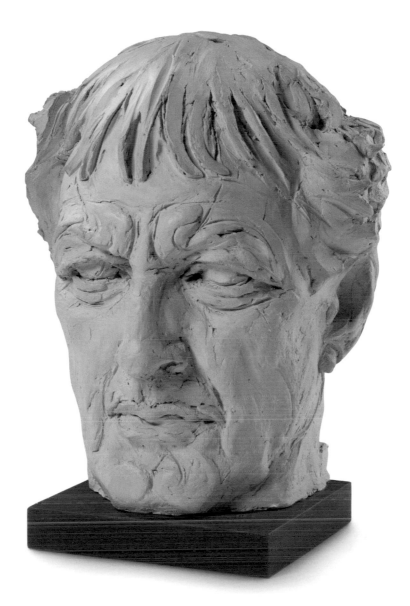

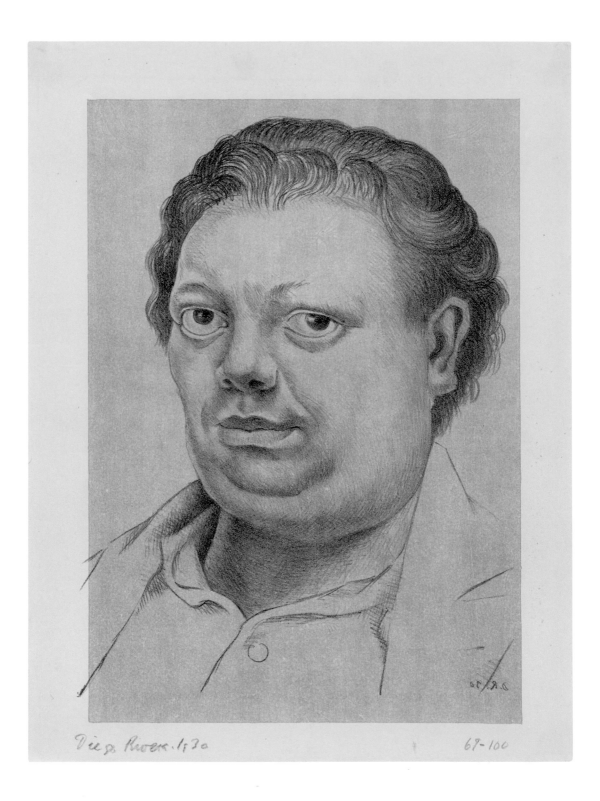

Diego Rivera. 1930 67-100

DIEGO RIVERA (1886–1957)

Diego Rivera is remembered for his public art and murals in Mexico and the United States. During the late 1920s and the 1930s, he painted monumental and powerful murals for public buildings in the United States, including a twenty-seven-panel fresco called *Detroit Industry* for the Detroit Institute of Arts. His 1933 mural for Rockefeller Center was canceled when he included among its portraits one of Lenin.

Rivera was well known in the United States by the time he created this self-portrait. It is one of numerous lithographs he produced as a means of supporting himself while working on more time-consuming projects. The lively crosshatching strokes used to model the contours of his face relate directly to the technique he employed in his monumental murals. Notably, this image was used by several major newspapers to accompany his obituary, and thus, in significant ways, it is how the American public pictured him. RA

Self-Portrait, 1930
Lithograph
46.7 × 35.7 cm (18 ⅜ × 14 1/16 in.)
The Abraham and Virginia Weiss Charitable Trust, Amy and Marc Meadows, in honor of Wendy Wick Reaves (NPG.2016.75)

ALINE FRUHAUF (1907–1978)

Known for her biting caricatures, Aline Fruhauf was equally incisive when she depicted herself. These two prints were created at the beginning of her career in New York City in the 1930s, when she was drawing celebrities from the worlds of theater, art, music, and other forms of entertainment.

The image from 1931 is only slightly exaggerated and depicts Fruhauf seated in front of her own caricature of Leonardo da Vinci's *Mona Lisa*, which hangs on the back wall. It presents a sympathetic image of an artist at home. But in the 1933 work, she has unleashed her vision and wit on herself.

Fruhauf wrote about the process, noting that her nose was prominent and bulbous at the end, that she made her mouth even smaller than it was, and that she created for herself an impossibly long neck. The result, an artist poised at her drawing board, perusing her own image, is as exaggerated and unruly as her published caricatures of the famous faces of the day. BF

Self-Portrait, 1931
Lithograph
34.2 × 27 cm (13 ⁷⁄₁₆ × 10 ⅝ in.)
Gift of Erwin Vollmer (NPG.83.260)

Self-Portrait, 1933
Lithograph with graphite on paper
48.2 × 31.8 cm (19 × 12 ½ in.)
Gift of Erwin Vollmer (NPG.83.63)

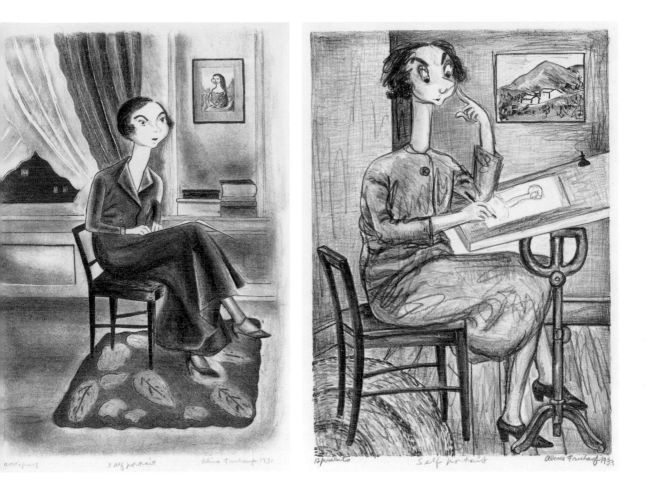

3 self portrait Alice Trumbull 1931

Self portrait Alice Trumbull 1933

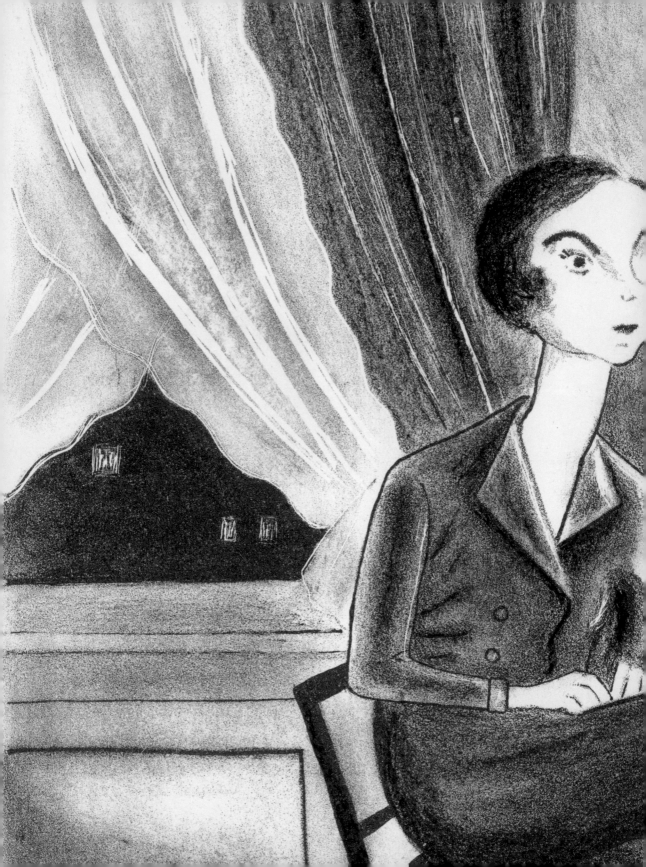

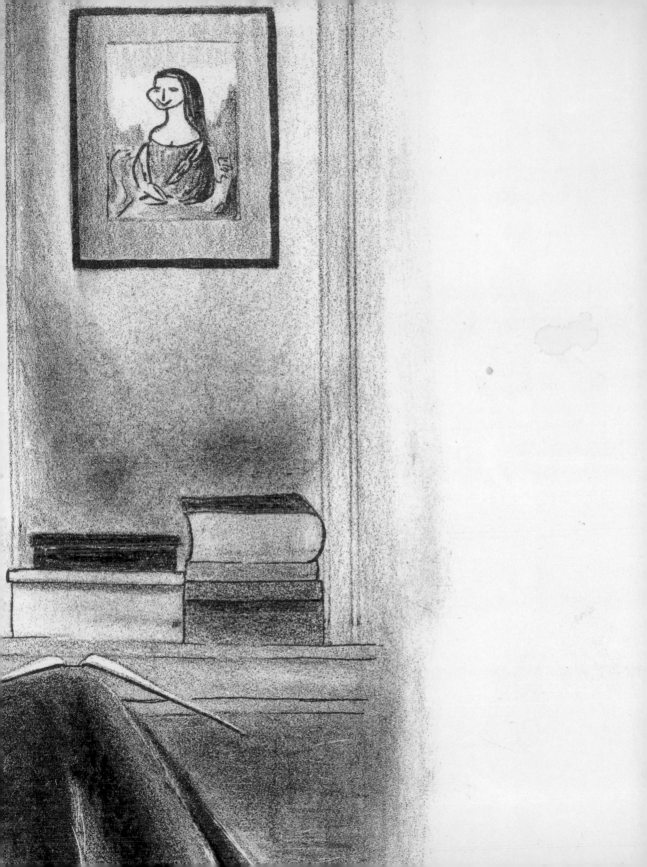

BERENICE ABBOTT (1898–1991)

In 1923, having given up her ambitions of becoming a sculptor, Berenice Abbott was residing in Paris, wondering what to do next. Then, her friend Man Ray hired her as his darkroom assistant, and Abbott helped him develop his portraits of writers, artists, and other cultural figures. Man Ray taught Abbott about photography, but her own instinctive ideas about posing subjects soon emerged.

By 1925, Abbott had begun to take photographs of friends and, soon after, began showing her work publicly. Her subjects included such notables as Jean Cocteau, Peggy Guggenheim, and Coco Chanel, as well as her close friends and lovers. She recalled: "I relied on my intuition about people a great deal . . . I tried to get them unposed." By the early 1930s, when she made this arresting self-portrait revealing her "startling glacial turquoise" eyes, Abbott's photographic interests were shifting away from portraiture to chronicling the life and architecture of New York City. BF

Self-Portrait, c. 1932
Gelatin silver print
14.1 × 10.9 cm (5 ⁹⁄₁₆ × 4 ⁵⁄₁₆ in.)
(NPG.92.55)

MABEL DWIGHT (1876–1955)

Mabel Dwight studied art in San Francisco and began her career in New York City, but after getting married in 1906, she temporarily stopped working. When she and her husband separated a decade later, she began to create again but did not really find her medium as an artist until, at fifty, she traveled to Paris and studied lithography in the Atelier Duchâtel.

Upon returning to New York, Dwight began to make lithographs that focused on the characters and unique places in the city. A Socialist with increasingly radical views during the 1930s, she looked for both humor and humanity in her everyday subjects; her work was often satirical but rarely angry. As her good friend, the art dealer Carl Zigrosser noted: "She gossips neither in her conversation nor in her art." In this self-portrait, she presents herself in a darkened space, quietly observing her features and recording them dispassionately on the lithographic stone. BF

Self-Portrait, 1932
Lithograph
40.6 × 29.5 cm (16 × 11 ⅝ in.)
The Ruth Bowman and Harry Kahn Twentieth-Century
American Self-Portrait Collection (S/NPG.2002.239)

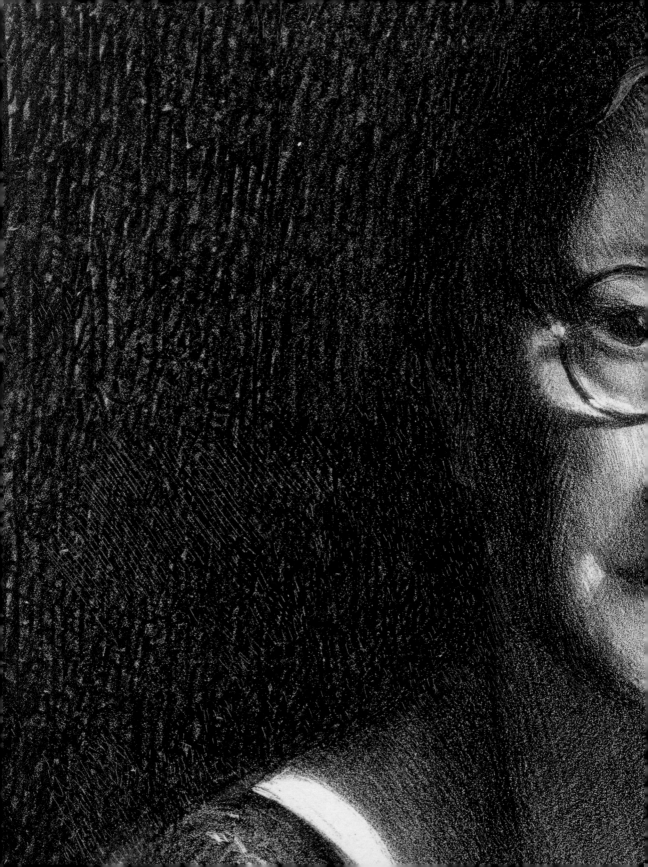

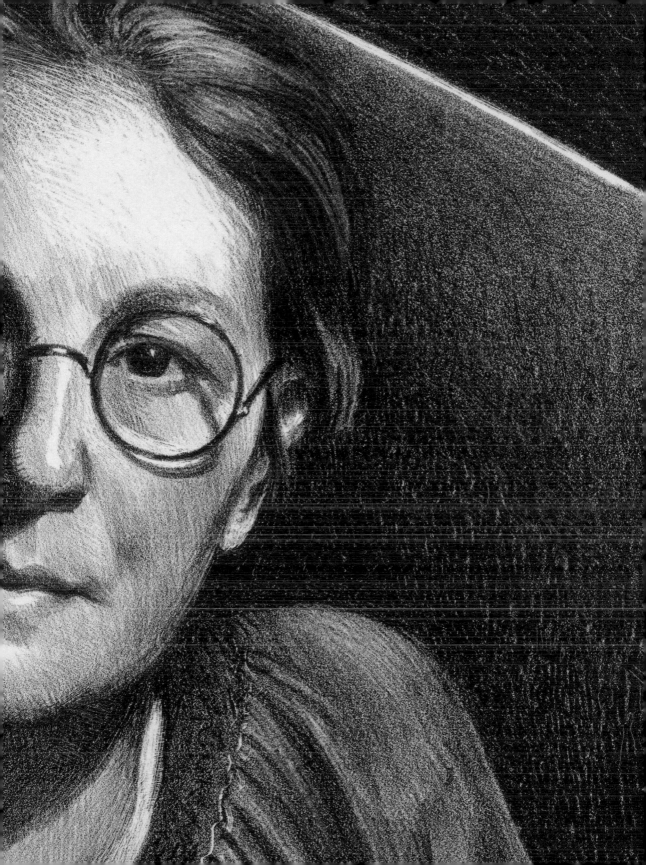

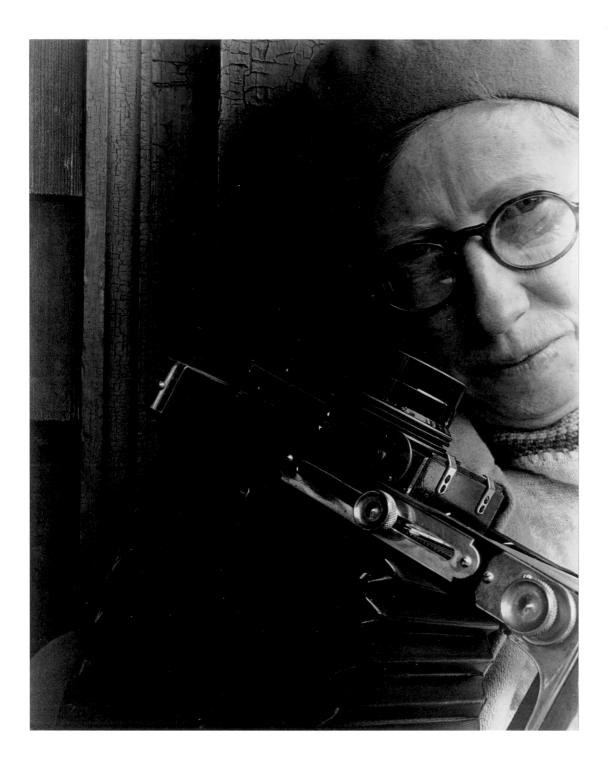

IMOGEN CUNNINGHAM (1883–1976)

Imogen Cunningham made this self-portrait around the time she joined Edward Weston, Ansel Adams, and other San Francisco photographers to promote photography as a fine art. Cunningham and her friends called their group "f/64," in reference to the smallest opening of a camera lens, which rendered the greatest range of tone. The name also reveals the group's distinctive aesthetic, for at this setting, cameras produce images that are crisp, bright, and sharply focused. Her self-portrait embodies this vision, as well as her own interest in close studies of nature and its tactile elements, such as the weather-beaten wood surface behind her and the textures of her camera and soft hat. Though short-lived, f/64 became extraordinarily influential as generations of photographers adopted the standards that Cunningham, Weston, and Adams pioneered. ᴧMS

Self-Portrait, 1933
Gelatin silver print
23.8 × 19 cm (9 ⅜ × 7 ½ in.)
(NPG.93.70)

GEORGE PLATT LYNES (1907–1955)

This intimate and quietly sensuous self-portrait was made in 1933, around the time that George Platt Lynes moved into a new studio in New York City. With printer and book publisher Monroe Wheeler and writer Glenway Wescott, whom he met when he was just twenty, Lynes had traveled back and forth to Europe for several years, experiencing the freedoms of Paris (where homosexuality was more widely accepted) and teaching himself photography. In 1932, a year before Lynes made this portrait, New York's Julien Levy Gallery had shown his photographs alongside the work of Walker Evans.

Lynes gained recognition as a photographer of well-known artists, writers, dancers, and Hollywood celebrities. He was employed as a fashion photographer, but he is perhaps best known today for his dramatic and provocative photographs of male nudes, which were not exhibited during his lifetime. BF

Self-Portrait, 1933
Gelatin silver print
23.6 × 17.6 cm (9 5/16 × 6 15/16 in.)
(NPG.93.360)

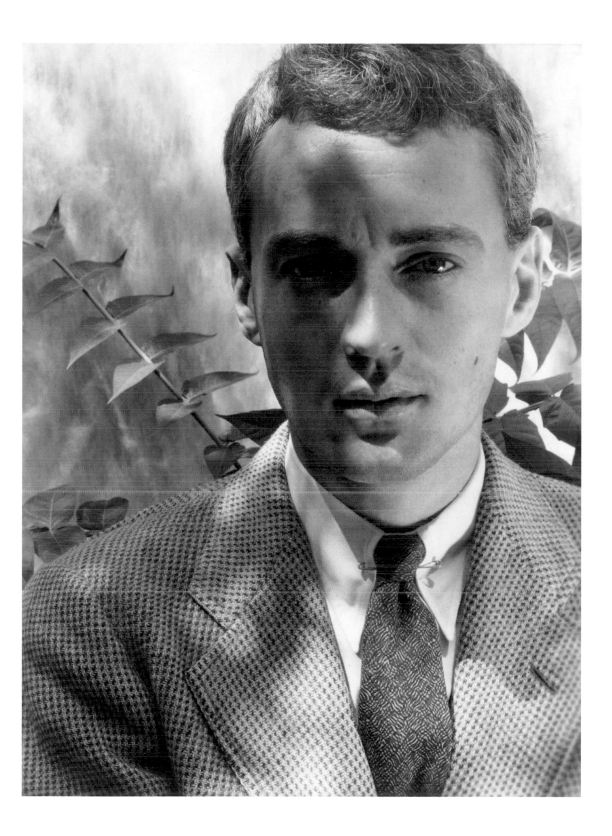

WALKER EVANS (1903–1975)

Walker Evans recorded the Great Depression's impact on rural America with his camera. As a photographer charged by the New Deal's Farm Security Administration (FSA) to document conditions in the country's agricultural regions, he carried only the most basic equipment. But that equipment proved more than sufficient.

The FSA pictures taken by Evans from 1935 to 1937 recorded with often-jolting clarity the toll of the Depression on the rural South. This forthright self-portrait was made around this time and captures Evans' commitment to clarity of vision and his engagement with documentary photography. Having shown his work with Ralph Steiner, Margaret Bourke-White, and George Platt Lynes, and bolstered by friendships with Lincoln Kirsten and Ben Shahn, Evans was at a turning point in his career. BF

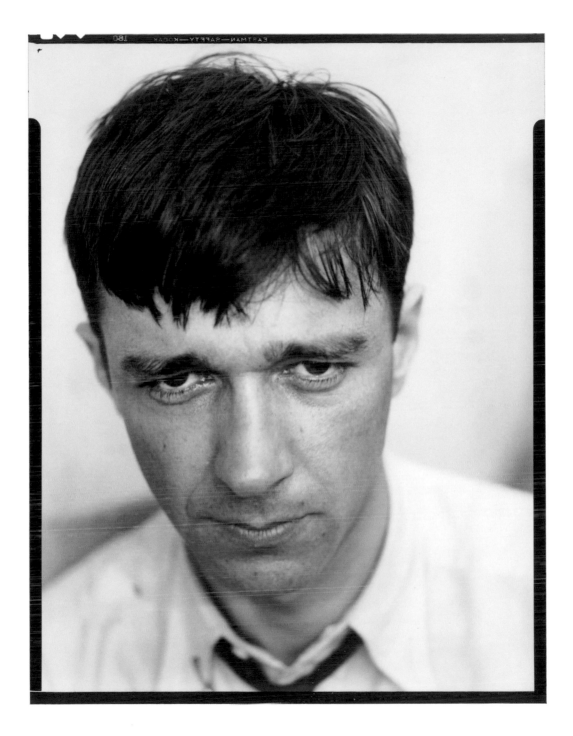

GEORGE GERSHWIN (1898–1937)

The great American composer George Gershwin initially had several Broadway hits, most notably *Lady, Be Good*, for which his brother Ira wrote the lyrics. His style evolved from popular songs like "Swanee" to sophisticated ballads such as "Someone to Watch Over Me." Gershwin experimented with placing jazz in a symphonic form with *Rhapsody in Blue* (1924), and he broke new ground with his "American folk opera," *Porgy and Bess* (1935).

Few people today know that Gershwin loved to paint or that he covered his apartment walls with works by Pablo Picasso, Paul Gauguin, and other modernist painters. This loosely brushed self-portrait combines Gershwin's recognizable profile, a sheet of music, and his hand as it emerges from behind to touch a piano key. Feeling a strong connection between what one sees and what one hears, he noted: "Music is design—melody is line; harmony is color; ... dissonance in music is like distortion in a painting." BF

Self-Portrait, 1934
Oil on canvas board
40 × 29.9 cm (15 ¾ × 11 ¾ in.)
Gift of Ira Gershwin (NPG.66.48)

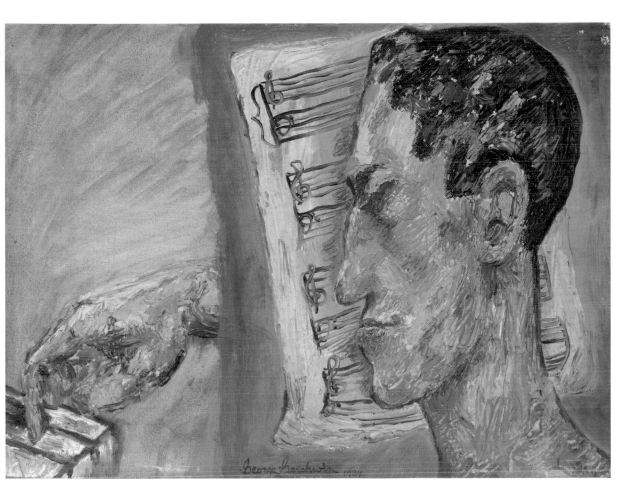

George Gershwin 1934

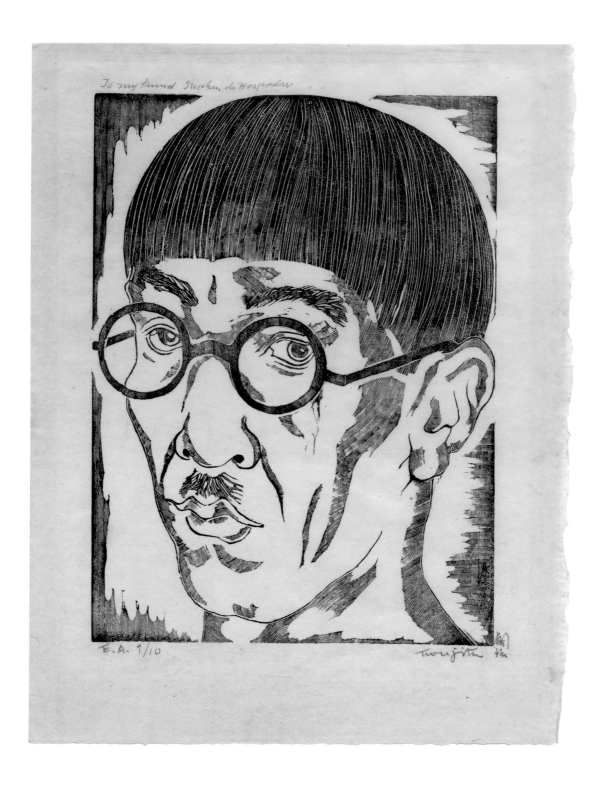

To my friend Stephen de Hospodar

E.A. 9/10 Tsouguita Fou

TSUGUHARU FOUJITA (1886–1968)

Tsuguharu Foujita was perhaps the most famous Japanese artist in Paris during the 1920s. Dramatic and bohemian and a friend of the artist Amedeo Modigliani, Tsuguharu developed a hybrid painting style that incorporated figures with flat ivory white skin, dark sumi ink outlines, and subdued colors. Tsuguharu made self-portraits during this time as well, often to advertise his artistic reputation rather than to tell us about himself.

In the early 1930s, when he had grown restless, he traveled to South America, Cuba, Mexico, and the United States. Upon returning to Japan in 1934, he created this self-portrait print, which is inscribed to the printmaker Stephen de Hospodar, whom he surely met in California. Caught between Japan and the West, Tsuguharu spent the war years supporting the Japanese cause, but after World War II, he left Japan and lived the rest of his life in France.

BF

Self-Portrait, 1934
Wood engraving
22 × 15.8 cm (8 ¹¹⁄₁₆ × 6 ¼ in.)
The Ruth Bowman and Harry Kahn Twentieth-Century
American Self-Portrait Collection (S/NPG.2002.244)

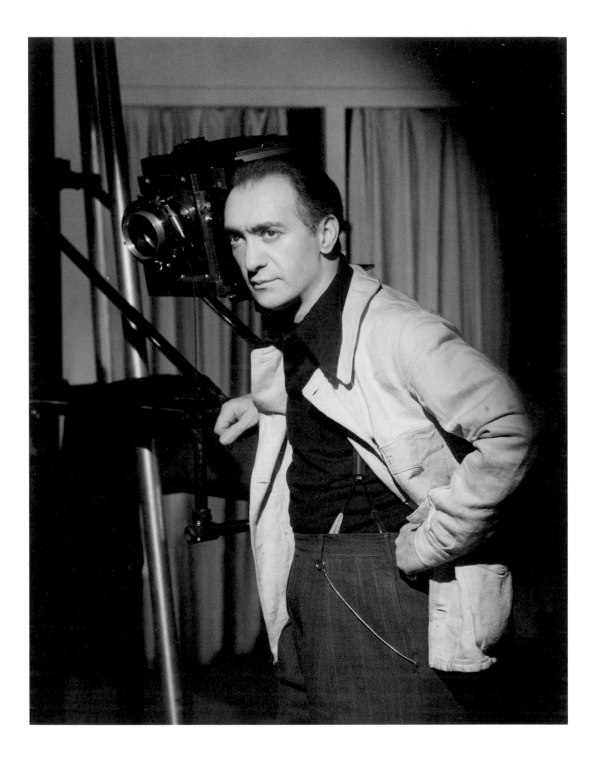

NICKOLAS MURAY (1892–1965)

In 1913, Nickolas Muray left his native Hungary to escape anti-Semitism and arrived at Ellis Island, feeling hopeful about his future. By the 1920s, he had mastered English and was sought after as a celebrity photographer. A charming and handsome man, he met his greatest subject, the Mexican artist Frida Kahlo, in 1931, and they were lovers for a decade. He was also a champion fencer at this time and competed in the 1932 Olympics.

During the lean years of the Great Depression, Muray focused on commercial and advertising work, and developed his skills in color photography. He rapidly mastered the new three-color process, and soon his vibrant images were regular features in popular publications, such as *Ladies Home Journal* and *McCall's*. Here, Muray poses with his one-shot color-separation camera. Using this camera, he could simultaneously expose three plates through three separate filters to make the color separations needed for color-carbro prints and color reproductions. BF

Self-Portrait, c. 1935
Gelatin silver print
24.2 × 18.9 cm (9 ½ × 7 ⁷⁄₁₆ in.)
Gift of Mimi and Nicholas C. Muray (NPG.91.206)

BERTRAM HARTMAN (1882–1960)

The Kansas-born artist Bertram Hartman, who was once well known in artistic circles of New York City and Paris, is shown here posing in his studio. Although he focused primarily on book and magazine illustration, stained glass, mosaics, and designs for batik textiles and hooked rugs, he also exhibited oils and watercolors alongside prominent American modernists.

A close friend of writer Ernest Hemingway and artists John Marin, Gaston Lachaise, and William and Marguerite Zorach, Hartman was admired for his multiple perspectives and cubist patterning. His watercolors drew particular attention. "Forms, light, and patterns of color interplay in sweeping rhythms," a *New York Times* reviewer noted. "Hartman's lyricism is uppermost in these watercolors and dash and freshness are explicit." Though known for his landscapes and skyscrapers, he periodically exhibited his figure paintings that incorporate more angular renderings. A playful repetition of geometric shapes animates this wry, attenuated self-portrait. WWR

Self-Portrait, 1935
Watercolor over graphite on paper
39 × 56.9 cm (15 ⅜ × 22 ⅜ in.)
Gift of Kurt Delbanco (S/NPG.91.203)

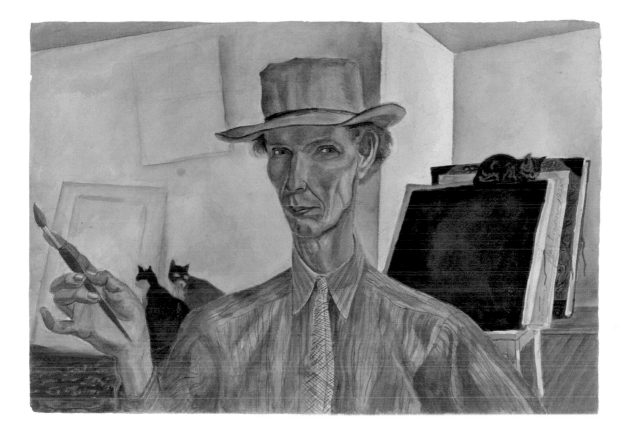

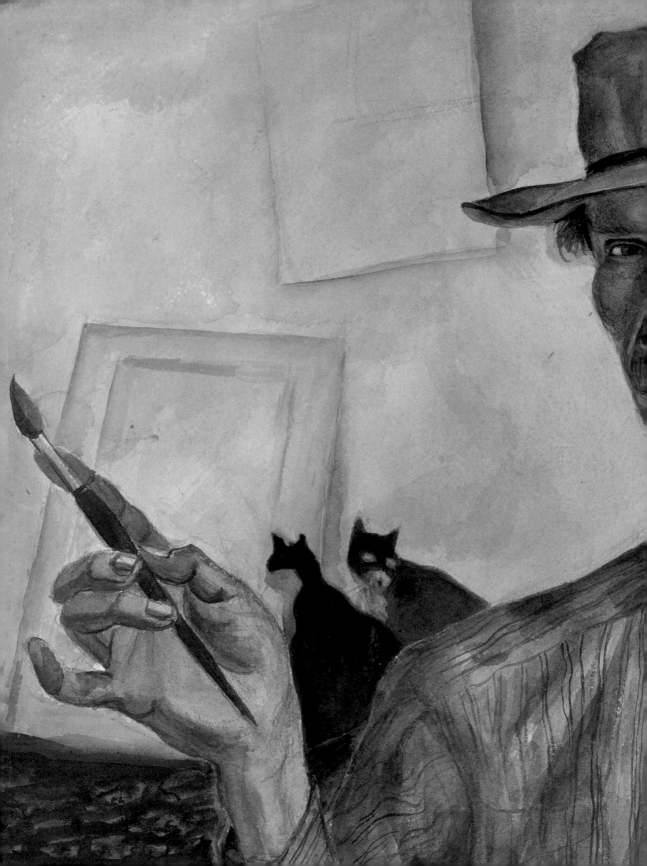

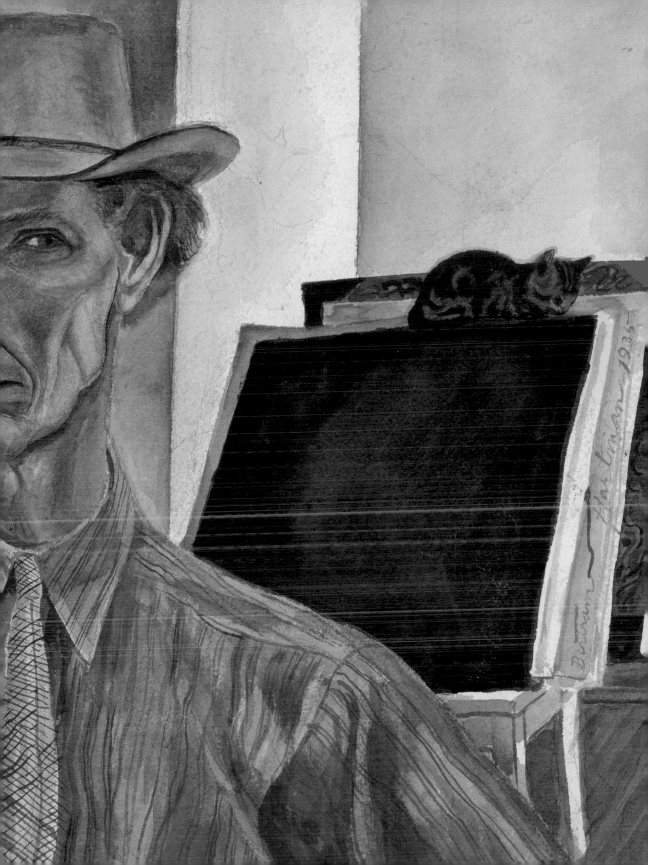

EDWARD HOPPER (1882–1967)

A gentle caricature, this drawing depicts the American realist artist in scruffy middle age, with a scrawny neck, socks slipping down to his ankles, and a basket of books at his feet. A semblance of elegance is retained, however, through the depiction of his plumed hat, full-length cape, and monocle.

Entitled "Josie's Dream," the portrait offers an image that his wife, Josephine Verstille Hopper, would embrace, and gives us clues to Edward Hopper's intellectual interests. The Hoppers shared a love of French literature and Symbolist poetry, and they had recently seen an exhibition on Dada and Surrealism at the Museum of Modern Art. The most recent book in the basket, inscribed as "Last Puritan," refers to the work by George Santayana, published in 1935, and noted in Jo Hopper's diary as a volume her husband had seized when he first saw it in the library in Truro, Massachusetts, near their home. BF

Le Rêve de Josie, c. 1936
Graphite on paper
27.7 × 21.5 cm (10 ⅞ × 8 ⁷⁄₁₆ in.)
(NPG.93.470)

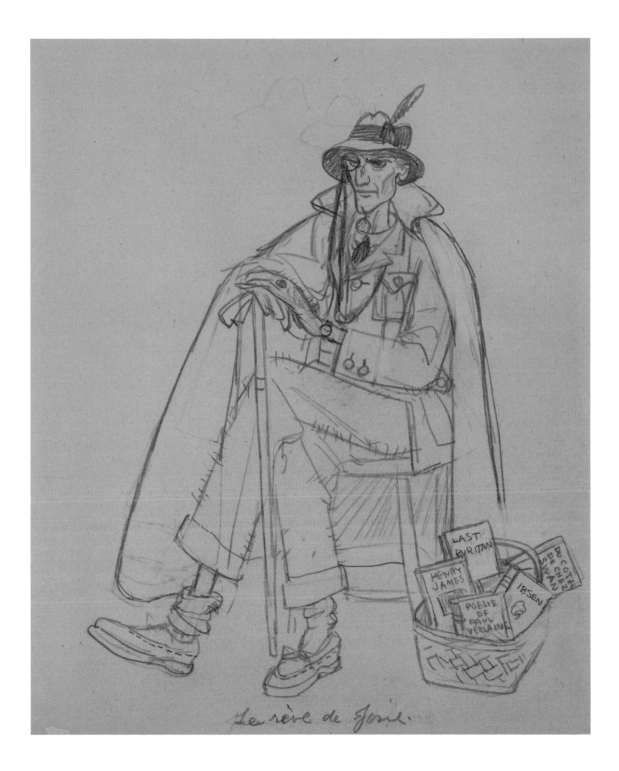

Le rêve de Josie.

LOTTE JACOBI (1896 –1990)

Soon after immigrating to the United States, Lotte Jacobi photographed this reflection of herself. Dressed in masculine clothing, she is shown emerging from a closet and smoking a cigarette. Born into a family of photographers, Lotte's Jewish heritage and leftist politics made her a target in Nazi Germany, so she left in 1935, traveling through London to meet her sister in New York City. There, she established a studio and for the next six decades continued her distinguished career as a photographer of portraits, landscapes, cityscapes, and abstractions. Lotte saw herself as an artist as opposed to a commercial photographer. However, her portrait work often touched on private and personal moments in the lives of public figures, such as Albert Einstein and Robert Frost. Here, she marks a time of transition in her life, asserting her creative energy through a self-portrait. BF

Self-Portrait, 1936
Gelatin silver print
11.5 × 16.9 cm (4 ½ × 6 ⅝ in.)
(NPG.93.65)

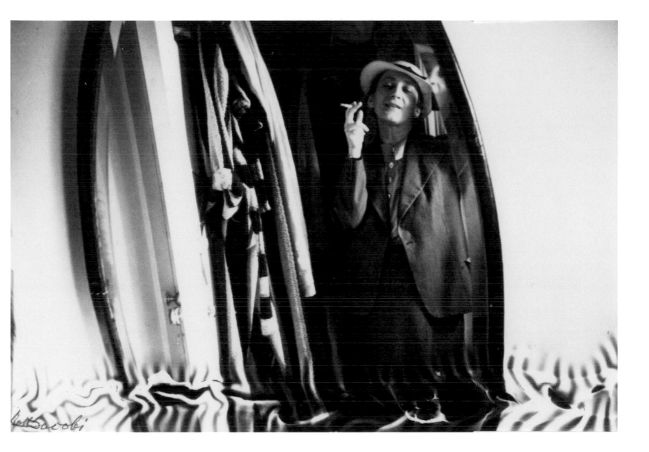

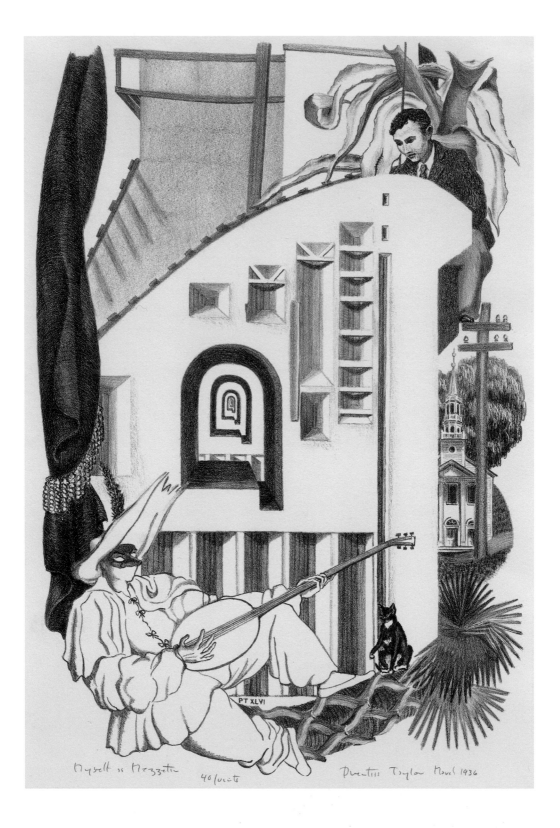

Myself as Mezzetin Prentiss Taylor March 1936

40/60ct

PRENTISS TAYLOR (1907–1991)

Prentiss Taylor spent most of his life in Washington, D.C., but he studied painting in Provincetown, Massachusetts, and lithography at the Art Students League in New York City. While in New York in the late 1920s and early 1930s, he grew close to the writer Carl van Vechten and the poet Langston Hughes, with whom he collaborated on several illustration projects born of the Harlem Renaissance.

In this unusual lithograph, which weaves together several aspects of Taylor's life in 1936, we see the artist perched at the top of the composition, looking down at a masked alter ego, the costumed figure of Mezzetin. The stock character of the Italian commedia dell' arte, Mezzetin was often lovelorn. Meanwhile, we see a cross-section of the newly completed TVA Norris Dam, which Taylor imaginatively associated with images of commedia dell'arte sets. His cat "Toussaint L'Ouverture" stands among other personal references. BF

Myself as Mezzetin, 1936
Lithograph
41.2 × 30.1 cm (16 ¼ × 11 ⅞ in.)
Gift of Eric Denker, in honor of Dr. Alan Fern (S/NPG.2002.77)

VICTOR HAMMER (1882–1967)

In Victor Hammer's study for a 1937 painting, the Austrian-born artist portrayed himself as a bookbinder with tools and an unfinished volume. Hammer maintained his interests in printing and book arts after he moved to the United States in 1939. The rectilinear background lines, which may indicate his antique press, reveal his fascination with framing devices and the internal structure of a picture. "How sweet it is to tell a story, tell it in those cold, geometrical terms," he once wrote. "I am engrossed in the abstract design. ... Why shouldn't I paint a portrait as if it were a triangle, and at the same time give a Likeness?"

The delicate tonalities and subtly reflective luster of the drawing were achieved with silverpoint, a Renaissance technique using a silver stylus on a prepared ground. A Renaissance man himself, Hammer was also a painter, writer, musician, architect, sculptor, and silversmith. WWR

Self-Portrait, c. 1937
Silverpoint, graphite, and watercolor on prepared paper
45.9 × 36 cm (18 1/16 × 14 3/16 in.)
Gift of Carolyn Reading Hammer (NPG.89.59)

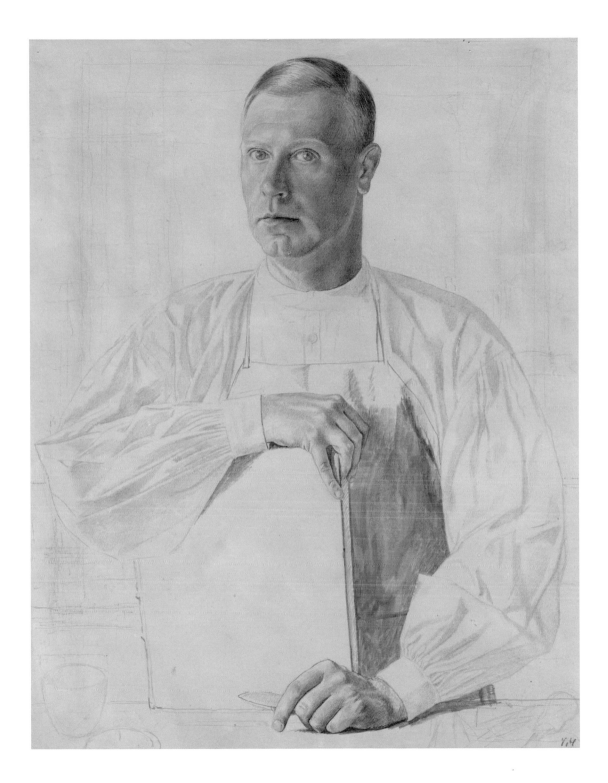

FEDERICO CASTELLON (1914–1971)

Federico Castellon here depicts himself against a coastal landscape reminiscent of his native southern Spain, where he had gone for a visit in the early 1930s, after having been away since his childhood. Following that memorable visit, Castellon studied art and exhibited in Spain and France before fleeing Europe in 1936 to avoid conscription in the Spanish Civil War.

By portraying himself in a Loyalist soldier's hat, the artist suggests his anguish over both the war and the United States's refusal to intervene in it. There is a keen sense in the portrait of longing, with its sensuous yet unavailable female figure, fetishistic shoe, and suggestive imagery. All of these elements attest to the influence of the Surrealists, with whom Castellon exhibited in Paris in 1935. Upon returning to the United States, Castellon had his second solo exhibition at the Weyhe Gallery in New York City. This print was one of his first lithographs, created when he began to gain critical and financial success. ECR

Self-Portrait with Spanish Cap, 1937
Lithograph
29.8 × 40.5 cm (11 ¾ × 15 ¹⁵⁄₁₆ in.)
The Ruth Bowman and Harry Kahn Twentieth-Century
American Self-Portrait Collection (NPG.2002.224)

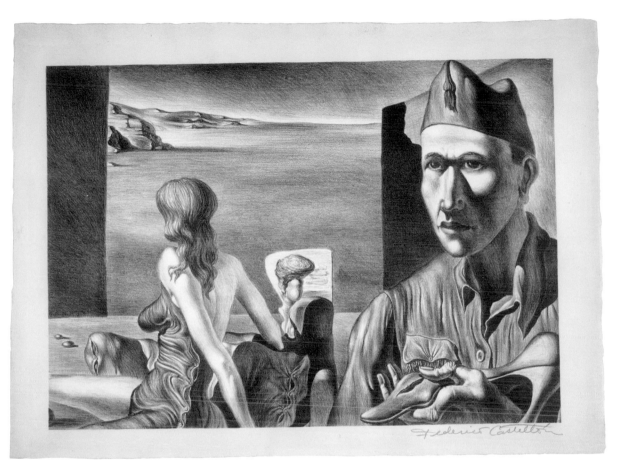

Frederick Castellon

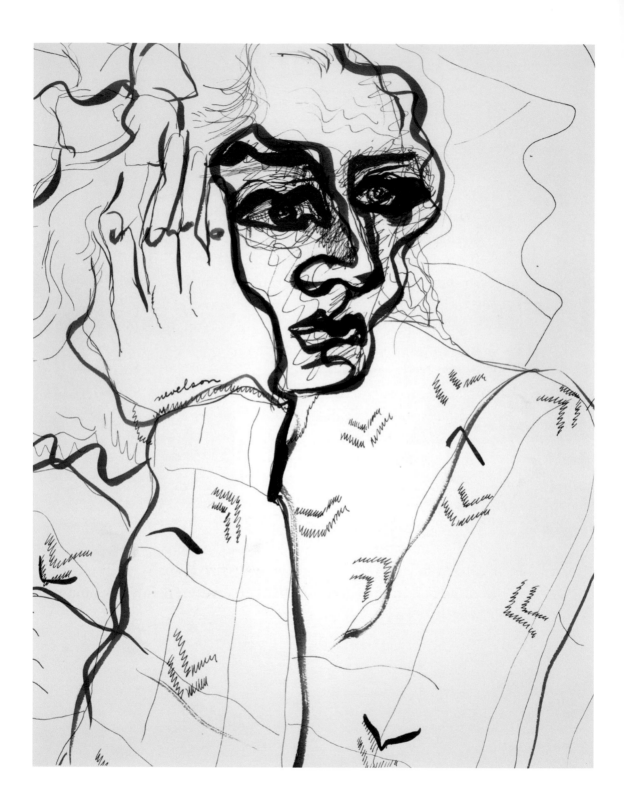

LOUISE NEVELSON (1899–1988)

"When I used a line, it was like a violin," sculptor Louise Nevelson claimed about her expressive drawings, which she frequently exhibited along with her three-dimensional work. In this self-portrait, wiry scratches, squiggles, bold black contours, and a red overdrawing compete for attention. The robust features convey her driven personality along with the muscular expression evident in her later sculpture. The double red contours of the face hint at both profile and full-face poses, suggestive of a rotating head, Pablo Picasso's cubism, and multiple-exposure photography.

Although Nevelson was described as beautiful, she distorts her features with an emotional intensity that relates to German Expressionism, Surrealism, African sculpture, and the murals of Diego Rivera, with whom she briefly apprenticed. But although Nevelson studied with Hans Hofmann and other renowned artists, she claimed no influence. Recognition for her powerful, often wall-sized, abstract sculpture came late in the career of this fiercely independent woman.

WWR

Self-Portrait, c. 1938
Ink and watercolor on paper
40 × 30.9 cm (15 ¾ × 12 ³⁄₁₆ in.)
The Ruth Bowman and Harry Kahn
Twentieth-Century American Self-Portrait Collection
Conserved with funds from the Smithsonian
Women's Committee (NPG.2002.307)

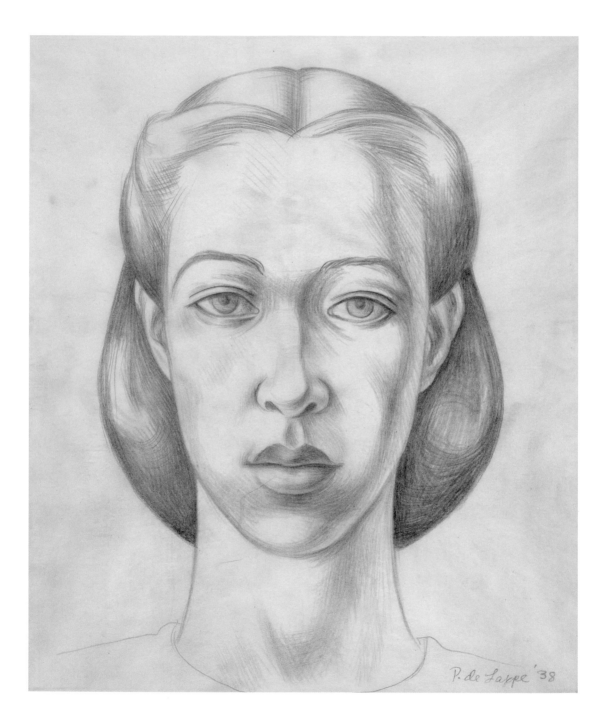

P. de Lappe '38

PELE DELAPPE (1916–2007)

Pele deLappe shared with many women artists of her generation the challenge of maintaining an artistic career while raising children and making a living. This 1938 graphite drawing, conveying both her beauty and her self-assurance, asserts an auspicious beginning.

The San Francisco-born deLappe met Diego Rivera and became a sketching companion of his wife, Frida Kahlo. In the early 1930s, deLappe studied at the Art Students League in New York City, but she returned to San Francisco in 1934, planning to concentrate on social-realist themes. Her style, however, reflected the influence of the Mexican muralists, including Rivera and her close friend David Alfaro Siqueiros, more than the quick-sketch approach of her New York compatriots. Her lithographs of the 1930s had a muralist's sensibility, with simplified compositions, broad planes, low viewpoints, and heroic figural forms. This statically posed and sharply outlined self-portrait shares a similar monumentality. WWR

Self-Portrait, 1938
Graphite on paper
34.8 × 27.5 cm (13 11/16 × 10 13/16 in.)
The Ruth Bowman and Harry Kahn Twentieth-Century
American Self-Portrait Collection (S/NPG.2002.290)

IMOGEN CUNNINGHAM (1883–1976)

In this photograph, we not only see Jane Foster looking in the mirror and creating a painted self-portrait but also the photographer Imogen Cunningham mirrored in the background. A model, called Alice, is the subject of the painting in the left foreground, and it is she who completes this complex composition of portraits hiding within portraits.

The ostensible subject of this photograph is Foster, an artist from the San Francisco area who led a fascinating life of travel, government service, and espionage, most likely serving as a spy for the Soviet Union during and after World War II. She and her second husband, George Zlatovski, were indicted for espionage by a federal grand jury in 1957, but they remained exiled in Paris and were never tried. Foster and Cunningham may have become acquainted through Cunningham's husband, Roi George Partridge, who taught at Mills College, where Foster graduated in 1935. BF

Jane, Alice, and Imogen, c. 1940
Gelatin silver print
23.6 × 19.1 cm (9 5/16 × 7 1/2 in.)
Gift of Annette and Robert Klayman (NPG.2017.23)

JOSEPH STELLA (1877–1946)

America's leading Futurist artist, Joseph Stella created monumental abstract paintings characterized by dramatic contrasts of light and color, thrusting diagonals, and dynamic movement. But this self-portrait focuses instead on self-revelation, reflecting the contradictions of Stella's artistic and personal life. Not known to be an introspective person, the Italian-born artist studied his own image more intensely as he grew older and more reclusive. Although the pose here recalls the classical Renaissance profiles he admired, the intensity and complexity of the image belie this tradition. Touches of red on the lips, eyelid, nose, and cheek are unsettling. The background, with its turbulent pattern and acrid yellow splotches, appears to share the same plane as the flattened profile, reinforcing the sense of encompassing anxiety. Yet the concentration of his gaze, the flare of his nostril, and the set of his lips convey the spirit of a headstrong individual who persists despite emotional turmoil.

WWR

Self-Portrait, c. 1940
Gouache, graphite, metalpoint, watercolor, and crayon on prepared paper
35.8 × 30.7 cm (14 ⅛ × 12 ¹⁄₁₆ in.)
(NPG.93.368)

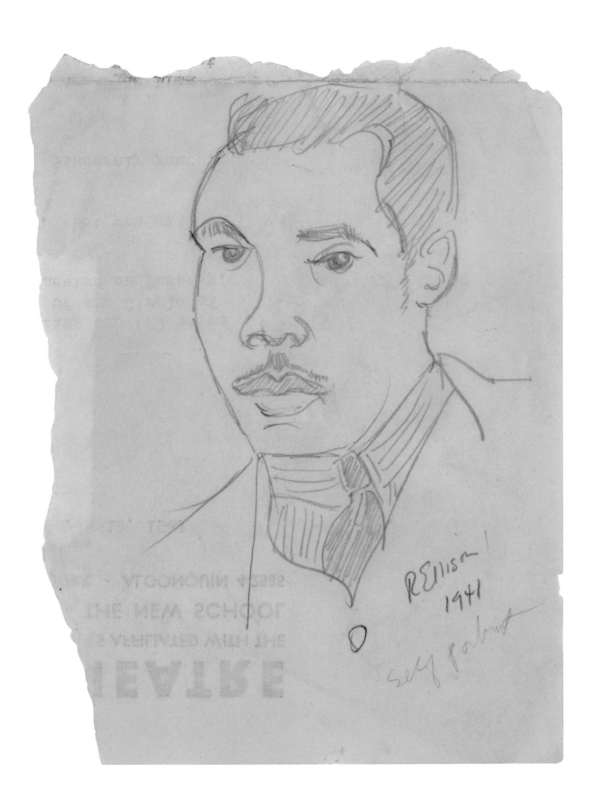

R Ellison
1941

self portrait

RALPH ELLISON (1914–1994)

Ralph Ellison, born in Oklahoma, wrote about the African American struggle, and though he was not a practicing artist, he created this self-portrait in 1941, during a formative stage in his literary career. His appearance as an introspective young man aligns with the themes of marginalized invisibility and alienation, as well as the drive for representation that he explored throughout his life.

A decade after Ellison made this portrait, he published his award-winning novel, *Invisible Man* (1952), a semi-autobiographical story about a young black man's frustrating attempts to find his own identity, both in the segregated South and during a volatile era in Harlem. After the release of *Invisible Man*, Ellison lectured and published essays and short stories, but he never wrote another novel. In 1971, he gave this likeness to Burt Britton, a collector who worked in a bookstore and asked for self-portraits from personalities he encountered there. PQ

Self-Portrait, 1941
Graphite on paper
14 × 11 cm (5 ½ × 4 ⁵⁄₁₆ in.)
(NPG.2009.82)

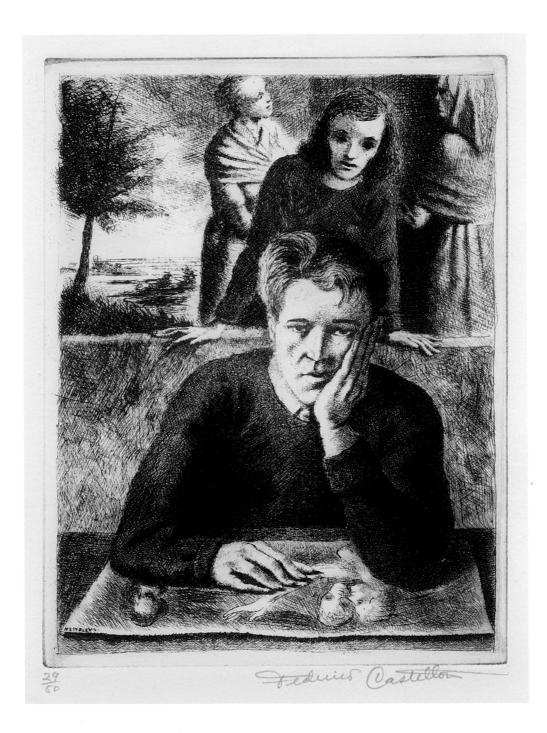

29/50 Federico Castellon

FEDERICO CASTELLON (1914–1971)

As a Spanish-born artist living in the United States, Castellon recalled that he felt like "a rejected foreign child," for his parents immigrated to the United States in 1921, when he was seven, and he did not return to Spain until the early 1930s. He described his work as "poetic mysticism," but he aligned himself with and admired the work of the Surrealists Salvador Dalí and Joan Miró, with whom he exhibited in Paris in 1935.

This etching, with its sense of reverie and classical idyll, depicts the artist in a contemplative pose with a drawing in process under his hand. "H" is his wife, Hilda Greenfield Castellon, whom he married in 1940. She gazes at her husband, leaning with concern over a low wall, but she, like the figures behind her, may be a figment of his imagination as he searches for what comes next. BF

Self-Portrait with H, 1942
Etching
28.5 × 20.4 cm (11 ¼ × 8 ¹⁄₁₆ in.)
The Ruth Bowman and Harry Kahn Twentieth-Century
American Self-Portrait Collection (NPG.2002.223)

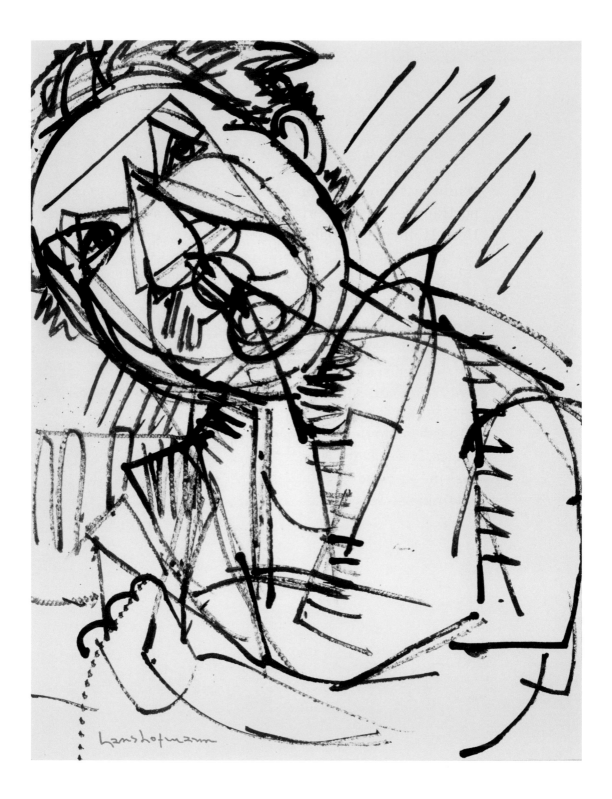

HANS HOFMANN (1880–1966)

While best known for his vibrant, painterly abstractions, portraiture and self-portraiture also played a critical role in Hans Hofmann's intellectual and artistic development. This undated self-portrait drawing appears to be related to a series of paintings that Hofmann made of himself in 1942. In those compositions, as here, Hofmann conceives of his physiognomy as a vocabulary of shapes: triangles, squares, circles, and ovals. Yet it was not simply his own form that concerned the artist but also the integration of his body with the space that surrounded it, as indicated by the use of energetic diagonal lines in this area of the composition. Hofmann's decision to tilt his head to the left intensifies this interaction between planes. His drawing thus reveals, in the artist's words, likeness in "a plastic sense, not in a photographic one," thereby obtaining an independent reality. ACG

Self-Portrait, 1942
Ink on paper
28 × 21.6 cm (11 × 8 ½ in.)
The Ruth Bowman and Harry Kahn Twentieth-Century
American Self-Portrait Collection (NPG.2002.274)

JOHN WILSON (1922–2015)

"This business of looking at people I latched onto when I was very young," John Wilson once noted. Wilson's 1944 self-portrait, drawn in lithographic crayon, reveals the twenty-two-year-old's assured draftsmanship and experience in modeling faces. He was initially taught to draw at the local boys' club, and although the chances of a poor young black artist succeeding seemed slim at the time, he enrolled in the school of Boston's Museum of Fine Arts in 1939.

He ultimately graduated with highest honors and received a prestigious travel grant that enabled him to study modernism in Paris with Fernand Léger and learn about non-Western art forms. In his portraiture, Wilson probed beyond momentary expressions and personality quirks to hint at an interior essence. Admiring the Buddhas in the Boston Museum that "are quiet, still, but ... have a spiritual force, an inner energy," he sought to express such universal human qualities in his own work. WWR

Self-Portrait, 1944
Lithographic crayon on paper
41.6 × 31.2 cm (16 ⅜ × 12 ⁵⁄₁₆ in.)
The Ruth Bowman and Harry Kahn Twentieth-Century
American Self-Portrait Collection (S/NPG.2002.366)

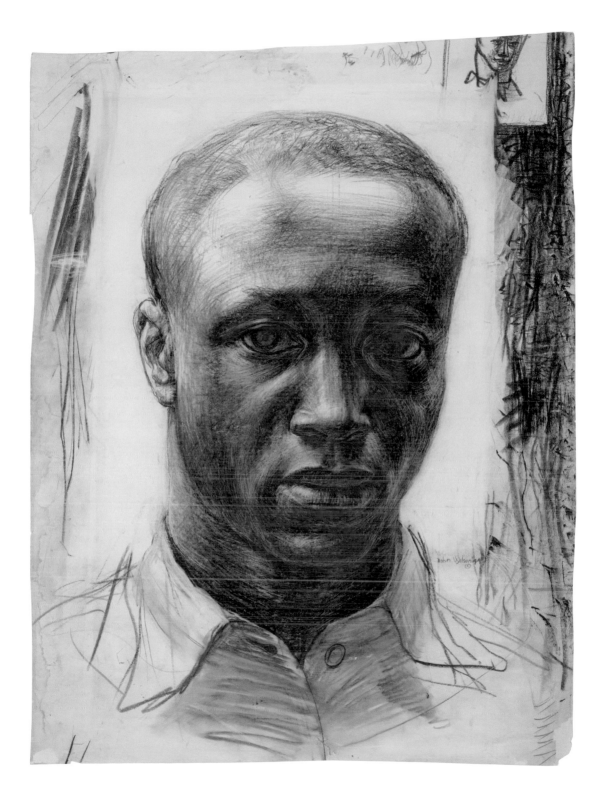

LOUISE NEVELSON (1899–1988)

This colorful, expressively scumbled, and compositionally compartmentalized portrait is one of many Louise Nevelson created during the mid-1940s in New York City, when she was moving between painting and sculpture. Having studied with the sculptor Chaim Gross and the painters Hans Hofmann and Diego Rivera, she experimented with both disciplines before choosing sculpture as her life's work.

Many of Nevelson's dark, richly colored paintings depict her friends and family, and some are autobiographical. This one, however, while certainly a stylized likeness, includes her name inscribed between the points of her crown. The heavy impasto and dimensionality of the paint surface are so sculptural that the painting seems imprisoned by the two-dimensional surface of the canvas. She most likely painted the original frame, as well. BF

Self-Portrait, 1945
Oil on canvas
55.9 × 46 cm (22 × 18 ⅛ in.)
(NPG.2000.54)

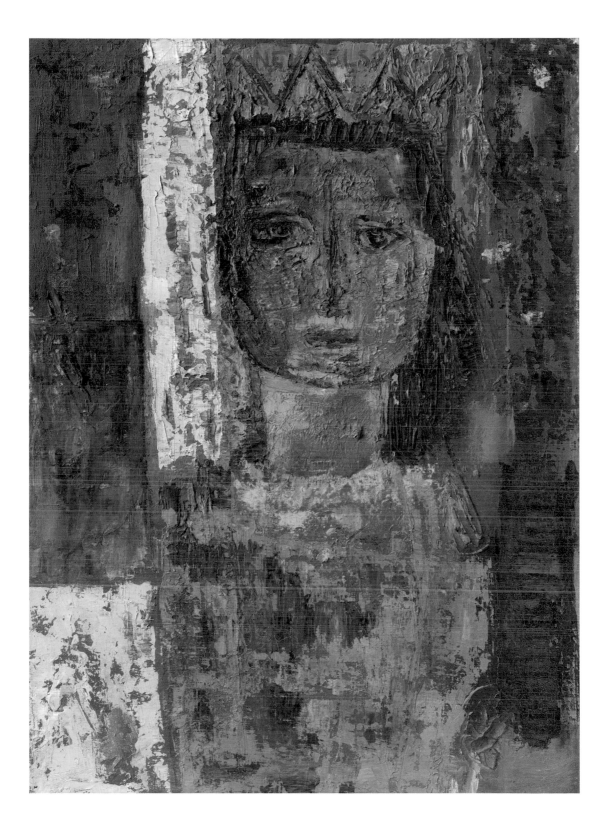

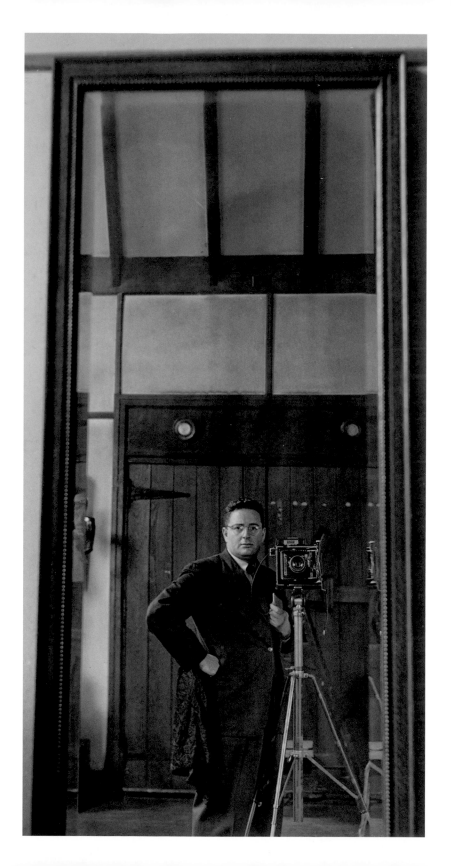

ARNOLD NEWMAN (1918–2006)

This self-portrait by Arnold Newman dates from 1945, the year in which the Philadelphia Museum of Art presented the photographer's portraits of contemporary artists in a solo exhibition entitled *Artists Look Like This*. Newman, who is best remembered for developing environmental portraiture, created iconic portraits of such cultural figures as Igor Stravinsky, Marilyn Monroe, and Pablo Picasso.

Here, the photographer and his camera appear in the reflection of a large mirror whose beveled border fractures the picture plane to create the illusion of an oddly receding space. By cropping the picture to eliminate the bottom of the mirror's frame, Newman seeks to persuade the viewer that the image is not a reflection but a scene glimpsed through an open window or a doorway. In this way, Newman places his photograph within the tradition of painted self-portraits. AMS

Self-Portrait, 1945
Gelatin silver print
23.9 × 12 cm (9 ⁷/₁₆ × 4 ¾ in.)
(NPG.2003.7)

ELAINE DE KOONING (1918–1989)

This painting and one in the collection of the Metropolitan Museum of Art in New York City are the most fully realized of Elaine de Kooning's self-portraits of the 1940s. She was using colors similar to those that her husband Willem de Kooning was using at the time, but she clearly asserts her own presence and skill.

Clad in trousers, a turtleneck, and a smock, the artist appears to be seated in her studio, working in a sketchbook. She confronts the viewer directly, a hallmark of self-portraits, but nonetheless references other genres. The composition includes a number of still-life objects that reflect her years of intense tutorials with Willem; he compelled her to look at objects and the spaces between them to develop her sense of pictorial organization. As she recalled, "everything was a matter of tension between objects or edges and space." BF

Self-Portrait, 1946
Oil on Masonite
76.8 × 58.4 cm (30 ¼ × 23 in.)
(NPG.94.81)

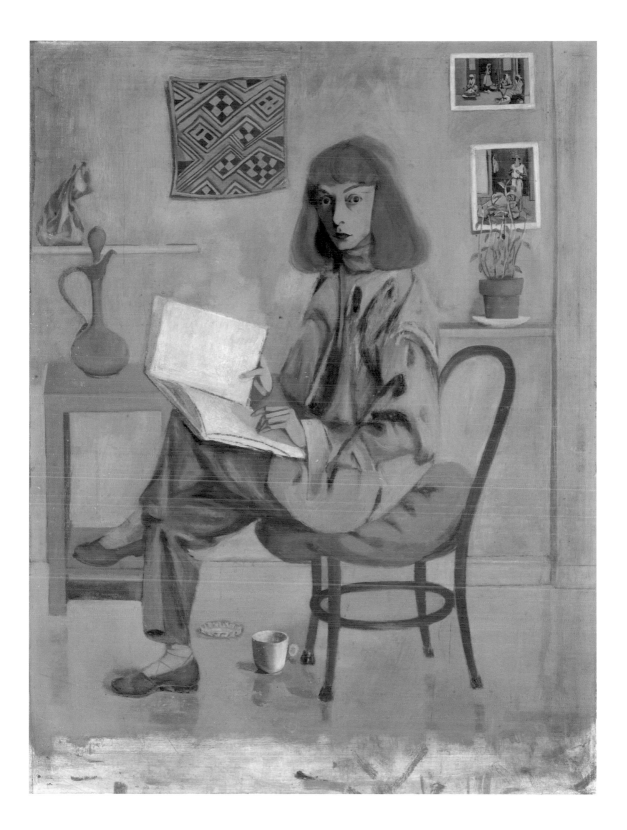

IRVING PENN (1917–2009)

Irving Penn spent 60 years working for *Vogue* and photographed 165 covers for the magazine. His clarity of vision and perfectionism resulted in beautifully composed images that were printed to last. Although Penn spent most of his career in the fashion industry, he also photographed nudes and still lifes, as well as close-up images of cigarette butts and other urban debris. Unable to serve in World War II because of a heart condition, he volunteered for the American Field Service in 1944 and drove an ambulance in Italy.

In 1946, Penn created this group portrait for the postwar reunion of *Vogue*'s leading photographers. Set on Horst P. Horst's wooded estate on Long Island, New York, the photographers, all men, are carefully posed around a woman—the model Dorian Leigh—and a large studio camera. From left to right, they are: Serge Balkin, Cecil Beaton, George Platt Lynes, Constantin Joffe, Horst P. Horst, John Rawlings (rear), Irving Penn (front), and Erwin Blumenfeld. BF

Vogue Photographers, 1946
Gelatin silver print
37.1 × 49.7 cm (14 ⅝ × 19 ⁹⁄₁₆ in.)
Gift of Irving Penn (NPG.88.70.57)

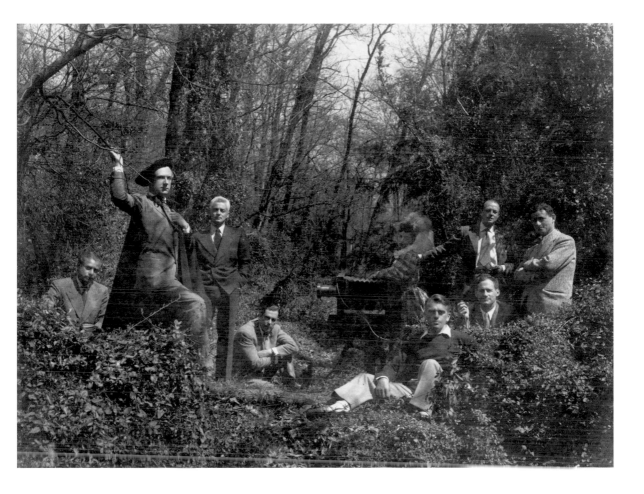

LOUISE BOURGEOIS (1911–2010)

Giant spiders cast in bronze, organic shapes that conjure the body—these are the artworks that we first associate with Louise Bourgeois. In addition to her sculpture with subjects tied to personal history and the unconscious, Bourgeois was a painter and printmaker, and during the 1940s, she created a number of drypoint engravings for a portfolio she called *Quarantania* (derived from the French "quarante," meaning forty). Many years later, in 1990, these plates were reprinted, and this one, "Bosom Lady," was reworked by the artist.

Bourgeois was fond of this image, with its hybrid woman/bird-like being, and she spoke about it in a 1994 interview: "A very definite mood is shown: it is happiness…it is a portrait…very intimate and very happy. It is in contrast to the dark self-portraits of low self-esteem…. She is at ease in her body…. she is very confident. These are her three eggs… her three children…her three jewels." BF

Quarantania IX, 1947/1990
Etching
33 × 47.5 cm (13 × 18 11/16 in.)
The Ruth Bowman and Harry Kahn Twentieth-Century
American Self-Portrait Collection (NPG.2002.214)

MIGUEL COVARRUBIAS (1904–1957)

Miguel Covarrubias, who moved to New York City from
Mexico when he was nineteen, was best known for his
popular caricatures of celebrities that were published in
Vanity Fair and other leading magazines of the 1920s and
1930s. His visual wit could be piercing, as in this small sketch
with which he greeted his friends during the holidays. The
artist, who is shown carrying a portfolio of drawings, chose
to exaggerate his features to fearsome effect, with soaring
eyebrows, dark circles under his eyes, and sharp teeth. BF

Self-Portrait, c. 1948
Watercolor, ink, and graphite on paper
14.6 × 9.6 cm (5 ¾ × 3 ¾ in.)
(NPG.2000.35)

Merry Christmas
& Happy New Year.

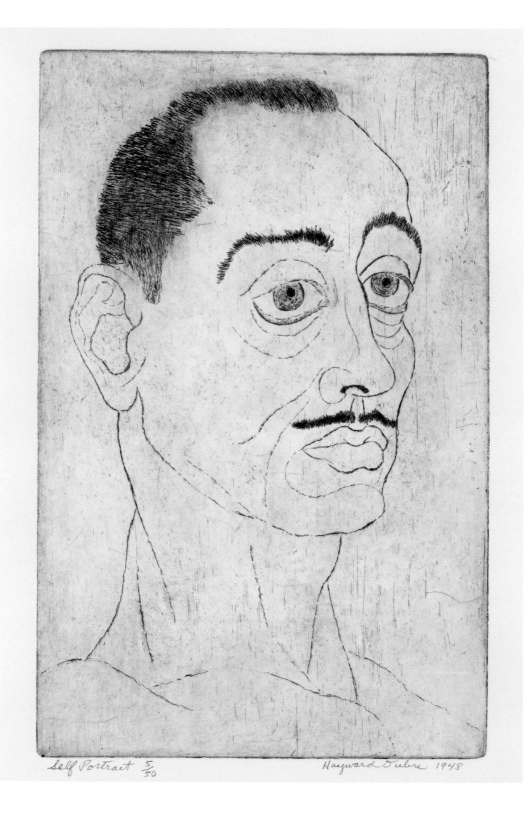

Self Portrait ⁵⁄₅₀ Hayward Oubre 1948

HAYWARD OUBRE (1916–2006)

"I fought racism with my art," Hayward Oubre asserted. Light-skinned, Oubre could have "passed" for white, but he proudly refused to do so. When a student in his printmaking class at the University of Iowa made a racist remark about him, he responded with a print of a black man attacking a snake that was meant to represent the white race. In this self-portrait, made in the same class, Oubre stressed the tan tone of his skin by using buff paper and leaving a thin coating of ink on the plate. He exaggerated the size of his eyes but avoided the gaze of the viewer, perhaps suggesting his alienation. Lines underneath the eyes evoke premature sags and possibly point to the stress of his having lived in segregated campus housing.

After earning an MFA in 1948, Oubre spent his career teaching, and around 1960, he began making wire sculptures that have earned increased recognition in recent years. AW

Self-Portrait, 1948 (printed 1993)
Etching
56.5 × 36.4 cm (22 ¼ × 14 5/16 in.)
The Ruth Bowman and Harry Kahn Twentieth-Century
American Self-Portrait Collection (S/NPG.2002.309)

163

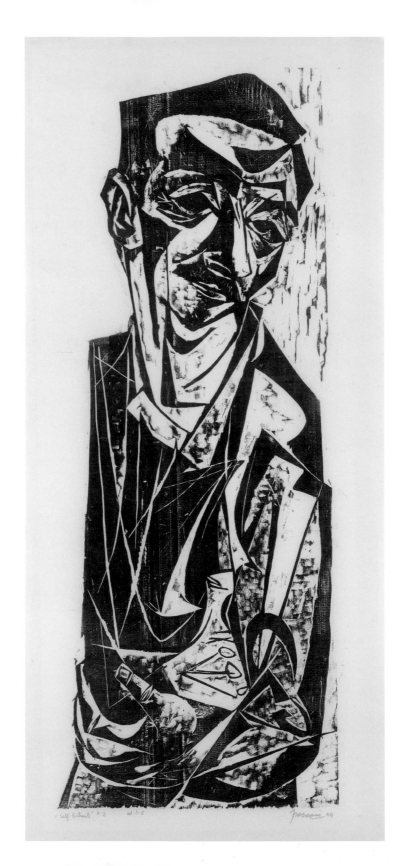

"Self Portrait" #2 ed. 1-5 Bascoli 49

ANTONIO FRASCONI (1919–2013)

This work reflects the politically themed woodcuts that Antonio Frasconi made while living in his native Montevideo, Uruguay. After he immigrated to the United States, in 1945, Frasconi remained committed both to the woodcut and to political causes. In 1948 and 1949, for example, he used a freely distorted cubist and expressionistic style in a series of paintings and woodcuts representing, he said, the "people of Spain [suffering under the Franco regime] ... through the heroic presence of Don Quixote."

In this print's original form, the idealistic knight on his steed appeared at the left, but Frasconi later cut away the section of the block picturing Quixote, thus simplifying a complex and specific image and making it a more flexible representation. Nevertheless, the work continues to evoke the agony of the Spanish struggle through the artist's face—with its distracted, hooded eyes—and his constrictive pose. AW

Self-Portrait #2, 1949
Woodcut
90.8 × 40.8 cm (35 ¾ × 16 ¹⁄₁₆ in.)
The Ruth Bowman and Harry Kahn Twentieth-Century
American Self-Portrait Collection
Conserved with funds from the Smithsonian
Women's Committee (NPG.2002.248)

PHILIPPE HALSMAN (1906–1979)

Philippe Halsman was one of many Europeans who fled the rise of Nazism in Germany; Albert Einstein, a family friend, arranged for his visa in 1940. Soon after arriving in the United States, Halsman found work with American magazines, photographing celebrities and other notables. He continued this work for over thirty years, generating more than one hundred covers for *Life*.

Halsman was also known for his whimsical, fantastic imagination and his interest in Surrealism. In one of his series of portraits, he asked famous subjects to leap into the air, and his complex collaboration with the artist Salvador Dalí led to his famous 1948 photograph of Dalí leaping, with three airborne cats alongside a splash of water. This self-portrait shows Halsman merging with his camera. His head rests atop the tripod's fixed plate, and his hand is cranking the worm gear sector that adjusts the angle of the plate for controlling and panning the camera. BF

Self-Portrait on Tripod, 1950
Gelatin silver print
34.8 × 27.4 cm (13 ¹¹⁄₁₆ × 10 ¹³⁄₁₆ in.)
(NPG.2002.106)

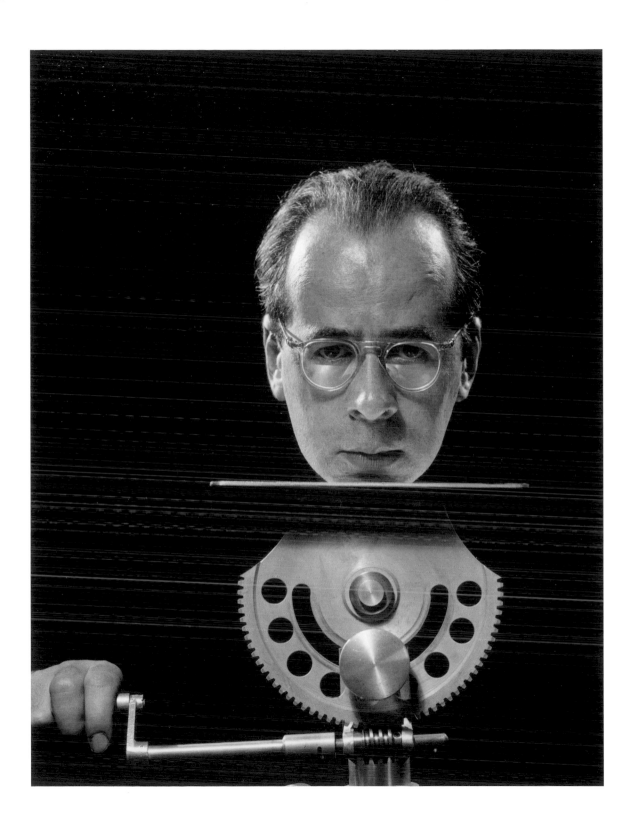

WOLF KAHN (born 1927)

In 1947, using his GI Bill benefits, twenty-year-old Wolf Kahn enrolled in the Hans Hofmann School of Fine Arts to study painting. Hofmann, who was based in New York City, had his students work from still lifes and nude models, but he also taught his theory of "push and pull," referring to the movements and counter-movements in a picture's structure. Kahn felt deeply engaged in Hofmann's classes but left in 1949 to study philosophy at the University of Chicago. After only a year, however, he was back in New York, painting and absorbing the work of Pierre Bonnard, Vincent Van Gogh, and Chaim Soutine.

Critics drew connections between Kahn and Soutine, particularly with regard to Kahn's thickly painted canvases and wash drawings, which were often landscapes and interiors. This dark, introspective self-portrait stares out at us with a haunting sense of purpose. Kahn soon found his own style by combining landscapes with intense color relationships. BF

Self-Portrait, 1952
Etching and aquatint
32 × 23.3 cm (12 ⅝ × 9 ³⁄₁₆ in.)
The Ruth Bowman and Harry Kahn Twentieth-Century
American Self-Portrait Collection (S/NPG.2002.277)

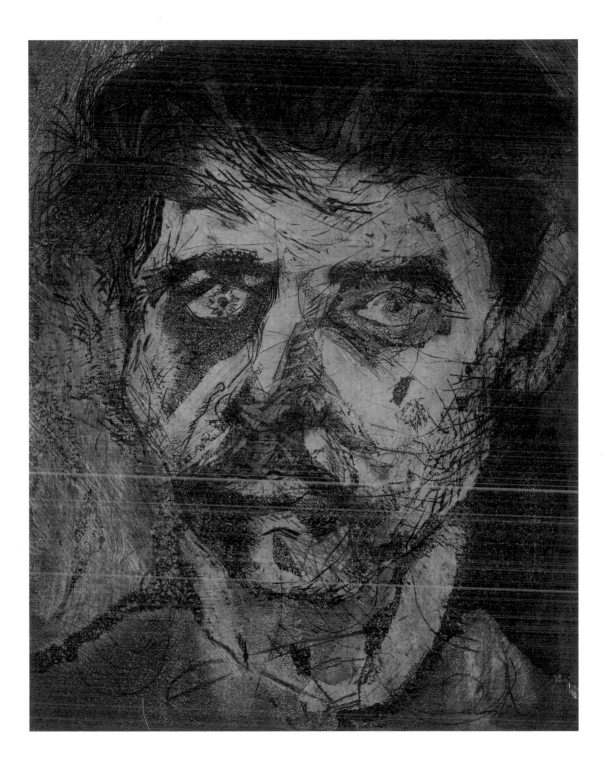

JOHN D. GRAHAM (1886–1961)

John Graham's self-portrait boldly asserts his self-characterization as a shaman. In this drawing, Graham uses both the front and back of the paper to invite the viewer to peer through the surface to an "inner eye," a Buddhist symbol for the state of spiritual enlightenment, in the center of his forehead.

During the course of his career, Graham fashioned an elaborate and mystical persona for himself. The imagery of Graham's *Self-Portrait as Fallen Angel* reflects a great deal about the artist's self-construction. In likening himself to a "fallen angel," he referenced the divine origins he claimed, asserting that he was "the son of Jupiter and a mortal woman." Graham's implied role of a prophet helps explain his inclusion of horns, which allude to traditional depictions of Moses. In fact, the visual iconography of Moses came to include horns during the Renaissance because of a faulty translation of Hebrew, demonstrating the role of scholarly study in iconography. ACG

Self-Portrait as Fallen Angel, c. 1955
Ink on paper
42.9 × 35.1 cm (16 ⅞ × 13 ¹³⁄₁₆ in.)
The Ruth Bowman and Harry Kahn Twentieth-Century
American Self-Portrait Collection (NPG.2002.258)

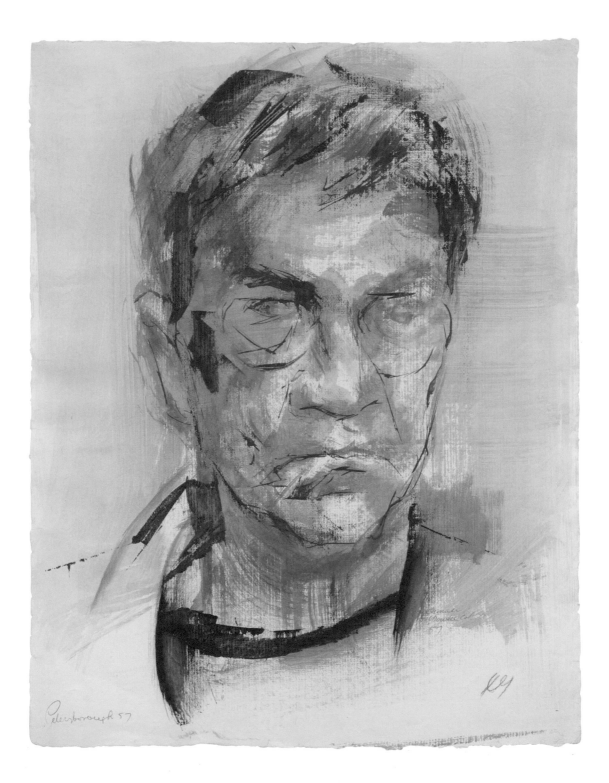

Peterborough 57

XAVIER GONZALEZ (1898–1993)

Xavier Gonzalez was a painter, sculptor, and educator who was active in New York City and Wellfleet, Massachusetts. He was born in Almeria, Spain, but experienced a nomadic childhood in Spain, Mexico, and San Antonio, Texas. While his works draw from reality, he manipulated what he saw to conform to his vision and reflect a modern sensibility.

In this self-portrait, which Gonzalez created in the middle of his life, a serious man looks out at the viewer with a determined set to his jaw. His round glasses, accented by prominent eyebrows, magnify his eyes and frame his penetrating gaze. The skillful use of ink with a light wash of paint translates human energy to a sheet of paper, capturing the artist's spirit. Gonzalez stated that he had "to approach painting indirectly, slowly, because a painting like a flower can die from too much handling. The overstatement of a truth kills it."
PQ

Self-Portrait, Petersborough, 1957
Ink, watercolor, and gouache on paper
66.5 × 51.3 cm (26 ³⁄₁₆ × 20 ³⁄₁₆ in.)
The Ruth Bowman and Harry Kahn Twentieth-Century
American Self-Portrait Collection (S/NPG.2002.372)

BRIAN O'DOHERTY (born 1928)

Although Brian O'Doherty has engaged with multiple concepts of identity throughout his career, he is best known for "Patrick Ireland," a persona he invented in 1972 following the Bloody Sunday killings in Northern Ireland. "Patrick Ireland" created richly conceptual works of art for thirty-six years, until O'Doherty symbolically killed and buried him in 2008.

O'Doherty, who emigrated from Ireland in 1957 to pursue a medical fellowship at Harvard University, soon turned to work in the visual arts. *Transitional Head*, a rare self-portrait painting, dates from that year of personal change. While referencing his interest in the fifteenth-century Italian artist Piero della Francesca in its coloring and clear light, O'Doherty also used bars of pigment to define the picture plane and deny the apparent three-dimensionality of the painted head. BF

Transitional Head, 1957
Oil on canvas
25.4 × 20.3 cm (10 × 8 in.)
Gift of Barbara Novak in honor
of Marc Pachter (NPG.2007.225)

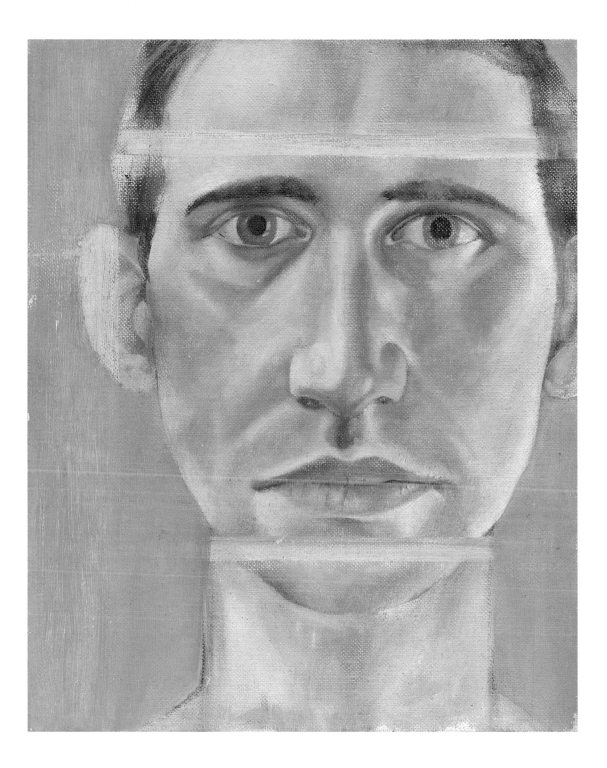

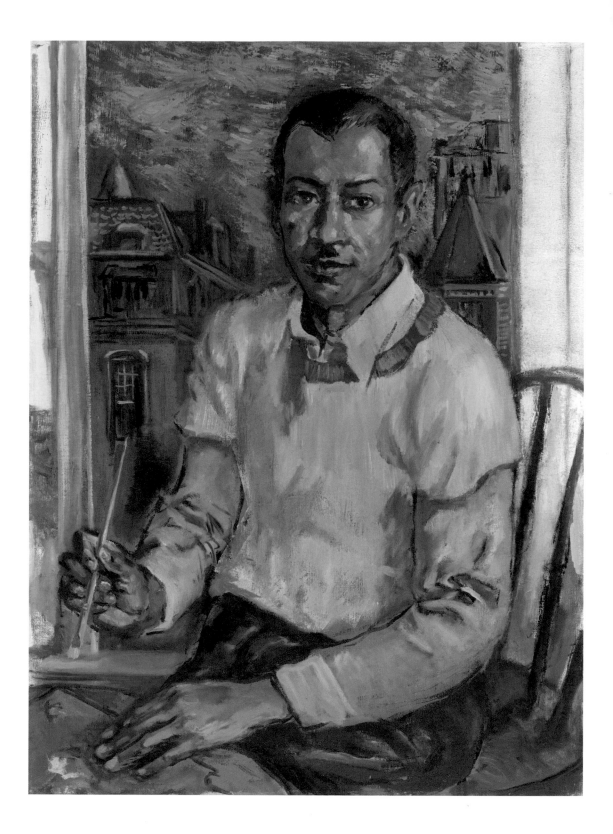

JAMES A. PORTER (1905–1970)

James A. Porter created the foundation for the field of African American art history. After graduating from Howard University in 1927, he spent a decade studying both art and art history in Paris and New York City, and earned an MA from New York University in 1936. He then went on to teach at Howard, where he eventually served as chair of the art department and director of the art gallery.

Porter championed African American artists, including those from the Caribbean. His influential book *Modern Negro Art* (1943) was the first to place the contributions of African American artists in the context of the history of modernism, and Porter's own art was exhibited at major institutions, including the Corcoran Gallery of Art and the Museum of Modern Art. Here, he presents himself in his studio, in front of an image of Howard Hall, one of the oldest buildings on Howard's campus. BF

Self-Portrait, 1957
Oil on canvas
76.4 × 56.2 cm (30 1/16 × 22 1/8 in.)
Gift of Dorothy Porter Wesley (NPG.92.31)

JUNE WAYNE (1918–2011)

June Wayne is best known for founding the Tamarind Lithography Workshop in Los Angeles in 1960, which helped revitalize the medium as an art form in the United States. This self-portrait drawing explores the imagery and techniques of a series of lithographs that she began in 1956, after having been inspired by the ecstatic love poetry of John Donne. Wayne is shown holding the phallic form of a mushroom, a symbol she frequently used as her emblem.

Choosing to use media that are typically reserved for lithographic stones or plates, the artist first applied ink washes and then added small amounts of greasy lithographic tusche and gum arabic. The tusche and gum separated into intricate networks of dots, enveloping Wayne in the same delicately textured, shadowy dreamscape in which she set Donne's lovers to wander. AW

Self-Portrait, 1957
Ink, graphite, colored pencil, and ink wash
with tusche and gum arabic on paper
73.7 × 58.5 cm (29 × 23 1/16 in.)
The Ruth Bowman and Harry Kahn Twentieth-Century
American Self-Portrait Collection (S/NPG.2002.362)

CHARLES HOPKINSON (1869–1962)

When Charles Hopkinson was in his ninetieth year, he created this small portrait, where his eyes are shadowed by his well-worn straw hat. The likeness displays his mastery of controlled composition and dramatic lighting, as well as a lifetime of experience with fluid brushwork and wet-on-wet painting. It was one of over seventy self-portraits by the artist that hung in his studio in Manchester, Massachusetts, at the end of his life.

Hopkinson privileged design over likeness, noting: "My chief theory is that a portrait should exist in the world of art and should not resemble a reflection in a mirror." And yet, he was known as a prolific painter of conservative, realistic-looking portraits. He portrayed hundreds of elite Bostonians and academics from Harvard University, along with President Calvin Coolidge, Abby Aldrich Rockefeller, and other nationally recognized clients. BF

Self-Portrait, c. 1959
Oil on artist board
35.6 × 25.4 cm (14 × 10 in.)
Gift of the artist's daughters (NPG.77.27)

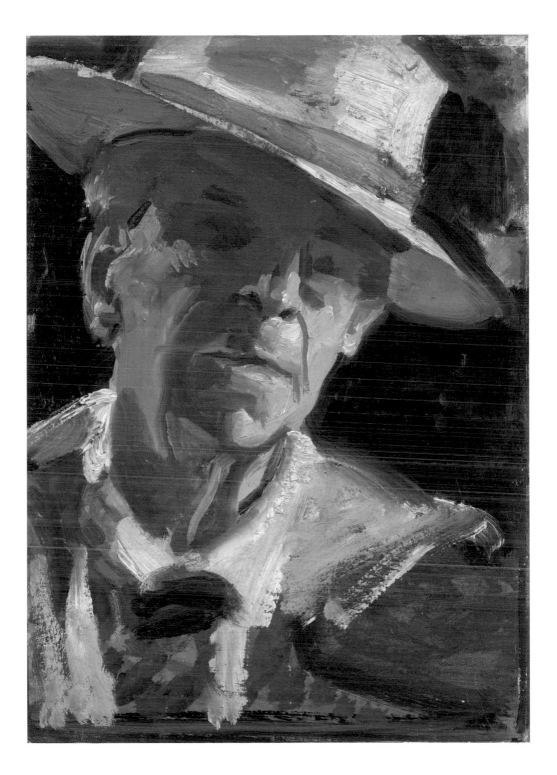

DANNY LYON (born 1942)

In the summer of 1962, Danny Lyon left the University of Chicago, where he was studying history, and hitchhiked south to immerse himself in the civil rights movement. Upon arriving in segregated Albany, Georgia, he became the first photographer for the Student Nonviolent Coordinating Committee (SNCC), which was then led by James Forman.

During his time in the South, Lyon documented SNCC protests and the harrowing conditions of African Americans; many of his images were used for posters and other materials meant to increase public awareness. Several of these documentary photographs are presented in a book, *Memoirs of the Southern Civil Rights Movement* (1990). Lyon notes: "I had the rare privilege to see history firsthand." This casual photograph, taken in Albany the morning after his arrival, shows him in front of the barbershop that served as the local SNCC office. BF

Self-Portrait, 1962
Gelatin silver print
16.1 × 24.1 cm (6 ⁵⁄₁₆ × 9 ½ in.)
(NPG.94.256)

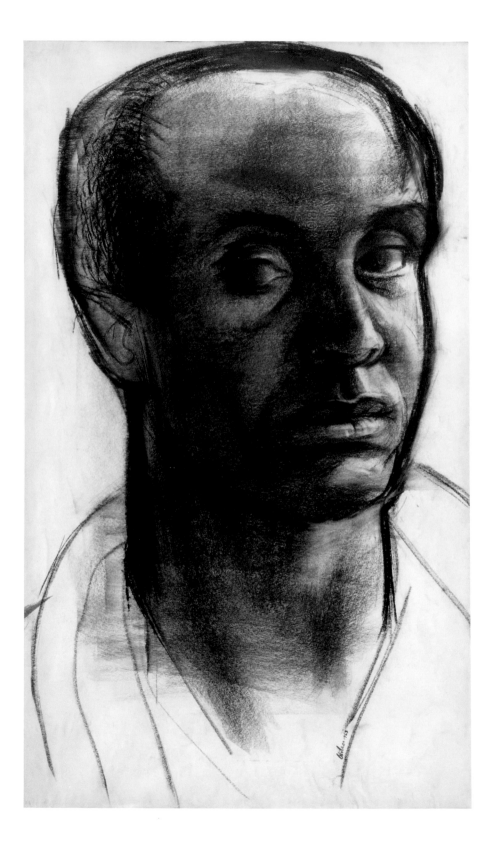

JOHN WILSON (1922–2015)

Racial consciousness, John Wilson admitted, was a key element of his art. "My experience as a black person has given me a special way of looking at the world," he stated, "and a special identity with others who experience injustice." The artist was also attracted to the social consciousness of the Mexican muralists, whose work, he felt, had a "kind of dense power." The boldness and scale of Wilson's self-portraits echo the muralists' heroic portrayals and themes of universal humanity.

After growing up in Boston's Roxbury neighborhood, Wilson lived in Mexico City, Chicago, and New York City. In 1964, he returned to his hometown and taught there for more than two decades. His bold, black pastel of 1963 resonates with the empowerment of the civil rights movement and the consciousness of presenting a black face in white America. He brought these same qualities to the monumental heads sculpted later in his career, including that of Martin Luther King Jr., which is on display at the U.S. Capitol building. WWR

Self-Portrait, 1963
Pastel on paper
60.8 × 35.3 cm (23 15⁄16 × 13 7⁄8 in.)
The Ruth Bowman and Harry Kahn Twentieth-Century
American Self-Portrait Collection (S/NPG.2002.367)

14/200 Jim Dine 1964

JIM DINE (born 1935)

Jim Dine, whose work often depicts objects with which he feels a personal association, adopted the motif of the bathrobe as a self-portrait after spotting one in an advertisement in the *New York Times* in 1964. For Dine, the image was more than just a found object. As he explained, "There was nobody in the bathrobe, but when I saw it, it looked like me." Shortly thereafter, the robe became the basis for an exhibition of paintings at the Sidney Janis Gallery. The robe also served as the motif for the artist's first foray into etching. As though reflecting his pride in his early command of a medium that he would describe as "drawing with acid," the bent elbows of the robe—conveying the invisible gesture of an artist with his hands on his hips—seem to signal youthful satisfaction.

ACG

Bathrobe, 1964
Etching
56.1 × 43 cm (22 ¹⁄₁₆ × 16 ¹⁵⁄₁₆ in.)
The Ruth Bowman and Harry Kahn Twentieth-Century
American Self-Portrait Collection
Conserved with funds from the Smithsonian
Women's Committee (NPG.2002.235)

JACOB LAWRENCE (1917–2000)

In about 1965, when Jacob Lawrence began this self-portrait, he had assumed a visibility beyond anything previously accorded to an African American artist. The 1941 exhibition of his epic series of sixty paintings, originally entitled *The Migration of the Negro*, had firmly established his reputation. Composition, color, and abstract pattern became the root of Lawrence's style as he painted the black experience. The human face and figure, normally subject to entrenched artistic conventions, were to him just shapes to be simplified or distorted.

With the exception of a small group of self-portraits that he made in the 1960s, Lawrence rarely attempted portraiture. In 1996, he updated this drawing of himself, adding bands of black around the face and changing its contours to a single sweeping curve. Transforming a linear drawing into a muscular interplay of black and white, the likeness reflects both the strength and the anxieties of the artist's advancing age. WWR

Self-Portrait, c. 1965/1996
Ink, gouache, and charcoal on paper
48.2 × 30.7 cm (19 × 12 1/16 in.)
(NPG.96.190)

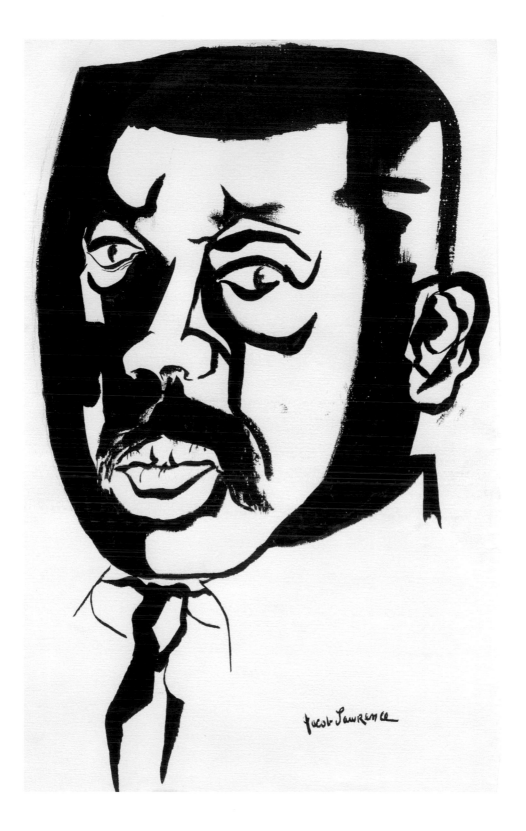

PAUL CADMUS (1904–1999)

Paul Cadmus met his partner, the young dancer Jon Anderson, shortly before he made this self-portrait in April 1965. Cadmus often used Anderson as a model for his nude drawings, but he also posed for himself. "I've done a great many just plain self-portraits," he noted, "being the most easily available model." Although the angled hand, dark-toned paper, and subtle touches of color recall his meticulous nudes, his unrelenting gaze conveys a less admiring appraisal, as if comparing his aging face to his companion's youth.

Critics always admired Cadmus's ability to draw and paint the human form, and he persisted in doing highly finished figurative drawings, even when they became unfashionable at mid-century. For him, a good drawing was "less an act of exploration than a fully resolved work, which, like a poem or musical composition, was worth consideration only in its final, perfected form." WWR

Self-Portrait, 1965
Crayon on paper
41.8 × 39.2 cm (16 7/16 × 15 7/16 in.)
The Ruth Bowman and Harry Kahn Twentieth-Century
American Self-Portrait Collection
Conserved with funds from the Smithsonian
Women's Committee (NPG.2002.219)

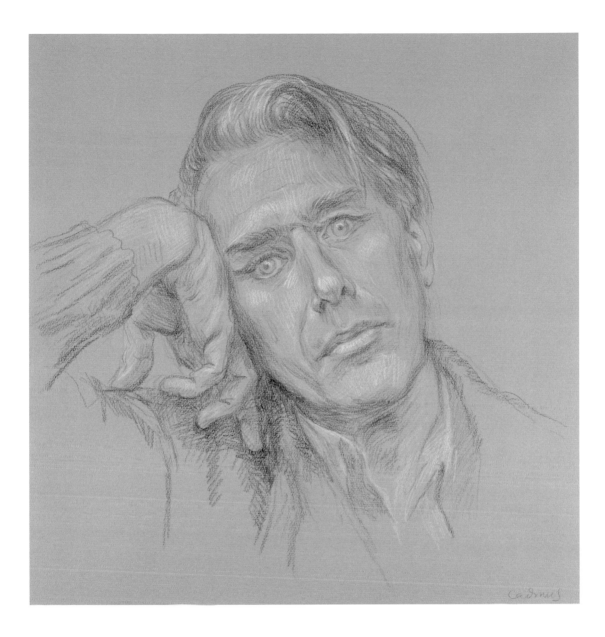

ALLAN KAPROW (1927–2006)

Allan Kaprow began his career as a painter, but by 1958, he had created his first environment, and by drawing his audience into the art experience, launched his first "happening" in 1959. Called *18 Happenings in 6 Parts*, it was a series of performances with strictly controlled instructions for participants and scripted sound. This bold, primary-colored self-portrait and its pendant, capture the lively sights and sounds of two of Kaprow's performances in the early '60s. They feature Kaprow quoting instructions from the well-known happenings, and offer unique insight into the artist's creative process. The self-portrait, *Tree*, narrates the random, vibrant movements and environment of the performance by the same name from 1963, which was originally performed at a farm as a kind of war game. It involved announcements from a director on a loudspeaker, large haystacks, and performers acting as forest people or trees. Accompanying music revealed the influence of John Cage. AN

Tree, 1966
Lithograph
76.2 × 56.5 cm (30 × 22 ¼ in.)
(NPG.2015.94)

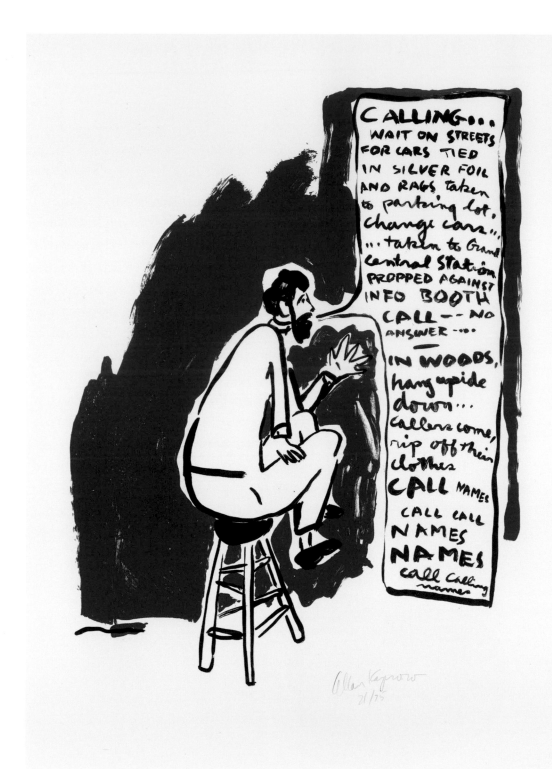

ALLAN KAPROW (1927–2006)

Kaprow's self-portrait, *Calling*, is a verbalization of key aspects of another of his happenings, a performance of the same name from 1965, which involved people in the guise of pedestrians and drivers in New York. The drivers picked up individuals who were then wrapped in aluminum foil or muslin cloth, driven to the railroad station, and carried inside the building. Then the human packages unwrapped themselves and called the drivers from a public phone booth. The next day involved hanging drivers from ropes in the woods while the packaged people searched for them, calling their names. Kaprow's self-portrait serves as visual description, complete with vibrant color and strong graphics, of his bizarre creation. The repetition at the end, "CALL NAMES CALL CALL NAMES NAMES Call calling names…," references the concept and the sounds enacted through the performance.

AN

Calling, 1966
Lithograph
76.2 × 56.5 cm (30 × 22 ¼ in.)
(NPG.2015.93)

HANS NAMUTH (1915–1990)

Hans Namuth, a native of Essen, Germany, worked as a photographer in Europe in the 1930s, but in 1941, during World War II, he immigrated to the United States, joined the army, and focused his efforts on defeating the Nazis. After the war, Namuth wanted to return to photography, and—with assistance from Alexey Brodovitch of *Harper's Bazaar*—he did. Brodovitch taught Namuth, introduced him to his contacts, and eventually gave him work at the magazine.

Namuth's most iconic photographs are those of Jackson Pollock, the Abstract Expressionist painter, who created his drip paintings on his studio floor. Namuth photographed Pollock in action in 1950, and the images were published in *Portfolio* the following year. He subsequently photographed other artists in their studios, notably Willem de Kooning, Lee Krasner, and Mark Rothko, as well as architects and others in the worlds of music and literature. Here, at the height of his productivity, Namuth depicts himself casually, in a close-up that shows him standing behind a camera on a tripod, with one eye focused on his subject and the other lost in a shadow.

BF

Self-Portrait, 1966
Gelatin silver print
24.7 × 25.6 cm (9 ¾ × 10 ¹⁄₁₆ in.)
Gift of the Estate of Hans Namuth (NPG.95.150)

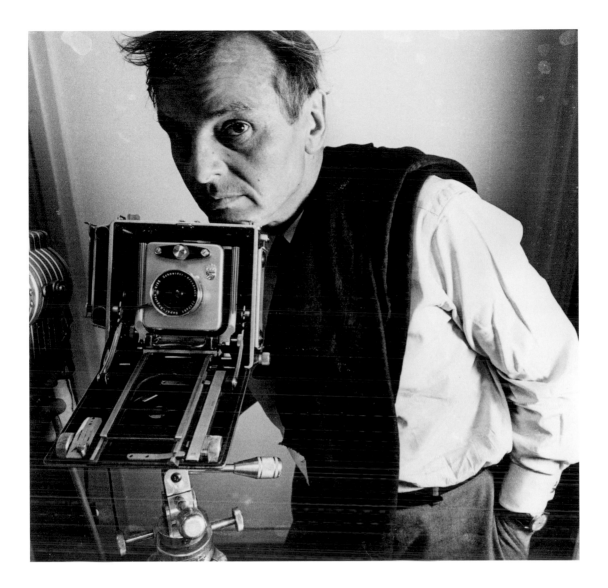

ANDY WARHOL (1928–1987)

Created for Andy Warhol's 1966 exhibition at Leo Castelli Gallery, where he spoke of his (supposed) retirement from painting, this self-portrait—an offset lithograph based on a photograph by an unknown maker—pictures the artist with his face deeply in shadow. The print's mechanical appearance and manufacture further disguise evidence of the artist. Warhol has even relegated his signature to the back of the work, rendering it invisible to most viewers.

Implicit in the metallic silver background, which recalls Warhol's famous pronouncement, "I want to be a machine," are references to his studio, known as the Factory; the cinema, appropriate given Warhol's experimentation with filmmaking; and religious icons, as Warhol had recently been dubbed "Saint Andrew" in the press. ACG

Self-Portrait, 1966
Lithograph on silver-coated poster board
58 × 57.7 cm (22 13/$_{16}$ × 22 11/$_{16}$ in.)
The Ruth Bowman and Harry Kahn Twentieth-Century
American Self-Portrait Collection (NPG.2002.357)

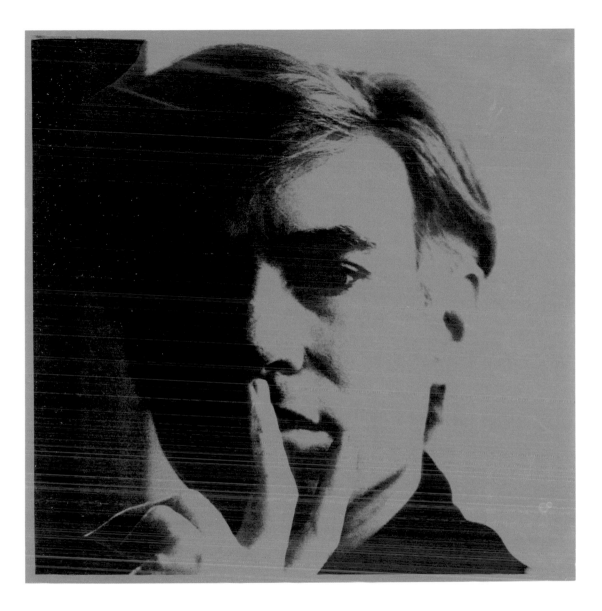

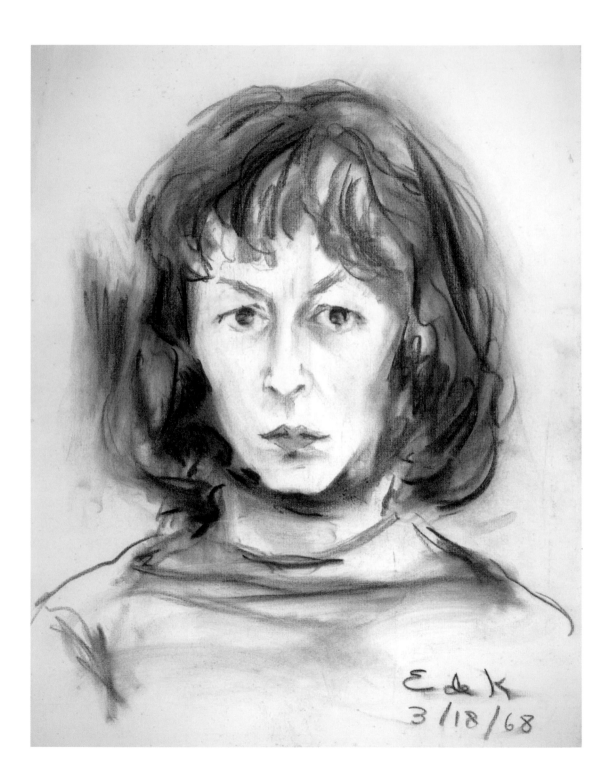

ELAINE DE KOONING (1918–1989)

Elaine de Kooning was best known for her expressive, gestural portraits and for her ability to capture the individuality of her subject's entire body. For her, "the pose *is* the person." She often did multiple drawings in graphite or charcoal while creating paintings of the same subject.

Here, in a drawing inscribed with the date, March 18, 1968 (just six days after her fiftieth birthday), de Kooning created a severe and introspective portrait of herself in charcoal. Although she delineated the slight effects of age, her features and hair approximate her appearance as captured in painted self-portraits from more than twenty years before. At this time she was separated from her husband, Willem de Kooning, and purchased a small house in Springs, East Hampton. It was close to her friends Ibram and Ernestine Lassaw, and near Willem's home and studio. She may have been taking stock of her life and charting a new course. BF

Self-Portrait, 1968
Charcoal on paper
60.2 × 46 cm (23 ¹¹⁄₁₆ × 18 ⅛ in.)
The Ruth Bowman and Harry Kahn Twentieth-Century
American Self-Portrait Collection
Conserved with funds from the Smithsonian Women's
Committee (NPG.2002.285)

ROBERT RAUSCHENBERG
(1925–2008)

Autobiography, a large-scale, multimedia work featuring both text and images, demonstrates the extraordinary ambition and innovation of its subject, Robert Rauschenberg. In 1964, the artist became the first American to win the international painting prize at the Venice Biennale, and four years later, he created this three-part portrait.

Rauschenberg appears in each of the panels: at top through an X-ray, in the center as a child in a boat with his parents, and at bottom, in a still photograph of his performance piece *Pelican*. In addition to photographic imagery, Rauschenberg has layered other signifiers of his identity into the work. The first panel includes an astrological chart (Libra), and the middle panel contains a narrative of his life and career. Meanwhile, the oil tanks in the third panel reference his hometown (Port Arthur, Texas) and the New York City skyline signifies his later residence in Manhattan. ACG

Autobiography, 1968
Lithograph
Three parts: 168.2 × 123.8 cm (66 ¼ × 48 ¾ in.);
168 × 123.8 cm (66 ⅛ × 48 ¾ in.);
168.1 × 123.8 cm (66 ³⁄₁₆ × 48 ¾ in.)
The Ruth Bowman and Harry Kahn Twentieth-Century
American Self-Portrait Collection (NPG.2002.313)

VITABLE FUSING OF SPECIALIZATIONS CREATING A RESPONSIBLE MAN WORKING IN THE PRESENT. "LINOLEUM" SIMONE WHITMAN. DEBORAH HAY, STEVE PAXTON, ALEX HAY. SHOW. 3 CONCERTS FOR L.A. COUNTY MUSEUM OF ART. THEATER PIECE FOR WASHINGTON, D.C. "NOW FESTIVAL." ROBERT MORRIS, THE ONCE GROUP, CLAES OLDENBURG, BROWN, TRISHA BROWN, JIM DINE, JUDITH DUNN, DAVID GORDON, ALEX HAY, KOBE OSAKA, END OF TOUR I STOPPED IN HAWAII, VIENNA, MANNHEIM, ESSEN, COLOGNE, LES BAUX, DANTE ILLUSTRATIONS, STEVE PAXTON, ALEX HAY, CHRISTOPHER S & DEBORAH HAY, STEVE PAXTON. ME. ROUND SUN. HEDGE. LOCK. TRAP. WHITECHAPEL SHOW. FIRST GOT IN NEW WING. ABRAMS PUBLISHE. RETROSPECTIVE: LONDON, DARTINGTON, YVONNE, S, BOURGES, VENICE (WHILE WE WERE THERE I WON THE 1ST PRIZE AT THE VENICE BIENNALE) SURVEY SHOW. WORKSHOP EXPERIMENTAL DIR. BECKE ATTANASIO ETTA. BRIAN ROBERTSON, LONDON, LYONS. WHALE, PRESS, VENICE. ALICE DENNEY. PROG. CHEEK. JEWISH MUSEUM. COMPREHENSIVE. WORKED WITH JUDSON GROUP. THEATRE/DANCE. BEGAN, SILK SCREEN PAINTINGS TERRAIN. ALAN SOLOMON, DIR. STOCKHOLM, CYRUS CHILDS, NIGHT WANDERING. MOVIE. T.V. SOURCE, HARBOR, QUOTE. TREE. FROG. UNIVERSAL SURVEY SHOW. BEGAN SIRIUS EXCHANGE. SIRIUS PAINTINGS JUMP. BLUE EAGLE. WITH ME & THE CHALLER. MELINE, STAR GRASS, STOP GAP. TRELLIS. DRY CELL. WOODEN GALLOP. ACE, EYE STREPPER, CARTOON, TROPHY V. CAROLYN BROWN, NYC. STARRING ABOUT SCENE. PAINTINGS ORBIT. MR. & MRS. III, BLACK MARKET. STOC. DAM, SANDBURG, DIR. OF STEZELLIK. MET MARCEL DUCHAMP & DAVID TUDOR. TIME PAINTINGS, FIRST LANDING JUMP, ART EDITION. INCLUDE OBJECTS & COLLAGE, FRANK STELLA, BILL. NIKI DE ST. PHALLE. JASPER JOHNS. JEAN TINGUELY & ME. DIE. BY MERCE CUNNINGHAM, DANCES, NOCTURNES, SPRING WEATHER & PEOPLE. TEREAN. ELEMENT IN MY LIFE WORKED POSITIVELY WITH WINTERMANN. TIME AND LONELINESS OF PAINTING. STEVE PAXTON PAINTING ORBIT. MR. & MRS. III, BLACK MARKET. SETON. O. SUMMERSPACE. CRISES ANTIC MEET. HIS PROPAGAN. WORK AT THAT TIME WITHOUT ME. YVONNE RAINER, JILL JOHNSON, ALEX HAY, O'YUNG BI, NIO AND I POLKED FUNDS. MADE JOHN CAGE 20. RETROSPECTIVE. ITS IDENTITY. PAINTINGS AND PERSPECTIVE FOR ME & PEOPLE. WAYARD STEVE PAXTON. JUDITH DUNN. FIRST FLAG. IT WOULD BE DIFFICULT TO IMAGINE THE DECORIRIVE LIGHTS AND ESCAPE OBJECTS TO ESCAPE PAINTING. MONOGRAM. 1ST PRIZE L. ISON, O' COLOR INSISTING THE OBJECT TO IMAGINE ART CONCRETE. WYARD TURO. ART. CARTOON. INSPIRED ME TO THE CHALLER. MUSICIANS. FEW FALSE PAINTINGS. STREPS AS COLOR. CAME OUT A CHEL E. COMPLEXION. WYARD. INCLUDE RETROSP, JEWING SHOW. DRAWING RECEIVE DRAWINGS. TERRAIN. — 1ST PRIZE PAINT, ITIC IN FLORENCE. FEW FALSE. JOHN STEVE PAXTON. ART. AL KAPLAN. DRAWINGS. ALL STEVE RAN OUT OF COMPREHENSIVE. SIN-OF-MUSIC. NYC 1952 NO SETON PHOTOGRAPH WITH RING OUT OF ANGEL, WYARD, OR COPLEY. MUSE. LINOLEUM TELEVIZED FOR O.K. TO NYC USING SUPERIMPOSIT. KA RICH ANGEL OR NUMBER. GROUP LINOLEUM BY STEVE PAXTON DWAH GALLERY LOS ANGELES. T.V. NAV.

DAVID ALFARO SIQUEIROS
(1896–1974)

Along with Diego Rivera and José Clemente Orozco, David Siqueiros was a leader in the Mexican mural movement from the 1920s until the 1940s, a period during which the artists painted large-scale social-realist scenes in public spaces. Through his work, he communicated his radical Marxist beliefs, his interest in the history of his native country, and his commitment to social justice. Siqueiros completed several mural projects in Mexico, and by 1950, when he won second prize for his art at the Venice Biennale, he had gained international acclaim.

This colorful, painterly portrait was part of a set of ten lithographs published in 1969 when Siqueiros was involved with *The March of Humanity*, a massive mural project. Referred to as the artist's "Mountain Suite," the series also includes images of dramatic landscapes and figures, done in a similar manner as this portrait, with sharp, expressive lines and heightened contrast. BF

Self-Portrait, 1969
Lithograph
57.8 × 50 cm (22 ¾ × 19 11/16 in.)
The Ruth Bowman and Harry Kahn Twentieth-Century
American Self-Portrait Collection (S/NPG.2002.331)

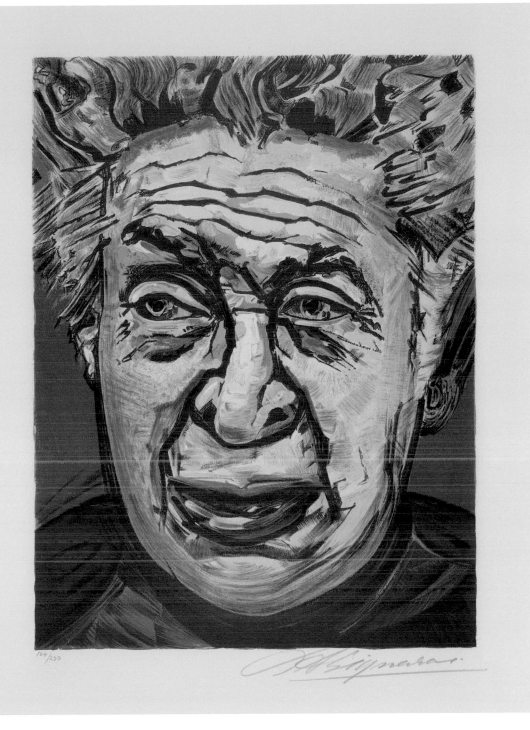

164/250

JASPER JOHNS (born 1930)

Jasper Johns helped pave the way for Pop, Minimal, and Conceptual art with his focus on the depiction of "real objects" and on the intellectual and physical construction of art. As though reflecting back on related works, he playfully applied the theme of "souvenir"—with its connotation of artifacts and memory—to a self-portrait lithograph that was made for his first print retrospective in 1970. Appropriately for this occasion, the beams of a flashlight bounce off of a rear-view mirror to illuminate the artist's likeness at lower left. Its circular format, in turn, refers to a "souvenir" of another sort: tourist plates Johns encountered in Japan. Recognizing the transformative impact of medium and context, Johns has explained: "I am concerned with a thing's not being what it was, with its becoming something other than what it is." ACG

Souvenir, 1970
Lithograph
78.1 × 56.8 cm (30 ¾ × 22 ⅜ in.)
(NPG.2002.383)

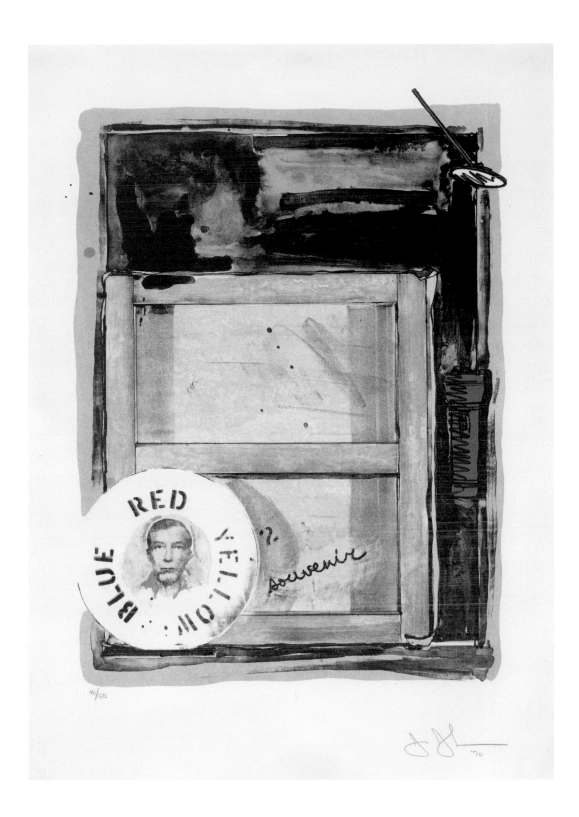

RED
YELLOW
BLUE

"Souvenir"

40/50

BEAUMONT NEWHALL (1908–1993)

In 1937, Beaumont Newhall, then a young librarian at the Museum of Modern Art (MoMA), presented the exhibition *Photography: 1839–1937* to commemorate the first century of the medium. This began his long, distinguished career as a pioneering historian and curator. Newhall was close to many great photographers of his time and promoted the 35mm camera for works of art as well as reportage. He also made photographs himself.

He made this self-portrait in 1970, the year he organized *Photo Eye of the 20s* for MoMA and the George Eastman House, where he then served as director. In a show that explored "the camera as a precise image maker" and "photography as a plastic medium," he chose to hang the photographs so that passersby could see them from the streets. As he wrote, "the unexpected, inexplicable counterplay of reflected and direct images within and without is a montage, expressing the spirit of the exhibition." BF

Self-Portrait, 1970
Gelatin silver print
21.3 × 32.9 cm (8 ⅜ × 12 ¹⁵⁄₁₆ in.)
(NPG.93.16)

Self portrait at The Museum of Modern Art. New York 11/1970 Beaumont Newhall

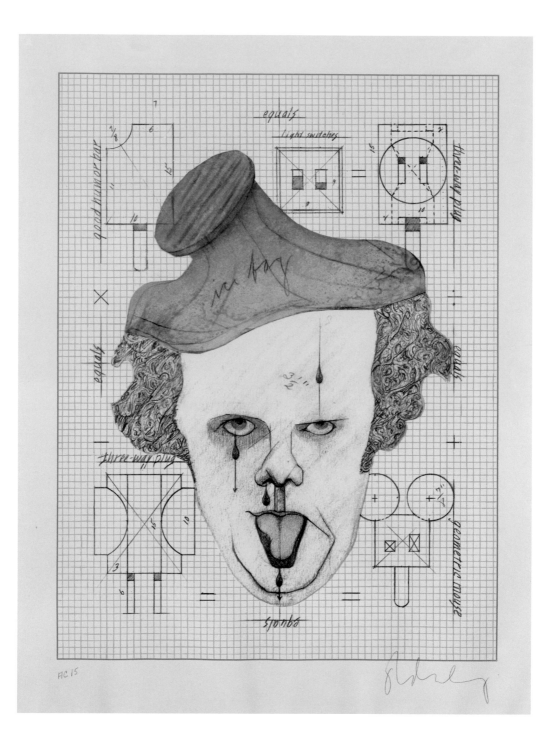

CLAES OLDENBURG (born 1929)

This self-portrait, a print based on a 1969 collage, contains biographical references to several of Claes Oldenburg's large-scale sculptural works of everyday objects. Drawings of light switches, three-way plugs, a Good Humor ice-cream bar, and the Pop artist's famous "geometric mouse" frame his head, which is then capped with a melting ice bag that alludes to another one of Oldenburg's signature sculptures. Ornately drawn black hair escapes the artist's "beret," but is contained by the precise measurements of the graph paper.

The artist explained his self-portrait at the time, noting that his face is visually divided by his prominent tongue into his two temperaments—brutal and kind. He recalled thinking of both a clown, specifically the Joker from the Batman comics, and his role as a magician who "brings dead things to life." PQ

Symbolic Self-Portrait with "Equals," 1971
Lithograph
72.1 × 52.9 cm (28 ⅜ × 20 ¹³⁄₁₆ in.)
(NPG.94.63)

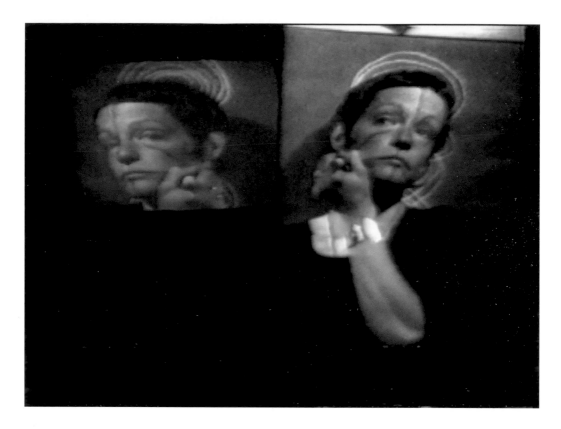
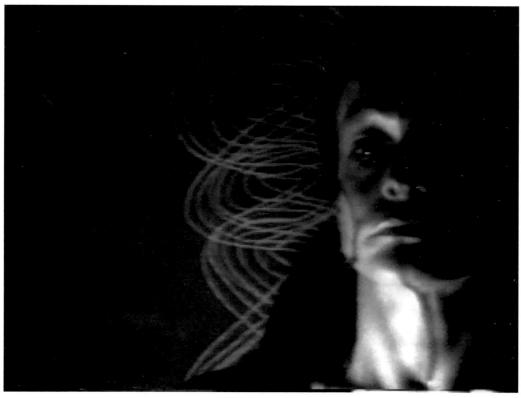

JOAN JONAS (born 1936)

Joan Jonas has been working within the conceptual and video art movements in New York City since their emergence in the 1970s, yet she did not have her first partial retrospective until 2003. The attention Jonas has received thereafter, culminating in the retrospective mounted by Tate Modern in 2018, represents the acknowledgment of her pioneering use of performance and film.

In *Left Side Right Side*, Jonas stands in front of the camera, accompanied by her own image displayed on a monitor, at times holding up a mirror to bifurcate her face. She then attempts, and sometimes fails, to identify correctly the side of her face to which she is pointing, adding her own voice to the work. The confusion and difficulty Jonas experiences in performing this exercise illustrate the distortion inherent in film. By simultaneously presenting multiple iterations of her face, she destabilizes notions of an authentic self and the assumed verisimilitude of film. AN

Left Side Right Side, 1972
Black-and-white video, with sound
8 minutes, 50 seconds
Acquired in 2018

MARTIN WONG (1946–1999)

An influential and openly gay artist during the AIDS era, Martin Wong worked in both San Francisco and New York City. He employed various mediums and styles and was an avid collector of found objects from popular and street culture, which he incorporated into his formal works. Wong frequently collaborated with Miguel Piñero, a poet and one of the leading voices of the Nuyorican movement, which promoted Puerto Rican culture in New York City.

Shortly after finishing college in California in 1968, Wong made sketches and portraits to earn income, calling himself the "Human Instamatic," a sly reference to the popular, easy-to-use cameras of the day. This drawing from that period is remarkable, not only for its fine draftsmanship but also for its ability to telegraph the bohemian, louche era—a time when AIDS cut short the lives of so many individuals, including that of Wong. AN

MW His Self, Nov 30, 72, 1972
Graphite on paper
35.2 × 27.3 cm (13 ⅞ × 10 ¾ in.)
Gift of the Abraham and Virginia Weiss Charitable Trust,
Amy and Marc Meadows, in honor of Wendy Wick Reaves
(NPG.2016.57)

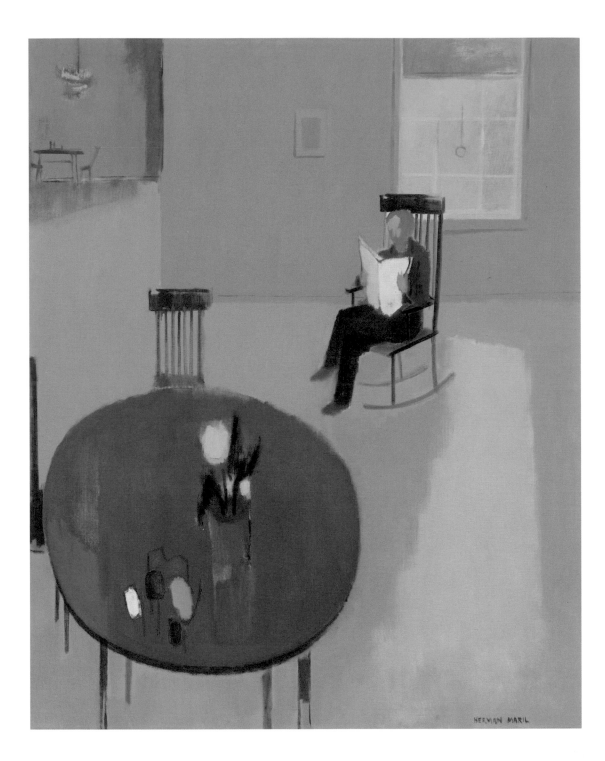

HERMAN MARIL (1908–1986)

The Morning Paper, a self-portrait, is representative of
Herman Maril's quiet interiors and landscapes in which the
artist's fascination with the articulation of space through
color is evident. In this charming composition, Maril rep-
resents himself seated in a rocking chair without articulated
facial features. Meanwhile, the still life on the red table in the
foreground pops against the expanse of gray that unifies the
three-part composition, dominating the canvas and suggest-
ing that the act of painting is the subject. Maril describes his
art, which merges figuration and abstraction, as an explora-
tion of space and color: "My preoccupation in painting has
always been space. . . I like to deal with big open spaces. And
color. Color and space is painting." DM

The Morning Paper, 1973
Oil on canvas
121.9 × 99.1 cm (48 × 39 in.)
Gift from the Herman Maril Foundation (S/NPG.2015.45)

JUNE WAYNE (1918–2011)

The Tamarind Workshop, which June Wayne founded to strengthen the practice of lithography, was taken over by the University of New Mexico and renamed the Tamarind Institute in 1970. After the transition, Wayne, who had inspired artists as varied as Philip Guston and David Hockney to work with the medium, began to create more of her own prints. She was particularly inspired by genetics, physics, magnetic fields, and other scientific topics, but also created compositions that focused on her family.

In 1973, Wayne made this mesmerizing self-portrait in four states. She used subtle positive and negative printing techniques and varied the opacity of the black ink to achieve a startling effect. This lithograph, the fourth state, is printed on Japon nacre paper. The ink is black, mixed in different combinations with a transparent medium, so that the image emerges from the dark background, with the white areas crisply defining her eyes. BF

Déjà Vu, 1973
Lithograph
58.2 × 46.3 cm (22 ¹⁵⁄₁₆ × 18 ¼ in.)
The Ruth Bowman and Harry Kahn Twentieth-Century
American Self-Portrait Collection (S/NPG.2002.360)

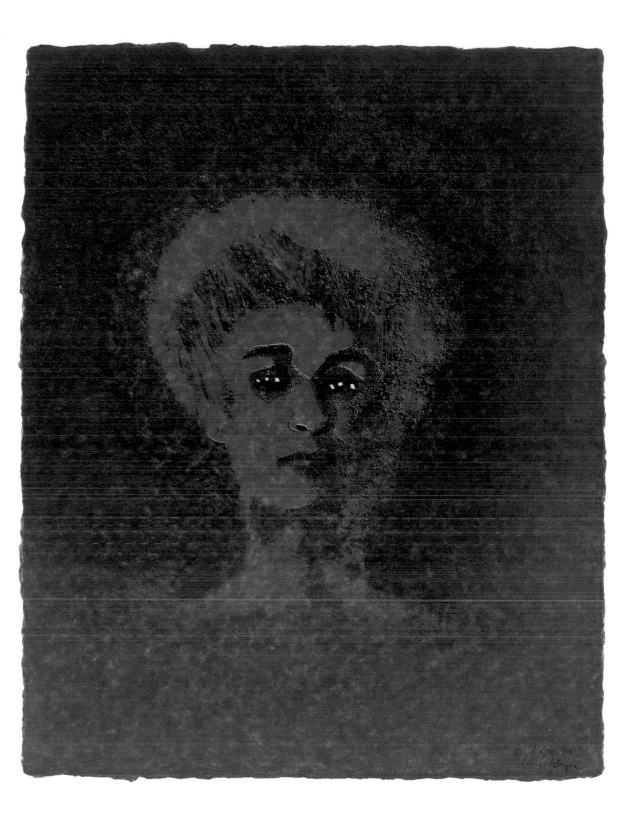

JACK BEAL (1931–2013)

When Jack Beal won a commission to paint murals for the U.S. Department of Labor in 1974, he built a new studio whose skylights appear in the background of this lithograph. Beal, one of the few realist artists of his era to paint from life rather than from photographs, thoughtfully reinterpreted what he saw in the mirror. Here, he shaped the fall of the light so that his visor's shadow would cut his face diagonally in half and leave his eyes intriguingly obscured.

Beal chose to show himself in a long-sleeved plaid shirt whose grid of lines let him model the fabric's surface while compositionally balancing the diagonals of the skylights. As in all his realist art, he marshaled every element in the image to communicate his own ideas. Beal asks us to imagine that the realm inside the image is, as he once put it, "a world that is as real as this world." AW

Self-Portrait, 1974
Lithograph
76.5 × 56.8 cm (30 ⅛ × 22 ⅜ in.)
The Ruth Bowman and Harry Kahn Twentieth-Century
American Self-Portrait Collection (NPG.2002.198)

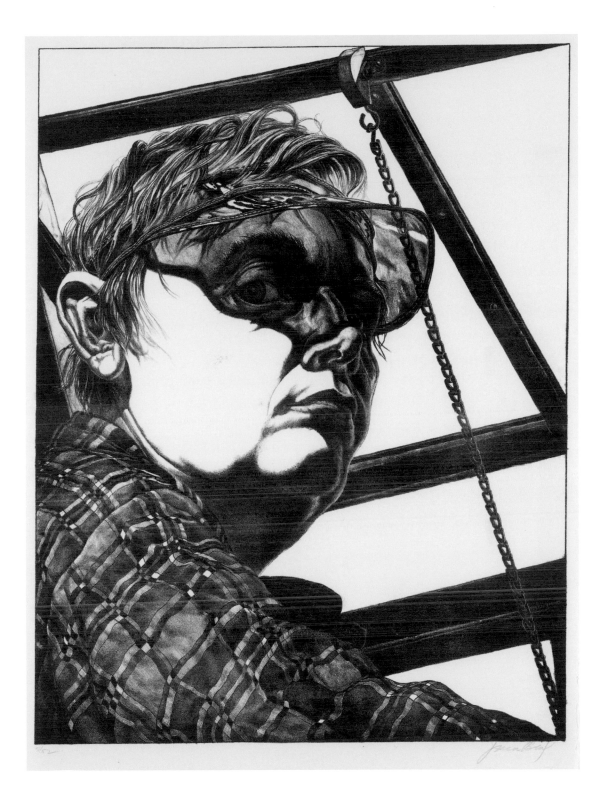

WILLIAM GEORGE BECKMAN
(born 1942)

"I am not a traditional portrait painter," William Beckman insists. "I am not interested in likeness. I am more interested in what feels right to me." The meticulous care evident in his self-portrait may seem startling in light of this pronouncement. But there is no inconsistency. Beckman does not use portraiture to flatter but instead turns an exacting eye upon himself. The result projects far more than mere physical appearance, with its palpable tension between distance and intimacy. Although the artist bares his chest and allows the waist of his jeans to droop, his intense expression and crossed arms offer no warmth. "I love being all alone," he explains. "My way of being with someone I like is by painting that person. It gives me company." In similar form, the artist's likeness renders him present in absentia, enabling Beckman to engage through his withdrawal. ACG

Study for a Self-Portrait, 1974
Graphite on paper
57.2 × 40.9 cm (22 ½ × 16 ⅛ in.)
The Ruth Bowman and Harry Kahn Twentieth-Century
American Self-Portrait Collection (S/NPG.2002.201)

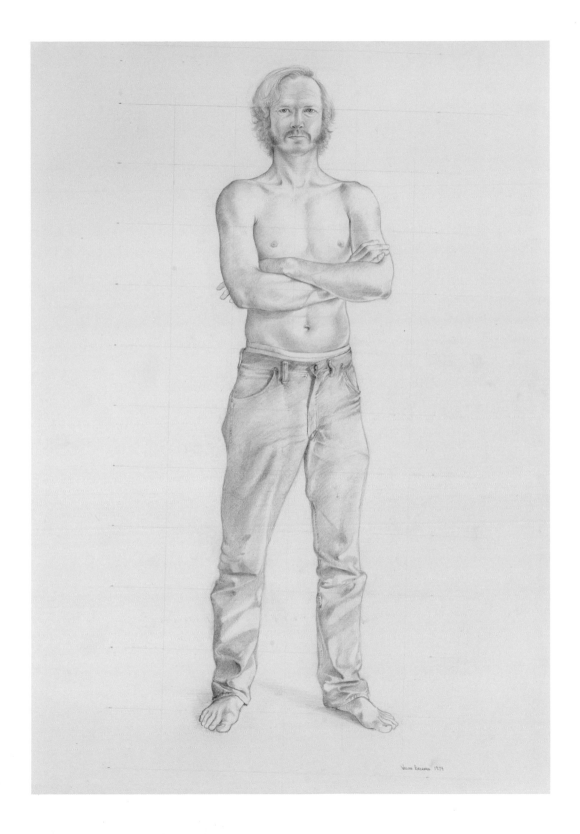

ANA MENDIETA (1948–1985)

By the early 1970s, Ana Mendieta had become a driving force in postwar American art. She helped shape the era's multimedia tendencies by interweaving earth-body art, sculpture, performance, and video while relying on her feminist practice. Mendieta and her peers denounced the art establishment for favoring white male artists, and they resolved to ditch the art market in an effort to restore the symbolic value of art.

A self-portrait, *Mirage* exposes Mendieta's naked body in nature through a mirror reflection. She holds a gourd and stabs it open to let the fruit's seeds fly away. Mendieta arrived in the United States at age twelve under the program Operation Peter Pan, which in the aftermath of the Cuban Revolution placed Cuban children in American foster homes. Through her art, she aimed to re-establish a bond with Mother Nature, from whose womb she had been cast when she was forced into exile. TC

Mirage, 1974
Single-channel projection (original: Super 8 film)
Color, silent
3 minutes, 58 seconds
Acquisition made possible through the Smithsonian Latino
Initiatives Pool, administered by the Smithsonian Latino Center
(NPG.2016.101)

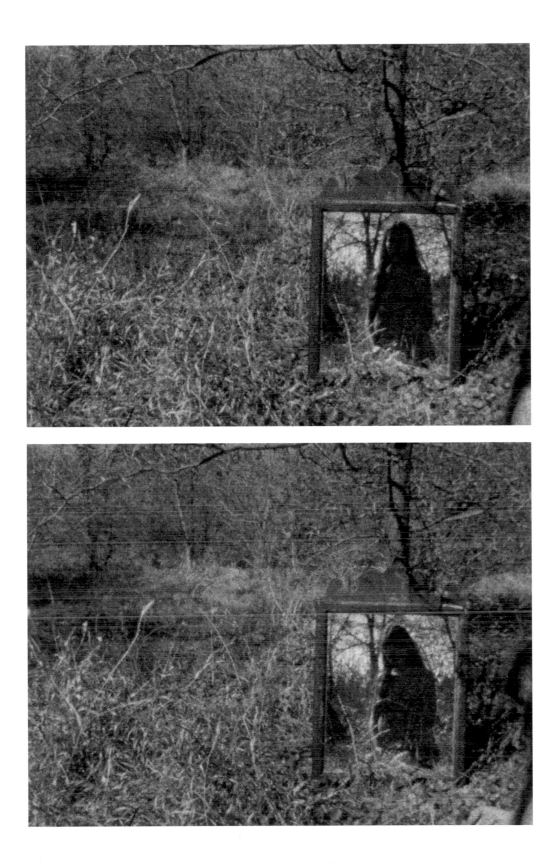

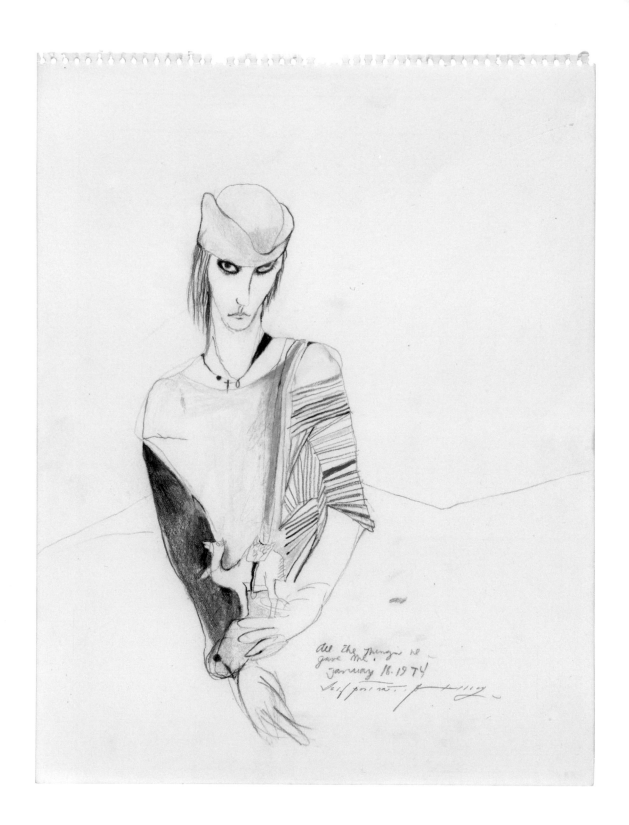

All the things he
gave me.
January 18, 1974
Self portrait, [signature]

PATTI SMITH (born 1946)

Musician, writer, and artist Patti Smith is known for her paradigm-shifting creativity. Fleeing suburban life for New York City in 1967, Smith wrote poetry and dabbled in photography and drawing before releasing her cutting-edge debut album *Horses* (1975), which fused her love of poetry with songwriting. Smith later memorialized this period of her life in the memoir *Just Kids*, which won the National Book Award in 2010.

In this raw, edgy self-portrait drawn in 1974, Smith depicts herself in a colorful top, staring out at the viewer with a punk-rock attitude. The inscription reads: "All the things he gave me," referring to her relationship in the early 1970s with Blue Öyster Cult band member Allen Lanier. Smith describes the work with her characteristic emphatic prose and sensitivity: "The felt Berber hat. A tiny platinum teardrop necklace. An ivory camel. ... Though a mere sketch it was done with great care in recognition to the giver." AN

Self-Portrait, 1974
Graphite and colored pencil on paper
32.1 × 24.5 cm (12 ⅝ × 9 ⅝ in.)
Funded by the Abraham and Virginia Weiss Charitable Trust, Amy and Marc Meadows, in honor of Wendy Wick Reaves (NPG.2015.17)

ROBERT ARNESON (1930–1992)

With its title referring to Robert Arneson's West Coast roots, *California Brick* expresses a poignant tension. The broken brick reflects the impact of apocalyptic force, while the fissure dividing the brick may refer to the fault lines of Southern California. Playfully irreverent, Arneson understood the freedom that comes from the breakdown of materials and their transformation into something else. But in addition to the liberation that such accidents produce, the work may also address darker concerns. In February 1975, after suddenly hemorrhaging, Arneson was diagnosed with bladder cancer, which plagued him for the remainder of his life. Yet despite his illness, Arneson retained his humor, remarking, "I like to do portraits if they project an attitude." Defiant in its posture, this self-portrait, like his accompanying *Brick*, launches a persistent challenge to the assaults of nature and the force of convention. ACG

California Brick, 1975
Etching
40.7 × 42 cm (16 × 16 ⁹/₁₆ in.)
The Ruth Bowman and Harry Kahn Twentieth-Century
American Self-Portrait Collection (NPG.2002.190)

"CALIFORNIA BRICK" Annssson '75

ROBERT ARNESON (1930–1992)

Well known for his ceramic sculptures and his numerous self-portraits, Robert Arneson tests the boundaries of self-representation—and even those of art itself—with this symbolic self-portrait. Despite its appearance, the object is not building material, but rather was cast by Arneson. *Brick's* physical association with the artist is a key component of its function as a self-portrait. Evidence of his hand is visible in both his name stamped on top and in the signature inscribed on the side. ACG

Brick, 1975
Terracotta
7 × 22 × 10.8 cm (2 ¾ × 8 ¹¹⁄₁₆ × 4 ¼ in.)
The Ruth Bowman and Harry Kahn Twentieth-Century
American Self-Portrait Collection (NPG.2002.191)

LARRY RIVERS (1923–2002)

One of the directors of Olympia Galleries in Philadelphia repurposed this small self-portrait by Larry Rivers and sent it as a postcard to the art critic Harold Rosenberg and his wife. At the time, the Rosenbergs were lending a collage by Rivers to an upcoming show at the gallery.

While Rivers frequently incorporated scribbles, stamps, and advertising logos in his work, the postage and writings on this drawing were added by others. Often described as an innovator, Rivers was considered a bridge between the Abstract Expressionist and Pop art movements. He was committed to figurative art and incorporated it into his work across artistic media. In this drawing, Rivers captures himself staring directly at us. He chose to detail only one of his eyes, as he often did, and used fast, yet precise, pencil strokes to create movement and evoke his wild nature. PQ

Self-Portrait, 1975
Graphite on paper, with ink
21 × 13.2 cm (8 ¼ × 5 ³⁄₁₆ in.)
(NPG.2000.100)

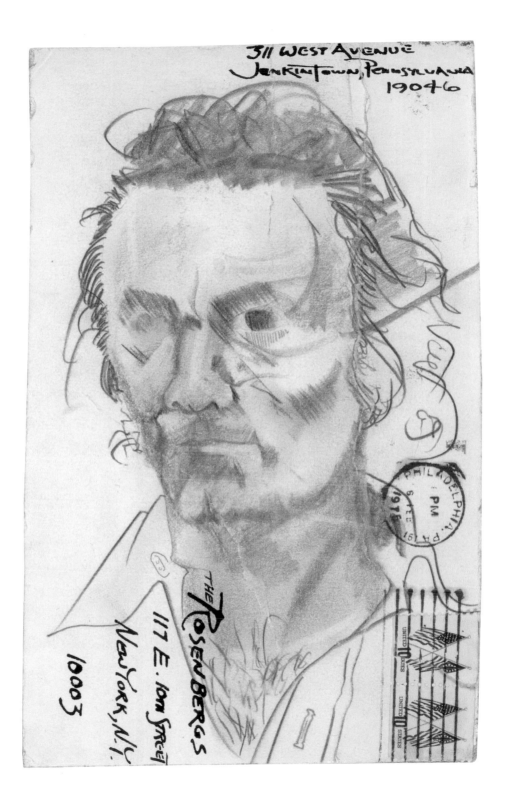

DON BACHARDY (born 1934)

Keeping alive the tradition of figuration, even in the midst of the vogue for abstraction, California artist Don Bachardy mastered a particular form of portrayal few can imitate: the large-scale, closely observed life portrait drawn with graphite lines or light ink and graphite washes. Bachardy relishes the intense, sometimes uncomfortable, collaboration that results from prolonged staring at a subject and considers each sitting a portrait in time, recording the mood of the moment. While he does not have that interaction in his self-portraits, he does apply the same standard of intense observation to his own features.

Here, Bachardy combines the softly applied wash of hair and torso with the sharp contour and meticulous shading of the facial profile. Even in his self-portraits, he "seems to leap at his subject," as one critic wrote, and wrings "every nuance of feature and gesture with swift discerning eye." WWR

Self-Portrait, 1976
Graphite and graphite wash with charcoal on paper
61 × 48 cm (24 × 18 ⅞ in.)
Gift of Don Bachardy and Craig Krull Gallery,
Santa Monica, California (NPG.2013.122)

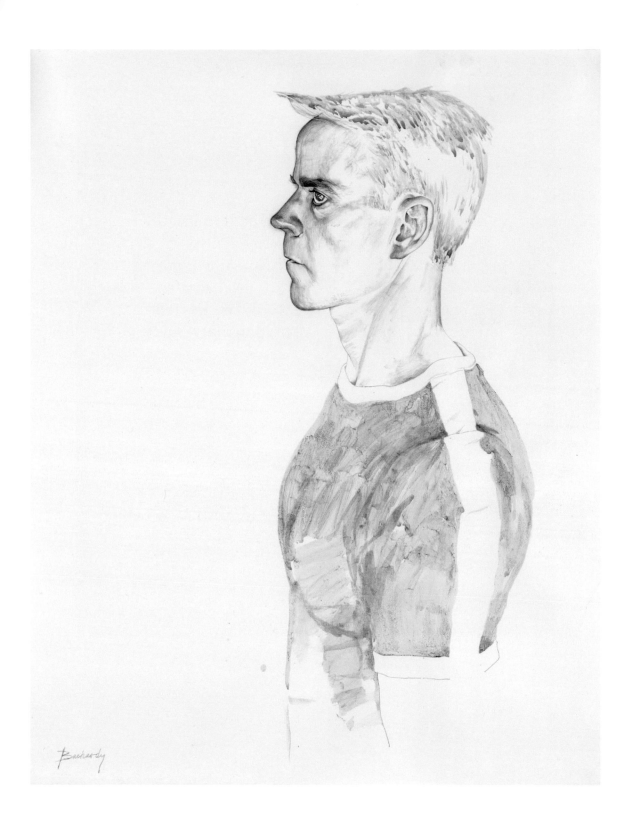

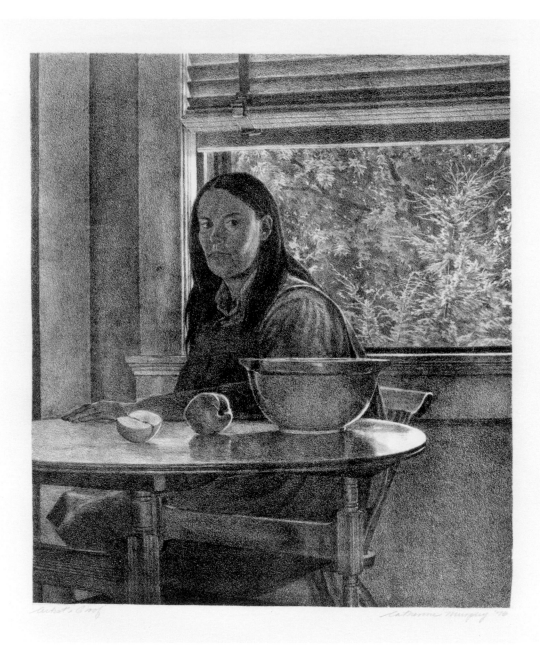

 Catherine Murphy '76

CATHERINE MURPHY (born 1946)

For decades, Catherine Murphy has been making paintings, drawings, and prints that engage rigorously with common-place subjects through intense observation. A realist painter based in New England and New York City, she has tackled landscapes, still lifes, and figures throughout her career. She has also made self-portraiture a recurring subject, presenting her likeness in complex spaces. Unsentimental and honest, Murphy's portraits pull us into a dialogue about art and representation.

In this self-portrait, made when the artist was about thirty, we see three visual planes—the still life on the table, the artist's figure in the middle ground, and the landscape revealed through the open window behind her. The darkness of the interior and the dramatic yet soft light work together to create a sense of intimacy and calm strength. Murphy likens her work to poetry: "How do you take something ordinary, that people see every day, and frame it so that you change the equation? That same thing happens in a poem." BF

Self-Portrait, 1976
Lithograph
32.4 × 28.1 cm (12 ¾ × 11 ¹⁄₁₆ in.)
The Ruth Bowman and Harry Kahn Twentieth-Century
American Self-Portrait Collection (S/NPG.2002.304)

RICHARD AVEDON (1923–2004)

The name Richard Avedon is synonymous with fashion photography. His imaginative, original camera work revolutionized the industry of fashion and modeling, and his images quickly gained recognition as art. He also created other forms of portraiture, revealing likenesses of celebrated Americans, such as Marilyn Monroe and Janis Joplin, or other people whom he found interesting.

Often choosing to create photographs in series, Avedon's well-known feature in *Rolling Stone* (1976), "The Family," featured non-idealized portraits of a group of powerful elite. In 1978, he made this self-portrait for the cover of *Newsweek*, on the occasion of a major retrospective exhibition of his work at the Metropolitan Museum of Art in New York City. Avedon was known for his insightful portrayals, but in this instance, he reveals very little of himself and chooses to look beyond the viewer, as though focusing his camera on another subject entirely. BF

Self-Portrait, 1978
Dye transfer print
36.1 × 26.9 cm (14 ³⁄₁₆ × 10 ⁹⁄₁₆ in.)
(NPG.93.94)

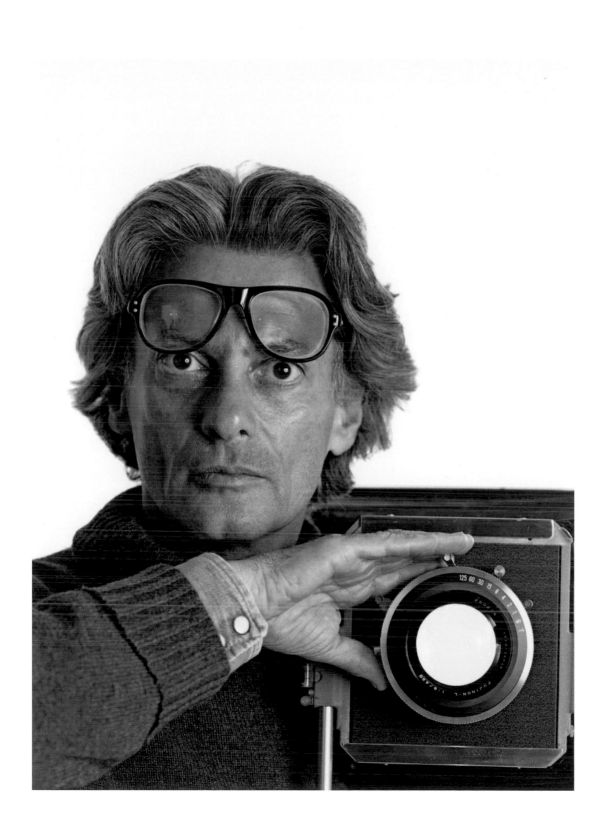

JIM DINE (born 1935)

Jim Dine's transition to figuration in the 1970s reflected his increased personal and professional confidence. And, as he later observed, "Making prints was the first place my interest in figurative art raised its head." Etching offered him a new way to approach self-representation.

In this portrait, the artist confronts the viewer with an intense gaze. Using a profusion of expressive lines, Dine captured the thickness of his beard and the hair around his temples, as well as the aging of his skin. Professing his interest in "what life has done to the face," he once remarked: "I love people's tracks. I want all that history." Taking advantage of etching's capacity to register such marks, Dine invests his 1978 self-portrait with yet another layer of autobiographical significance, printing it on paper watermarked with his initials: J. D. ACG

Self-Portrait on J. D. Paper, 1978
Etching
64.8 × 49.5 cm (25 ½ × 19 ½ in.)
The Ruth Bowman and Harry Kahn Twentieth-Century
American Self-Portrait Collection (NPG.2002.236)

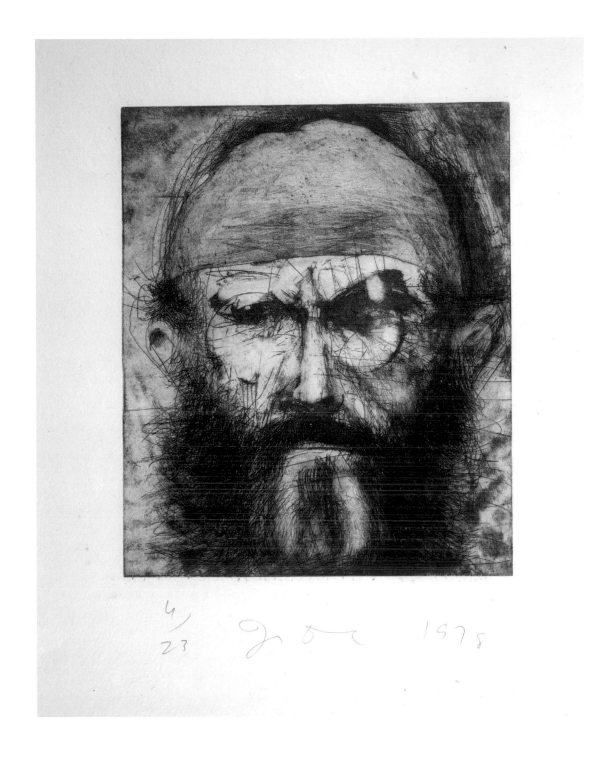

4/23 1978

CARMEN LOMAS GARZA
(born 1948)

Carmen Lomas Garza relies on her memory to create art that recalls the traditions of her family and those of the South Texas Latino community. Since the 1970s, she has worked in a variety of media to draw on her experiences growing up Mexican American in Kingsville, Texas. Lomas Garza often employs the language of folk art to deconstruct racial inequality by celebrating the positive. Her work is separated from the more overtly political work of some of her contemporaries within the Chicano movement.

Lomas Garza is also an author and illustrator, and her book, *Family Pictures / Cuadros de familia*, is based on her childhood traditions. The publication won several national awards, including the Pura Bulpré Award from the Modern Language Association. Most of the artist's self-portraits depict her as a child within her family unit. This is a rare image fully focused on her adult self. TC

Autorretrato (Self-Portrait), 1979
Linoleum block print
28 x 22.8 cm (11 x 9 in.)
Acquired in 2018

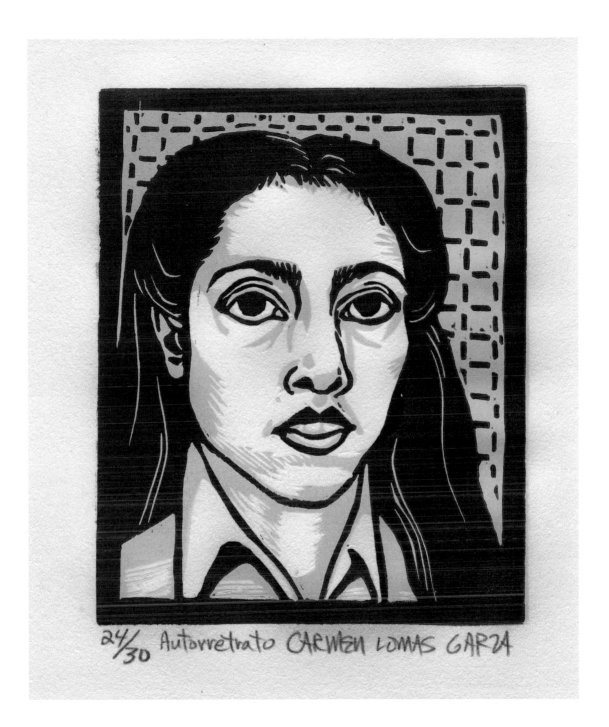

24/30 Autorretrato CARMEN LOMAS GARZA

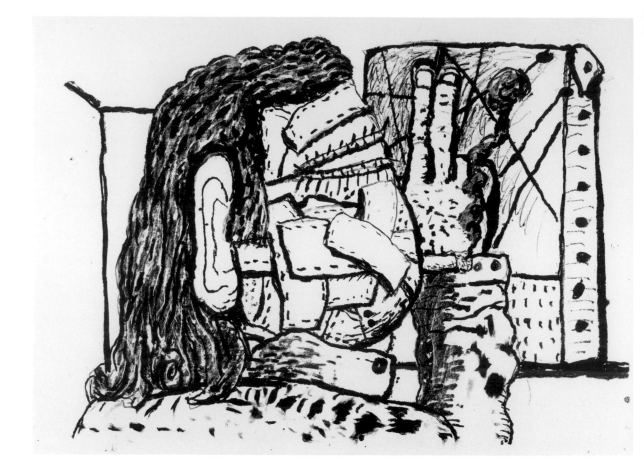

PHILIP GUSTON (1913–1980)

Philip Guston started his career in the 1930s as a figurative painter, became a leading Abstract Expressionist in the 1950s, and returned to figuration in the 1960s, when, as he said, "the brutality of the world" made him "sick and tired of all that Purity!" that abstract painting implied. *Painter*, produced during the final year of Guston's life, seems to illustrate a reference he made in 1978 to his work as a "battle … with dozens of brushes as weapons." Here, his battle-scarred and bandaged face, with its Cyclopean eye (a common self-depiction of the 1970s), stares out at his right hand. The pose alludes to his cigarette smoking, to a benediction, or to the meditation of an infirm artist on his future ability to produce art. Such self-reflection characterized Guston's career, which author Nicole Krauss called "an unflinching journey towards the most unflinching expression of self." ECR

Painter, 1979
Lithograph
81.4 × 108.3 cm (32 ¹⁄₁₆ × 42 ⁵⁄₈ in.)
The Ruth Bowman and Harry Kahn Twentieth-Century
American Self-Portrait Collection
Conserved with funds from the Smithsonian
Women's Committee (NPG.2002.261)

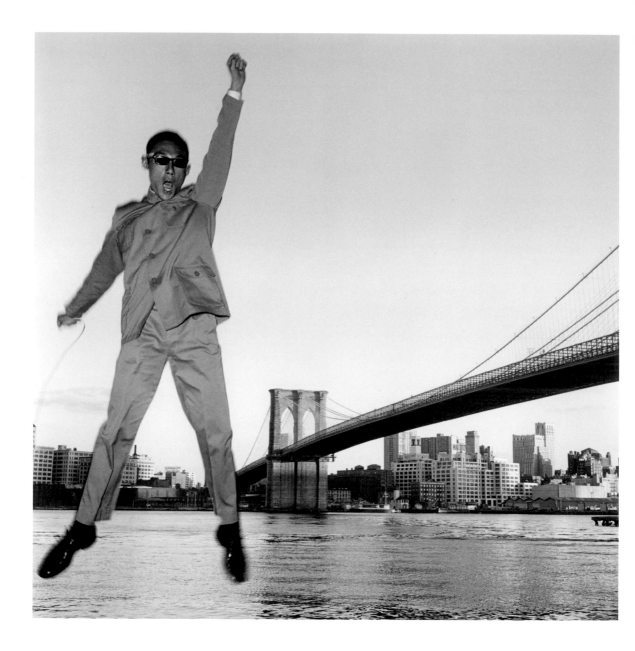

TSENG KWONG CHI (1950–1990)

Wearing dark glasses and a Mao Zedong suit, Tseng Kwong Chi traveled worldwide to create his evocative series *East Meets West*, in part inspired by Richard Nixon's 1972 visit to China. Born in Hong Kong to exiled Chinese Nationalists, he invented the persona of a Chinese "Ambiguous Ambassador" to explore tourist photography and critically assess political tensions of the 1970s and 1980s.

While mocking the period's U.S.-China relations, Tseng's images also highlight his ability to move freely across borders, a right that was denied to many Chinese. In this image, he jumps ecstatically before the Brooklyn Bridge, creating a photograph that is both a tongue-in-cheek and thoughtful consideration of the role of a historic site, tourism, and a foreign traveler's body in the landscape. We also catch a glimpse of the shutter release and cord attached to the camera, the technology that made this self-portrait possible. LU

New York, New York, 1979 (printed 2017)
Selenium-toned gelatin silver print
38.2 × 38.1 cm (15 ¹⁄₁₆ × 15 in.)
Acquisition made possible through federal support from the Asian Pacific American Initiatives Pool, administered by the Smithsonian Asian Pacific American Center (NPG.2017.100)

ALICE NEEL (1900–1984)

In making a portrait, one critic observed, Alice Neel "hurls shafts that hit the mark but do not sting," pinpointing the penetrating yet compassionate quality in the figure studies for which she is best known. Neel adhered to portraiture in the midst of the Abstract Expressionist movement and was consequently ignored by the art world until shortly before two retrospective exhibitions held during the early 1970s. "Life begins at seventy!" she said of her career's newfound transformation.

In 1975, Neel began this shocking, endearing, and utterly unconventional self-portrait, one of only two she ever made. She took five years to complete the work and later, recalling the process, said: "The reason my cheeks got so pink was that it was so hard for me to paint that I almost killed myself painting it." A striking challenge to the centuries-old convention of idealized femininity, Neel's only painted self-portrait is openly accepting of her aging body. BF

Self-Portrait, 1980
Oil on canvas
135.3 × 101 cm (53 ¼ × 39 ¾ in.)
(NPG.85.19)

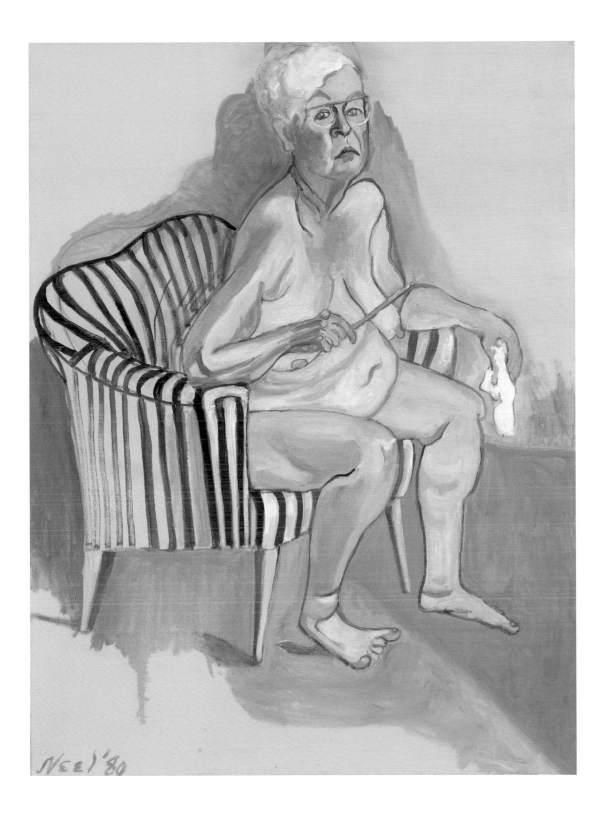

FRANCESCO CLEMENTE (born 1952)

Intensely mystical, Francesco Clemente's self-portrait presents not a literal truth, but instead a symbolic order. As Clemente engages the viewer with his direct gaze, he simultaneously probes, with a fork, a serpent presented in the form of the Ouroboros (the snake biting its own tail). Replete with symbolic significance across many cultures, the form conveys notions of infinity and spiritual rebirth that are consistent with Clemente's own view of challenges of self-portraiture, providing a metaphor for self-representation: "If the face is a mask—no, a persona—that means the face reminds you of what is constant in your consciousness, but also reminds you of what is not constant. ...To meditate on your face means to meditate on this continuous transition we all go through, which we are not aware of, or we dislike being aware of, because it's frightening." ACG

Self-Portrait #4 (Snake), 1981
Etching
41.1 × 51.6 cm (16 ³⁄₁₆ × 20 ⁵⁄₁₆ in.)
The Ruth Bowman and Harry Kahn Twentieth-Century
American Self-Portrait Collection (S/NPG.2002.229)

CHUCK CLOSE (born 1940)

Since the late 1960s, Chuck Close's monumental heads have been transforming notions of portraiture. His portraits, based on photographs, seem to dissolve into separate patches and then coalesce into huge mug shots. *Self-Portrait* is part of a series of handmade paper multiples he started in the early 1980s, in collaboration with master printer Joseph Wilfer. Following Close's color-coded drawing, Wilfer squeezed liquefied rag pulp in twenty-two different shades of black, gray, and white into the sections of a plastic grid. After the grid was removed, the liquid pulp dried, bonding to the thick hand-made background paper. Close heightened the sense of self and softened the rigidity of the grid structure by pushing through the still-wet pulp with his own fingers. He also let the paper dry naturally, creating a rough, three-dimensional texture. The result is a highly animated surface that seems to move before one's eyes. WWR

Self-Portrait, 1982
Handmade toned paper pulp cast on grid
97.8 × 73 cm (38 ½ × 28 ¾ in.)
The Ruth Bowman and Harry Kahn Twentieth-Century
American Self-Portrait Collection (NPG.2002.230)

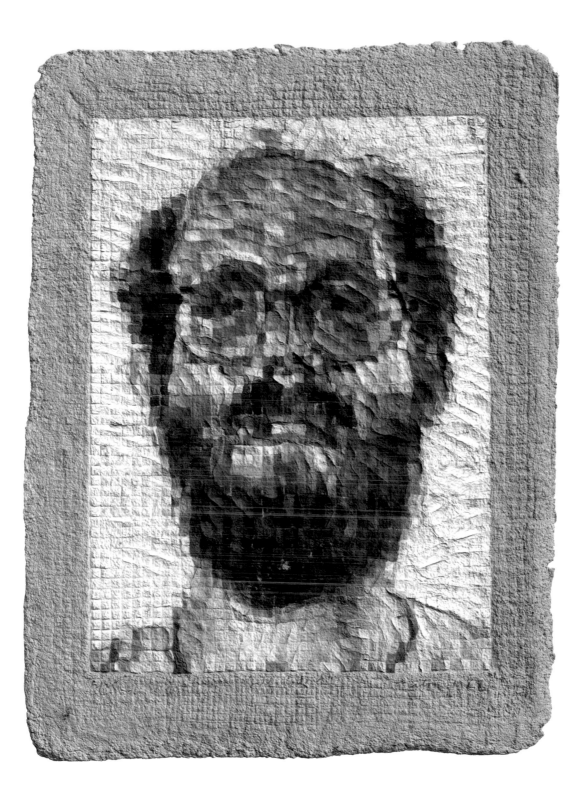

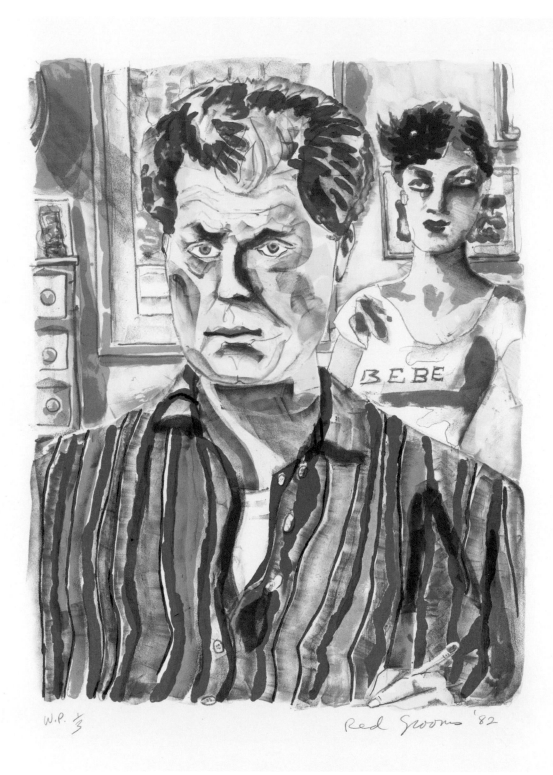

W.P. ⅓ Red Grooms '82

RED GROOMS (born 1937)

Painter and sculptor Red Grooms began his career in the late 1950s as a performance artist in New York, creating "happenings" in collaboration with such artists as Claes Oldenburg and Jim Dine. He proceeded to room-sized multimedia "sculpto-pictoramas," offering witty pictorial commentaries on American cities, heroes, and contemporary life.

Although influenced by Abstract Expressionism, Grooms made his name with a zany, unorthodox take on representation. His paintings, prints, sculptures, and films established a strain of comic mania hard to reconcile with the more reserved Pop and Minimalist trends. In this self-portrait (with his friend Elisabeth Ross in the background), Grooms wears a serious expression of deep concentration, but the juxtaposition of bright colors and the wildly wiggling stripes of his shirt convey the vibrant energy of his art. Grooms' crowd-pleasing whimsies caused one commentator to describe him as a "latter-day P. T. Barnum or Walt Disney, albeit crossed with Marcel Duchamp." WWR

Self-Portrait with Liz, 1982
Lithograph
52.6 × 41.8 cm (20 ¹¹⁄₁₆ × 16 ⁷⁄₁₆ in.)
(NPG.2003.66)

DAVID HOCKNEY (born 1937)

Present with his mother through his intentional inclusion of the tips of his feet (bottom center), David Hockney builds on the lessons of Cubism in this unconventional double-portrait. Using snapshots taken at Bolton Abbey, where his parents courted, Hockney explores the unfolding of human relationships over time. He invites the viewer to step into his shoes and observe his mother in the wake of the death of her husband (and Hockney's father). One of the most prominent features of the portrait is an empty space that hovers above her head, which invokes the artist himself. "In a sense, you are a void," Hockney has asserted. "The world begins outside of you, and it's why, in the end, I've come to believe that this space very close to us is mysterious." ACG

My Mother Bolton Abbey, Yorkshire, Nov. 82, 1982
Chromogenic prints on paper
120.5 × 70 cm (47 7/16 × 27 9/16 in.)
The Ruth Bowman and Harry Kahn Twentieth-Century
American Self-Portrait Collection
Conserved with funds from the Smithsonian
Women's Committee (NPG.2002.273)

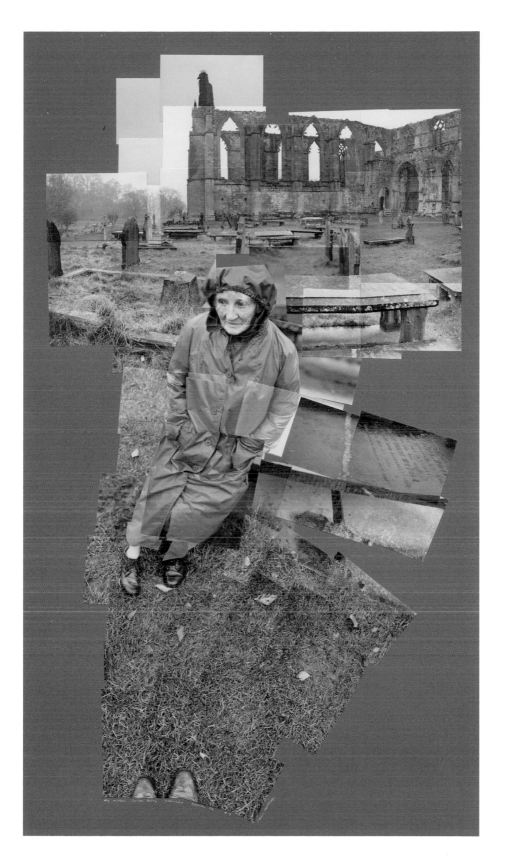

RAPHAEL SOYER (1899–1987)

The social-realist artist Raphael Soyer spent his career pictur-
ing people around him, often those who were dispossessed.
He also made self-portraits, often prints or drawings,
throughout his life in a continuous process of self-explora-
tion. He told an interviewer in 1973: "You look at the world
through yourself.... I always paint myself appearing introvert-
ed. Painting myself is like talking about myself, but I never
make myself entirely like myself. I always appear older-look-
ing, or unshaven, or all alone. It's the result of looking a little
bit more deeply." This lithograph was commissioned by the
Smithsonian Institution in 1982, when Soyer was honored
with two shows at the Hirshhorn Museum and Sculpture
Garden. They were his last major exhibitions. He looks into a
mirror that we cannot see; the inscription he is writing is in
ancient Greek letters, and translates as "Know thyself." BF

Self-Portrait (with Greek letters), 1982
Lithograph
52.3 × 40.8 cm (20 9/16 × 16 1/16 in.)
The Ruth Bowman and Harry Kahn Twentieth-Century
American Self-Portrait Collection (NPG.2002.339)

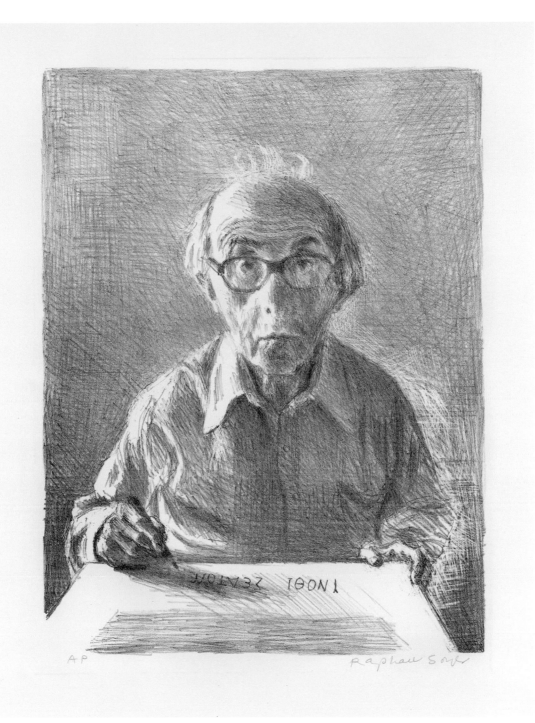

Raphael Soyer

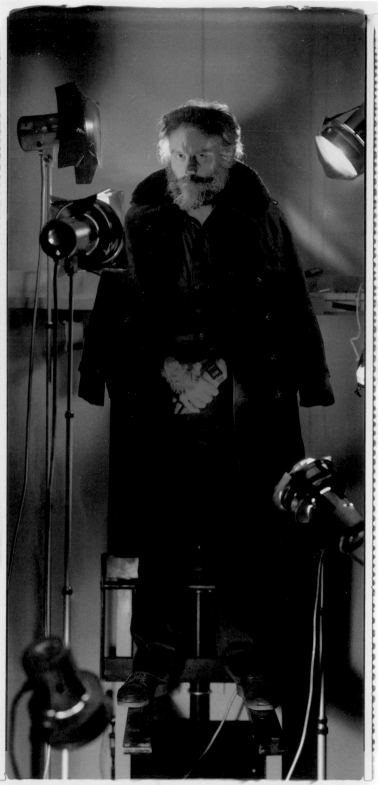

LUCAS SAMARAS (born 1936)

Lucas Samaras is a complicated artist who works in a wide variety of media, including assemblage, photography, sculpture, and performance. Born in Kastoria, Macedonia, in Greece, he immigrated to the United States as a teenager and attended Rutgers University in New Jersey. While there, he studied with artists George Segal and Allan Kaprow, and participated in Kaprow's Happenings in the 1960s.

Samaras uses his own image to explore themes of sexuality, terror, mortality, and transformation. In this supersized self-portrait, he portrays himself as a looming, fearsome, quasi-religious figure. The dramatic lighting, with tones of red, green, and black, adds to his ominous presence. His gaze is imperious while his pose is aggressive, seemingly poised to react to a challenge from the viewer. Samaras remarked: "You may like my work; you may find, however, that you do not like me." PQ

Self-Portrait, 1983
Dye diffusion transfer print
224.2 × 103.5 cm (88 ¼ × 40 ¾ in.)
(NPG.88.211)

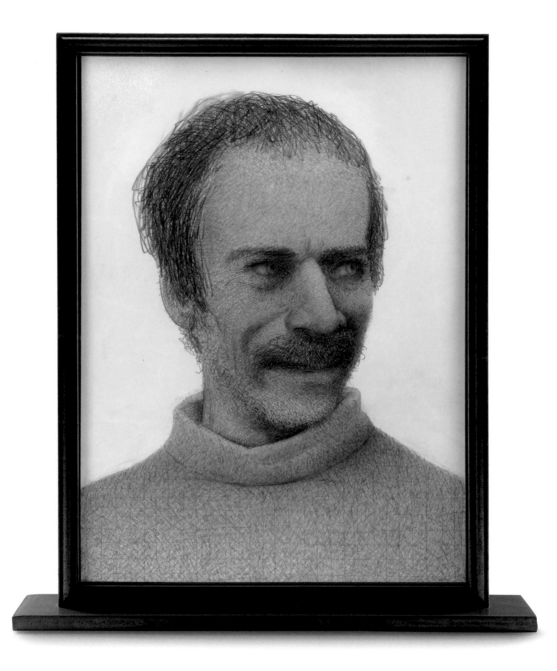

GREGORY GILLESPIE (1936–2000)

Self-portraiture played a critical role in Gregory Gillespie's career, enabling him to carry on an internal dialogue about the hopes, fears, and contradictions that shaped his outlook and his art. Gillespie's expression radiates satisfaction, and the light that filters through this image intensifies the sense of his spiritual fulfillment. The challenge of maintaining such harmony is conveyed by the work's very materiality: the heavily worked graphite is inherently fragile, perpetually threatening to disturb the artist's crisp marks. Such tension has metaphorical significance. As the artist explained: "My job is to turn the chaos and pain into art." ACG

Self-Portrait, 1983–84
Graphite on mylar
43.1 × 31.6 cm (16 $^{15}/_{16}$ × 12 $^{7}/_{16}$ in.)
The Ruth Bowman and Harry Kahn Twentieth-Century
American Self-Portrait Collection (S/NPG.2002.252)

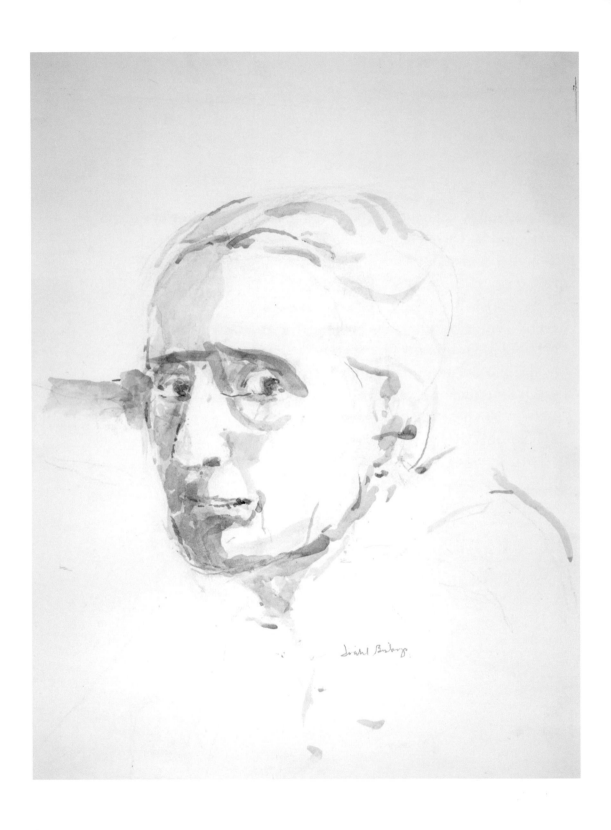

ISABEL BISHOP (1902–1988)

Although artist Isabel Bishop moved to the Bronx after her marriage, she traveled almost daily to her Union Square studio to observe and sketch her favorite subjects: the varied dramas of urban life. But when, after a long, successful career, failing health forced her to give up her beloved Manhattan studio, she turned to self-portraiture. In a series of unsparing self-appraisals, she conveyed the anguish of her physical limitations. Nonetheless, she continued to challenge herself. She turned away from her former preoccupation with "mobility"—which she described as the "potential for movement"—to the depiction of motion itself. In the process, she noted: "I found I was much less interested in the genre aspect of the picture, in particularity." In this drawing, one senses the actual rotation of the head. That immediacy, ironically, does not convey the specific individual or precise moment but instead the sense of a timeless, universal truth. WWR

Self-Portrait, 1984–85
Brush and black ink with traces of graphite on wove paper
43.7 × 36.9 cm (17 ³⁄₁₆ × 14 ½ in.)
The Ruth Bowman and Harry Kahn Twentieth-Century
American Self-Portrait Collection (NPG.2002.212)

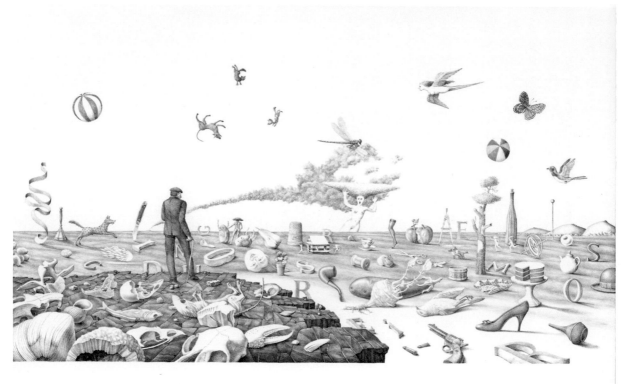

JOHN H. WILDE (1919–2006)

John Wilde was a leader in Surrealism and Magic Realism, working in Wisconsin for his entire long career. His self-portrait offers a sweeping view of both the psychological and intellectual landscape of the artist. The print seems comical at first, filled with such imagery as "raining" cats and dogs, a half-bird/half-woman figure, a pipe referencing René Magritte's most famous work, layered cake, fruits, high heels, and beach balls. Upon closer inspection, a different mood emerges. Skeletal bones, running and naked individuals, dead animals along with decaying flesh, and a gun are placed throughout the composition. Surveying this phantasmagorical, disparate scene is the calm figure of Wilde, standing with his back to us. He is overseeing a surrealist landscape of his own making, reflecting the harsh realities of his lived experience. Though created later in his life, it is typical of his enormous body of work, which is just beginning to be fully appreciated today. AN

Wildeview XLIV/LXXXV, 1985
Lithograph
59.9 × 90.4 cm (23 ⁹⁄₁₆ × 35 ⁹⁄₁₆ in.)
(NPG.2018.5)

ELLSWORTH KELLY (1923–2015)

Best-known for his bold abstract compositions that often incorporate areas of pure color, Ellsworth Kelly frequently turned to self-representation over the course of his career as a means of grappling with formal and stylistic concerns. Just as many of Kelly's color compositions carry within them echoes of forms observed in the world, so too does this self-portrait merge abstraction with representation. Part of a series, this work incorporates a Polaroid of Kelly's face that has been duplicated with a photocopier. Here, color becomes shape, a formal element that both literally and metaphorically represents the artist who is pictured, testifying not only to his appearance, but, even more importantly, to the concerns that have informed his work. ACG

EK Spectrum III, 1988
Lithograph
37.5 × 101.6 cm (14 ¾ × 40 in.)
The Ruth Bowman and Harry Kahn Twentieth-Century
American Self-Portrait Collection
Conserved with funds from the Smithsonian
Women's Committee (NPG.2002.280)

11/50

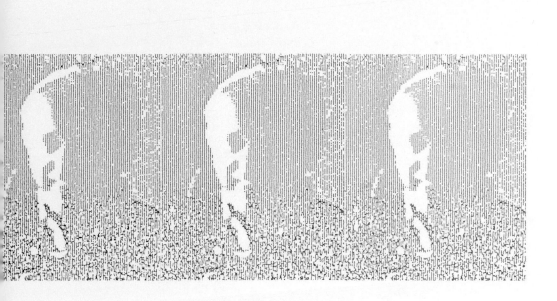

Kelly

CHUCK CLOSE (born 1940)

Chuck Close has focused on large-scale heads for most of his long career as an artist, varying his materials, but not his efforts, to make a person's face into an overwhelming, impersonal presence. He has made portraits of friends, family members, and models for many years, but he has also created a number of self-portraits.

Close suffered a collapsed spinal artery in 1988, leaving him a quadriplegic, and in 1989—the year this self-portrait was made—he was finding new ways to make his artworks. For a long time, he only used photographs as reference material for his paintings and drawings, but he eventually saw their potential to stand on their own as art. He was particularly drawn to large-format Polaroids and hyper-real images, like this one, where viewers may find themselves overwhelmed by the size and the visual information provided in the composite image. BF

Self-Portrait, 1989
Dye diffusion transfer prints
Approx. 273.2 × 219 cm (107 ⁹⁄₁₆ × 86 ¼ in.),
framed, (NPG.92.125)

Self-Portrait /16 part chuck close 1989

LOIS DODD (born 1927)

Lois Dodd, active in the New York art world since the 1950s, is known for the cityscapes that she painted from her New York studio window and the landscapes that she did in the woods and gardens of her Maine summer house. As the only woman founder of the Tanager Gallery, an influential artist-run gallery in the East Village, she helped form an outlet for emerging artists whose work the established New York galleries would not exhibit.

Although surrounded by the Abstract Expressionists, Dodd created a unique style of realism. Her maxim, "The more you look, the more you see," provides a guide to viewing this self-portrait, where she peers through oversized glasses toward the viewer, with a questioning gaze. A black hat frames her wild hair, giving her an eccentric appearance, while the lavender, green, orange, and yellow tones shadowing her face resemble the colors from nature seen in her landscapes. PQ

Self-Portrait, 1989
Oil on Masonite
42.5 × 37.5 cm (16 ¾ × 14 ¾ in.)
Gift of Rebecca Mitchell and Ben Harris
Acquired in 2018

BRUCE NAUMAN (born 1941)

Over the course of his career, Bruce Nauman has, in a wide variety of media, consistently returned to his own body as a site of experimentation. Nauman's self-reflexive turn finds expression in this self-portrait, which subverts traditional expectations by distancing the artist from the viewer rather than promoting engagement. Nauman's drypoint etching reflects the artist's interest in the front-back reversals inherent in printmaking. Here, it is not only a mirror reversal with which Nauman works, but also a shift of orientation. Positioned horizontally, the artist's profile hovers between a recognizable image and a fluctuating line. Whether sleeping, unconscious, or daydreaming, whether speaking or merely breathing, the artist, through his likeness, resists personal contact, even as he exposes himself. Ultimately, this may be the artist's most provocative gesture: that of deliberate withdrawal, even as he makes himself visible. ACG

Self-Portrait, 1990
Drypoint
42.7 × 49.3 cm (16 $^{13}/_{16}$ × 19 $^{7}/_{16}$ in.)
The Ruth Bowman and Harry Kahn Twentieth-Century
American Self-Portrait Collection
Conserved with funds from the Smithsonian
Women's Committee (NPG.2002.306)

JACOB LAWRENCE (1917–2000)

When Jacob Lawrence—best known for his vibrant depictions of African American life and history—made a self-portrait, he treated his own face like any other subject: as a basis for inventing expressive abstract shapes. Inspired by colorful throw rugs and textiles from his Harlem childhood, Lawrence internalized dynamic abstract patterning. In this mask-like drawing, he concentrated his appearance into a few essential lines and shapes. A black arc describes the shape of his skull, wavy lines convey a shaggy mustache, and heavier curves evoke folds of aging flesh. He left out the faintly sketched ear, focusing instead on a geometric grid of black marks to signify the eyes. Lawrence poetically combined observation with geometry to reflect both his appearance and his approach to art. He left most of his face white to set off his stylized black shapes, forcing the viewer to confront his sophisticated abstract vision. WWR

Self-Portrait, 1993
Ink and graphite on paper
28.6 × 24.8 cm (11 ¼ × 9 ¾ in.)
The Ruth Bowman and Harry Kahn Twentieth-Century
American Self-Portrait Collection
Conserved with funds from the Smithsonian Women's
Committee (NPG.2002.292)

LUCAS SAMARAS (born 1936)

"I have found for myself an uncultivated field; that uncultivated field is the self," notes Lucas Samaras, who is well known for his diverse and long-standing explorations of self-portrayal. Here, in this relief etching, the artist uses his eyes to form an intense connection with his audience, while his mouth, covered by a thick beard, is rendered invisible. Small dots coalesce to form a likeness but seem, simultaneously, to be on the point of dissolution, promising yet another transformation and reformulation of the self—a self that is not only personal but also communal: "And so this body is my body and it is also my ancestors' body," observed Samaras. "It takes pictures and it is pictures. It has prettiness, ugliness and temporality and through it I exist in a heightened state among others." ACG

Self-Portrait, 1994
Relief engraving
50.7 × 38.2 cm (19 ¹⁵⁄₁₆ × 15 ¹⁄₁₆ in.)
The Ruth Bowman and Harry Kahn Twentieth-Century
American Self-Portrait Collection (S/NPG.2002.319)

MARÍA MAGDALENA CAMPOS-PONS

(born 1959)

María Magdalena Campos-Pons brings into public consciousness Afro-Caribbean history and culture, and she has explored the concept of exile through the use of her body, including performance art. For Campos-Pons, exile refers not just to her departure from her native Cuba in the 1990s, but also to her identity as a member of the African diaspora, carrying the experience of her enslaved ancestors who shaped Cuban culture.

 This photograph, with vertical white stripes on her face, a Strelitzia—or "Bird of Paradise"—flower (perhaps an offering), and the crown of beads on her head, recalls Yoruba rites transferred to her island through the Afro-Cuban religion of Santería. Her closed eyes evoke a state of spiritual trance, where body and soul can bifurcate and be present in different places. The idea of being between places or translocated is reinforced in the title, which starts in English and ends in Spanish, with a phrase that translates as "I'm there." TC

Untitled from the series When I am not Here, Estoy allá, 1996
Dye diffusion transfer print
66.8 × 54.5 cm (26 5/16 × 21 7/16 in.)
Gift of Julia P. and Horacio Herzberg (C/NPG.2017.122)

FAITH RINGGOLD (born 1930)

In *Seven Passages to a Flight*, Faith Ringgold explores African American themes through historical faces and autobiographical memories, combining actual events, fantasy, and history. Some images blend her childhood experiences with those of her daughters. Others depict the performers Marian Anderson and Paul Robeson, who appear in the mosaic murals she made for New York City's 125th Street subway station.

In this image, Ringgold recalls recuperating from asthma as a child, when her mother would provide her with crayons, paints, and pieces of cloth. Those early memories serve as inspiration for Ringgold's enduring interest in hand-crafted fabric art. WWR

Seven Passages to a Flight, 1998
Book of hand-painted etchings with pochoir borders on linen
Case: 26 × 21.3 × 2.9 cm (10 ¼ × 8 ⅜ × 1 ⅛ in.)
(NPG.2004.24)

FAITH RINGGOLD (born 1930)

Faith Ringgold based her 1998 artist's book, *Seven Passages to a Flight*, and this accompanying quilt on autobiographical memories drawn from her own Harlem childhood. Searching for a way to express the experiences of African American women, she started working in textiles in the 1970s. Her innovative story quilts draw inspiration from Tibetan "tankas," African piece work, and black American quilting traditions.

Long an activist for racial and gender equality, Ringgold used flight here as a metaphor for overcoming the challenges that she had encountered. The bridge, which she could see from her tar-covered Harlem rooftop symbolizes opportunity. "Anyone can fly," she writes in her children's book, *Tar Beach*. "All you have to do is have somewhere to go that you can't get to any other way." The imagery of flying, Ringgold has explained, "is about achieving a seemingly impossible goal with no more guarantee of success than an avowed commitment to do it." WWR

Self-Portrait, 1998
Hand-painted etching and pochoir borders on linen with
quilted cotton border and nylon backing
128.4 × 109.3 cm (50 9/16 × 43 1/16 in.)
(NPG.2004.25)

Seven Passages to a Flight

SUSAN HAUPTMAN (1947–2015)

For Susan Hauptman, the exploration of selfhood was a long-term artistic quest. Like so many of her self-portrayals, *Copper Self-Portrait with Dog* appears purposefully disjointed. The hyperrealism of the dog and the mid-twentieth-century skirt and hat contrast with the folk-naive rendering of the feet and the mismatched proportions. Juxtaposing the ultra-feminine ruffles and flowers with a masculine, nearly hairless head creates a disturbing disparity. The whimsical costume, with its canine "accessory," appears comical at first glance, but the confrontational pose and serious expression deny laughter. Even Hauptman's beautiful, meticulous technique stands in stark contrast to rougher, seemingly unfinished portions of the drawing.

While Hauptman questions gender stereotypes and draws upon self-portrait traditions of dressing up and masquerading, she does not do so to impersonate others or to reinvent the self. The constant comparing and contrasting seems instead to be an exploration of dualities within herself that coexist with creative tension. WWR

Copper Self-Portrait with Dog, 2001
Pastel with copper leaf on paper
250.8 × 103.8 cm (98 ¾ × 40 ⅞ in.)
Gift of an anonymous donor (S/NPG.2006.108)

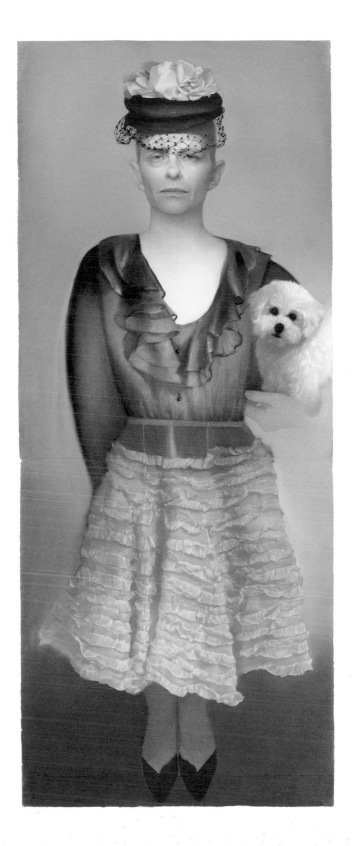

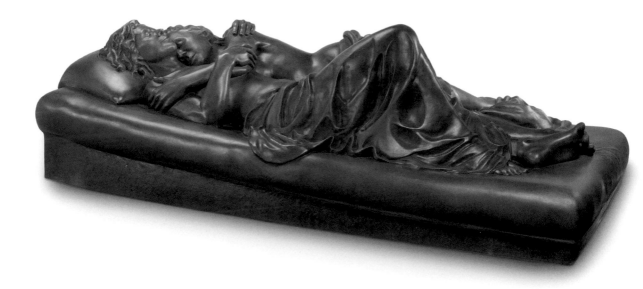

PATRICIA CRONIN (born 1963)
DEBORAH KASS (born 1952)

In 2002, the cross-disciplinary artist Patricia Cronin carved a Carrara marble self-portrait with her then-partner, now wife, the pioneering feminist artist Deborah Kass. Conceived in the tradition of nineteenth-century funerary sculptures, *Memorial to a Marriage* presents two influential feminist artists and life partners in an eternal embrace. As a powerful commentary on gender, sexuality, and marriage, it tells both a transcendent story and one that is historically and culturally significant. The work was made a decade before Cronin and Kass were granted the right to marry in their home state of New York. After creating the original marble sculpture for New York City's historic Woodlawn Cemetery, Cronin made three bronze casts of the work, one of which is shown here.

DM

Memorial to a Marriage, 2002
(cast 2013) by Patricia Cronin
Bronze
68.6 × 213.4 × 137.2 cm (27 × 84 × 54 in.)
Gift of Chuck Close (C/NPG.2016.119)

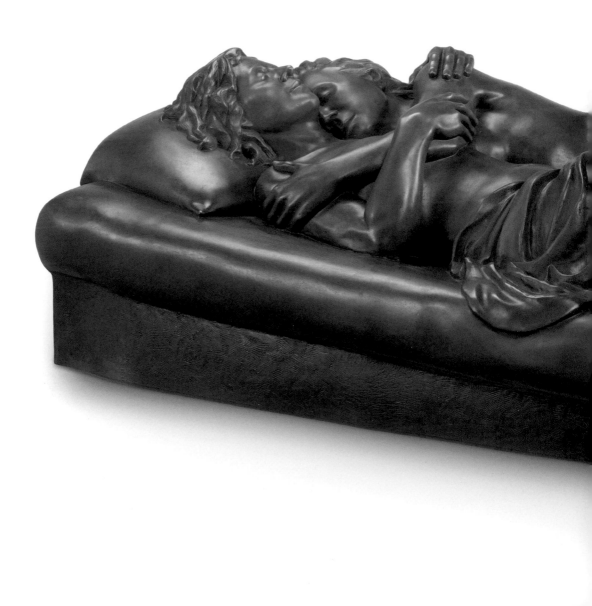

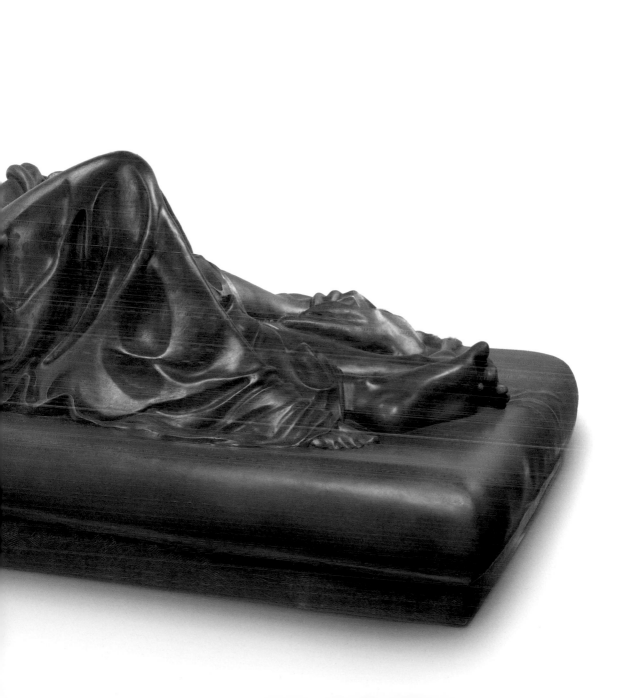

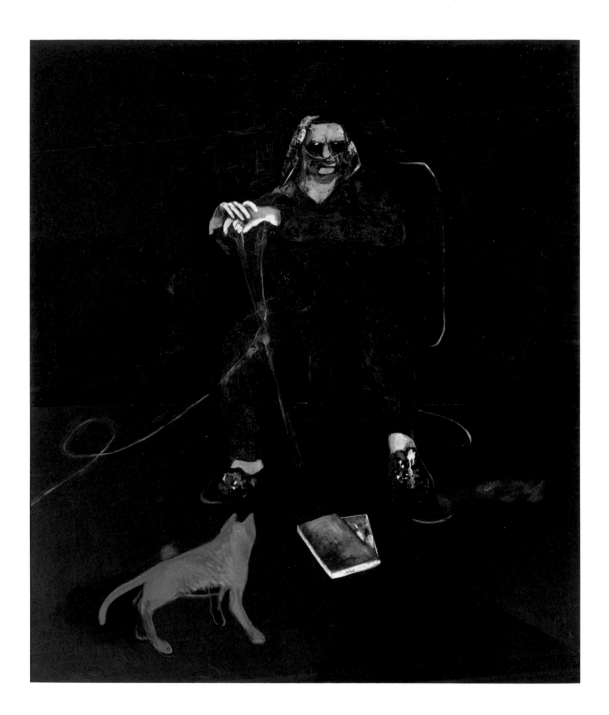

FRITZ SCHOLDER (1937–2005)

A painter of Native American subject matter in the 1960s and 1970s, Fritz Scholder developed an approach that became known as Indian Pop. This is his last self-portrait, made in 2003 when he was battling complications brought on by diabetes.

The dark, moody canvas features the artist boldly facing the viewer as he leans on his cane. His eyes are covered by tinted glasses, and the tubes from his oxygen tank are visibly running from his nose to the ambiguously shadowy floor, which has been described as a reference to the "shadow of death." An avid reader, Scholder chose to include two books in the foreground, and the gray cat likely refers to the Egyptian feline goddess Bastet. Critics, who often cite this painting as a particularly important self-portrait, also point to the influence of Francis Bacon, an artist Scholder deeply admired. DM

Self-Portrait with Grey Cat, 2003
Acrylic on canvas
203.2 × 172.7 cm (80 × 68 in.)
(NPG.2018.2)

BURTON SILVERMAN
(born 1928)

Burton Silverman has created many self-portraits over his lifetime as a painter of figures and landscapes. This sketch was made for a larger painting and was described by the artist as being "executed within a few years of my heart attack, in the aftermath of which I experienced a new sense of myself as a survivor. With this heightened awareness came a special need to strip to the waist in painting myself as if my essential selfhood was now more than just head and shoulders. This painting perhaps also 'celebrates' my survival, both as a human being and as an artist. The tools of my lifelong career are represented by the brushes in my right hand and the camera in the other." The visual complexity of the portrait is enhanced with Silverman's study of the reflections of trees and sky in the sliding glass door of his country studio. BF

Study for Survivor, 2004
Oil on linen
91.4 × 61 cm (36 × 24 in.)
Acquisition made possible through the generosity of the
Audrey Love Charitable Foundation (S/NPG.2016.124)

ROZ CHAST (born 1954)

A contributor to the *New Yorker* since 1978, cartoonist Roz Chast has had over one thousand cartoons appear in the magazine. She is also a prolific author of graphic books, including *Can't We Talk about Something More Pleasant? A Memoir* (2014), a meditation on the death of her parents, and most recently, *Going into Town: A Love Letter to New York* (2017). Her wry humor and her subjects revolve around domestic and family life, and her drawing style appears to be both energetic and unschooled.

A graduate of the Rhode Island School of Design, Chast found immediate success with her frumpy characters and untidy line. Although her mockery is unerringly precise, she charms her audience by implying that those cartoon anxieties are only slight exaggerations of her own. In *Me, Age 9*, she depicts herself as a shy hypochondriac and voracious reader, terrified that she has a slew of horrible diseases. BF

Self-Portrait, 2009
Ink and watercolor on paper
30.5 × 23 cm (12 × 9 ¹⁄₁₆ in.)
Alan and Lois Fern Acquisition Fund (NPG.2010.1)

ROGER SHIMOMURA (born 1939)

As an artist, Roger Shimomura has focused particular attention on the experiences of Asian Americans and the challenges of being "diffcrcnt" in America. He knows well the pain and embarrassment associated with xenophobia: as a small child during World War II, he and his family were relocated from their home in Seattle to a Japanese American internment camp in Idaho.

This painting takes as its source Emanuel Leutze's 1851 painting *Washington Crossing the Delaware*, which is in the collection of the Metropolitan Museum of Art in New York City. Shimomura presents himself in the guise of America's Founding Father, but he replaces George Washington's colonial troops with samurai warriors, and he remakes the body of water they cross to resemble San Francisco Harbor with Angel Island (the processing center for Asian immigrants) in the background. Finally, the work echoes the compositional format of a Katsushika Hokusai wood-block print. BF

Shimomura Crossing the Delaware, 2010
Acrylic on canvas
Three panels: 182.9 × 365.8 cm (72 × 144 in.) overall
Gift of Raymond L. Ocampo Jr., Sandra Oleksy Ocampo,
and Robert P. Ocampo (NPG.2012.71)

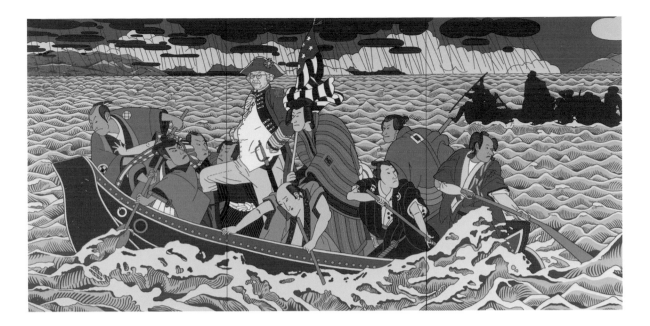

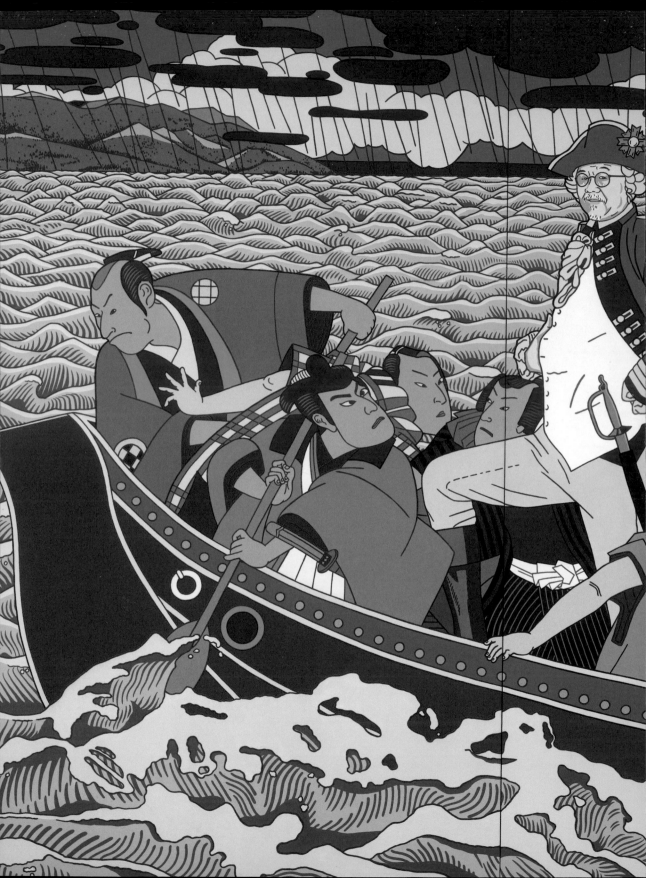

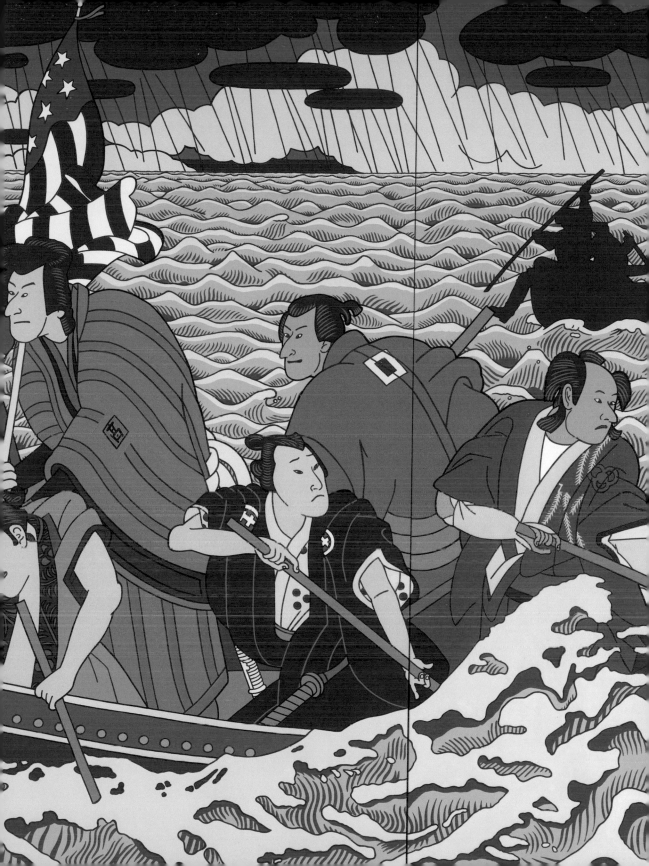

DEBORAH KASS (born 1952)

Deborah Kass has been one of the most consistently innovative and productive artists of the post-Pop era. Early in her career, Kass, channeling Andy Warhol, focused on appropriation: adapting other works of art to elaborate on—and change—cultural and art historical traditions. In *Red Deb*, *Yellow Deb*, *Silver Deb*, and *Blue Deb*, she models her self-portrait on Warhol's screenprints of celebrities before resplendently colored backgrounds. While in some respects the self-portraits closely imitate Warhol's 1964 print of Elizabeth Taylor, Kass' subtle shifts change the meaning to reflect her own themes: her gender, Jewishness, and sexuality. In repurposing Warhol's style, she challenges the male-dominated art world; in choosing Taylor, she plays on the actress's WASP background and conversion to Judaism; and in borrowing the heavy makeup, she implies an ironic, hyper-girlish reference to her lesbianism. Masquerading on multiple levels, Kass uses her own identity to challenge narrow presumptions. WWR

Red Deb, 2012
Yellow Deb, 2012
Silver Deb, 2012
Blue Deb, 2012
Screenprints
61.5 × 61.5 cm (24 ³⁄₁₆ × 24 ³⁄₁₆ in.) each
Gifts of the Abraham and Virginia Weiss Charitable Trust,
Amy and Marc Meadows, in honor of Wendy Wick Reaves
(C/NPG.2013.75.1–4)

ROGER SHIMOMURA (born 1939)

Now retired, Roger Shimomura spent his career as a professor at the University of Kansas. As a painter, printmaker, and performance artist, he continues to focus his artwork on the experiences of Asian Americans and the obstacles they face. When Shimomura was a small child during World War II, he and his family (all American citizens of Japanese descent) were relocated from their home in Seattle to a Japanese American internment camp in Idaho. His work often addresses that experience, as well as the racist stereotypes used to characterize Asian Americans.

Shimomura creates self-portraits as a way to investigate his own identity vis-à-vis popular imagery. Here, he depicts himself as Superman, flying through the air. Noting that his image interrogates "whether Superman must be Caucasian to be complete," he also explains that the "term buddhahead was a World War II term used by the Japanese American soldiers among themselves." BF

Super Buddahead, 2012
Lithograph
85.2 × 33.2 cm (33 ⁹/₁₆ × 13 ¹/₁₆ in.)
Acquired through federal support from the Asian Pacific American Initiatives Pool, administered by the Smithsonian Asian Pacific American Center (NPG.2017.24)

ALISON SAAR (born 1956)

As a child, Alison Saar watched her mother, the renowned assemblage and collage artist Betye Saar, make prints and sculptures, and her father, Richard, a painter and art conservator, restore works of art. From these experiences, as well as exposure to multi-cultural spiritual traditions, Saar developed an innate curiosity about global traditions of art. Depicting such objects as frying pans, knives, snakes, and mirrors, her works allude to a geographical range of metaphysical and religious beliefs.

Saar's woodcuts draw on her preference for sculptural practices: her carvings evoke the medium of the wood, and her sparse backgrounds cause the figure to appear as a freestanding three-dimensional form. This self-portrait, entitled *Mulatta Seeking Inner Negress II*, suggests Saar's bi-racial heritage with the black and white palette, while the "primitive" African-based image in the mirror points to her yearnings to identify as a black woman. AN

Mirror, Mirror; Mulatta Seeking Inner Negress II, 2015
Woodcut on chine collé
96.8 x 54.8 cm (30 1/8 x 21 9/16 in.)
C/NPG.2018.34

ENRIQUE CHAGOYA (born 1953)

Painter, printmaker, and professor at Stanford University, Enrique Chagoya uses his art for activist causes, employing seemingly cartoonish or naïve imagery as an entryway for discussions of complex cultural and geopolitical issues. After researching his DNA ancestry, Chagoya learned that his ancestors were Native American (Central Mexico), European, Ashkenazi, Middle Eastern/North African, Sub-Saharan African, and East and South Asian.

This work, entitled *Aliens Sans Frontières* (Aliens Without Borders) includes six self-portraits of the artist, each drawing on a pernicious stereotype of a certain ethnicity. Printed from nine plates of mylar sheets hand drawn using acrylic paint and pencils and toned washes, the work is a highly technical, accomplished print—graphic in its geometric patterning, gritty in its evocation of street graffiti, and subversive in its crisscrossing of gender and class lines. AN

Aliens Sans Frontières, 2016
Lithograph on handmade paper
60.2 × 70.9 cm (23 ¹¹/₁₆ × 27 ¹⁵/₁₆ in.)
(C/NPG.2017.84)

SHAHZIA SIKANDER (born 1969)

Shahzia Sikander often explores the traditions of Indo-Persian miniature painting, bringing the formal elements of that discipline into the depiction of her own identity as a Muslim American. In reinvigorating the traditional, Sikander has turned to video art and digital animation. She was awarded a MacArthur Fellowship in 2006.

These two self-portraits, which are part of a suite of etchings, exhibit Sikander's mastery of drawing and her sophisticated manner of layering. Anchored by beautifully etched likenesses that are bathed in the colors of a sunrise, the images reference the historical Miraj paintings of the visionary night journey of Prophet Muhammad. The white silhouette of a horse-riding figure serves as a metaphor for the journey for artistic truth. As self-portraits, these works reveal powerful, complex, and nuanced insights into Muslim American identity. AN

Portraits of the Artist, 2016
Etchings
56.2 × 42.9 cm (22 ⅛ × 16 ⅞ in.) each
Acquisition made possible through federal support from the
Asian Pacific American Initiatives Pool, administered by the
Smithsonian Asian Pacific American Center (NPG.2017.92–93)